Mastering Hebrew Calligraphy

Mastering Hebrew Calligraphy

Izzy Pludwinski

The Toby Press

Mastering Hebrew Calligraphy
Second Edition 2015

The Toby Press LLC
POB 8531, New Milford, CT 06776-8531, USA
& POB 4044, Jerusalem 91040, Israel

www.tobypress.com

ISBN 978 159 264 3417, hardcover

A CIP catalogue record for this title is
available from the British Library

Book design by Ruth Lubin

Cover design by Izzy Pludwinski

Images on cover are taken from works by
Izzy Pludwinski, Ruth Lubin, Sharon Binder, Archie
Granot, Lynn Broide and Barbara Wolff.

Printed in Israel

Contents

DISCLAIMER

Although this book is entitled Mastering Hebrew Calligraphy, it is doubtful whether book study alone can accomplish this. Mastering an art, any art, requires both passionate engagement on the one hand and a commitment to hard work and practice on the other. It is my intention that, at the very least, this book will present you with sound fundamentals and useful techniques. But I also hope it will inspire you and open your eyes to see things differently. In so doing you not only learn an art but are also changed by it. Consider then this book an invitation to begin an open-ended process, a journey that never really ends, for the goals keep on changing.

Over the past 30 years, Hebrew calligraphy has taken me many places—geographically, artistically and spiritually; yet there is still so much more to learn and experience. I know I still have a long way to go yet I am enjoying every moment of it. I hope that you, too, will find yourself on a path that leads you to grow in unexpected ways. Welcome to the journey.

Frank Lalou. *Creation*, 2010

Introduction

THE HEBREW ALEPH-BET is a fascinating world unto itself. In mystic lore the letters are no less than the potential energy, the building blocks, from which the world was created. In Midrashic texts the letters each have personalities of their own. In Rabbinic legal texts there are dozens of laws connected with the proper way to write each letter. In Judaism the commandment to write a Torah scroll is incumbent on all Jews—so to some extent, we are all enjoined to become Hebrew calligraphers!

But why calligraphy? In our modern, digital age, it is legitimate to ask "Why bother writing letters by hand at all, when one can use the computer to 'write' with an almost infinite variety of fonts?" To the uninitiated, calligraphy can appear to be nothing more than a quaint, outdated hobby. In response to this I offer a few thoughts.

First, on the level of experience. As a craft, there is a simple, primal pleasure to be had in the act of making something with one's own hands, using materials—things of the material world, tangible materials, that arouse the senses. The smell of the ink, the look and feel of velvety parchment or a beautiful handmade paper, the sound of the pen swooshing in a flourish. All this is absent in the sterile world of the computer monitor and mouse. To create something unique (and what can be more unique than one's own hand-writing?), something that bears the stamp of one's own personality, something that cannot be exactly duplicated by anyone else on earth (including our own selves!) is an experience of everlasting value, especially in our digital, everything-is-replicable, age.

But it is not only a matter of the calligrapher's subjective experience. Hand-created letters are alive. They are the tangible result of a process that involves the human mind, body and spirit. The energy of this involvement, this excitement, is transferred to and embodied in the letters through the creative act, enlivening them. It is the encounter with the life-force of the letters that allows a beautiful piece of calligraphy to touch and move the viewer on a deep, human level in a way that fixed-font letters can never hope to attain.

On an entirely different level, type and digital fonts have freed calligraphers from their original role of being passive servants to the text, when the concern for legibility was the supreme factor and the calligrapher's own personality was to be transparent. Calligraphy today is an exciting art form as well as a craft. The relationship of calligrapher to text is much less obvious than in the past. Lettering art can have many different purposes and the modern calligrapher/artist can use letters in forms that range from the formal and clearly legible to the wildly expressive and abstract. The sky has become the limit for the calligrapher.

But whether conservative or radical, to be effective one must have a strong grounding in the principles that make for good calligraphy. What I hope to accomplish in this book is more than just to present good scripts and how to write them. I would like to present sound fundamentals so that students will be able to work with any script, whether found in this book, in historical manuscripts or in their imagination, and write them effectively.

There is no real word in Hebrew for calligraphy. The term traditionally used for good writing is *k'tivah tamah,* which could be translated as "simple writing", or pure writing. I like the wholesomeness of that term. We do not have to be fancy. Good and simple are what we strive for—beauty will then happen on its own.

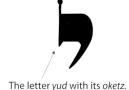

The letter *yud* with its *oketz*.

Stan Brod. *Tov* , 1982

Hebrew Calligraphy and Jewish Tradition

Calligraphy is an authentic Jewish art and craft. The Jewish connection to the word and the art of the written word can be traced back to the very beginnings of Judaism. According to one interpretation of a famous *midrash*, the letters in the Torah received crowns because at Sinai, God handed over his royal authority to the letters. Since then, understanding those letters, studying those words and grappling with those texts has become paramount to spiritual development.

But surprisingly, along with the call to study was a second call—to actually write the texts. The Torah scroll, as well as many other Jewish ritual objects, such as *mezuzot*, *t'filin* and *megillot*, must all be hand written. Perhaps the Rabbis understood that writing the letters by hand, or even deciding how to write the letters, fosters a deep relationship with the words—it becomes a way to embody the text.

In the Jewish tradition it is not only the content that has meaning, but also the forms that embody the words—the shapes of the Hebrew letters. There is an entire mystical tradition attaching holy meanings to every detail of every letter of the *aleph-bet*. (In fact, it was precisely this that drew me to the Hebrew letters to begin with. I was in a synagogue and saw a poster which had an enlarged image of the letter *yud*, with a statement warning that if an entire Torah scroll was written perfectly correct but one *yud* was missing an *oketz*—the thorn-like protrusion jutting from the lower left corner—the entire Torah scroll would be deemed invalid. "What powerful, mystical secrets lie within that *oketz*?" I wondered. This led me to study to be a *Sofer STaM*.)

It is not only the sacred letters that have played a role in the Hebrew calligraphic tradition. Artists have been playing with the forms of Hebrew letters for centuries—from 9th century micrography, through the beautifully flourished letters found in medieval illuminated manuscripts, to the freer forms found in the works of artists such as Ben Shahn and Leonard Baskin, through to today's modern calligraphers.

This tradition of seeking relevant forms falls, in my opinion, under the category of *hiddur mitzvah*—glorifying, making beautiful, a sacred object. To make something deeply beautiful means to make it deeply relevant. As the world continues to evolve, so too must our creative expression of what matters to us; this is the only way to communicate effectively. Rebbe Nachman of Breslov expressed it succinctly: האדם חייב להתחדש תמיד —Man must renew himself constantly.

It is my hope that this book will help to serve as a connection to this written past and provide some tools and inspiration to use this connection to branch out and find ever-new relevant ways to communicate what is meaningful to us, and thus touch the hearts and souls of others, as well as our own.

Putting the Scripts into Historical Perspective

The scripts in this book have their roots in what is paleographically termed the "Hebrew Square Script", or Jewish Script—a script that began to take form around 300 B.C.E. when it began to usurp what is known as the "Ancient Hebrew Script". The Dead Sea scrolls, found at Qumran, are our oldest full texts in this script, and in a later chapter we will be taking a closer look at them.

𐤋𐤅𐤔𐤀𐤋/𐤋 𐤌𐤀𐤇𐤉𐤉𐤌 𐤗𐤔𐤅 𐤌𐤋𐤇 𐤌𐤋𐤆𐤐 𐤌𐤋/𐤋𐤅𐤔𐤏/𐤋 𐤅𐤔𐤏𐤂𐤗

Ancient Hebrew script

ולבישולם נוים עוד שנת מעחתם שנעתה

Hebrew Square script from Qumran, 1st century BCE

Over the years, this square script took on local features characterized by the country in which the scribe was from. The scripts have traditionally been divided into Sephardic and Ashkenazic scripts, but each script has many variations. The beauty of many of these scripts reached their zenith in the Middle Ages.

ממצרים שני והנרת לנך כיום ההוא לאמר בעבור

Medieval Square Sephardic script, 14th century

העבירה תוזיקי ותעל שרעם

Medieval Square Ashkenazic script, 15th century

In addition to the formal square script, a more informal, semi-cursive script (Hebrew does not have a true cursive*) was also used. These were faster to write and in some cases their shapes are much rounder. These scripts vary widely depending on their country of origin and can provide much inspiration for calligraphers looking to develop newer forms for their calligraphy.

מתושלנוש : להביא מה ושתי המולכה רסכי המלך בכתר מלכה
והשדיים מה יפיה כי טובה מדוה היו והשמותי המולכה רסמי

Semi-cursive script. Italy, 15th century

Semi-cursive script. Spain, 15th century

In the German semi-cursive script below one can see many of the roots of modern Hebrew handwriting.

Semi-cursive script. Germany, 15th century

Sample of 20th century (the author's father's) Hebrew handwriting, in the Yiddish language.

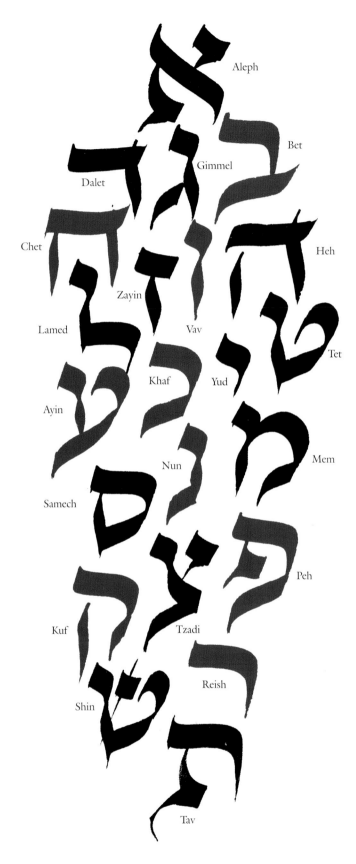

Aleph

Bet

Gimmel

Dalet

Chet

Heh

Zayin

Lamed

Vav

Tet

Khaf

Yud

Ayin

Mem

Nun

Samech

Peh

Kuf

Tzadi

Reish

Shin

Tav

The 22 letters of the Hebrew *Aleph-bet* (medial forms)

Chapter 1
A Hebrew Skeletal Aleph-bet

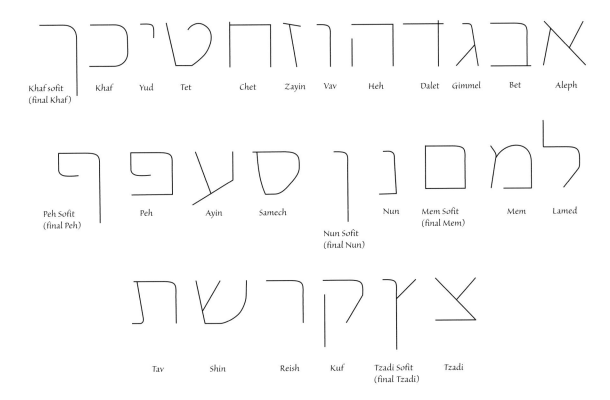

| Khaf sofit (final Khaf) | Khaf | Yud | Tet | Chet | Zayin | Vav | Heh | Dalet | Gimmel | Bet | Aleph |

| Peh Sofit (final Peh) | Peh | Ayin | Samech | Nun Sofit (final Nun) | Nun | Mem Sofit (final Mem) | Mem | Lamed |

| Tav | Shin | Reish | Kuf | Tzadi Sofit (final Tzadi) | Tzadi |

BEFORE BEGINNING to write with a pen, it is important to have a good understanding of the essential characteristics of each of the letters—their shape and proportions. No less important will be learning to put the letters together to form words and lines of writing. These are the "bones" of all good calligraphy. The skill of writing with a broad-edged pen discussed later in the book is the meat that is added on. But it is the bones, the skeleton, that underlies and determines the quality of all our work and this is what will be addressed first. This chapter is meant to be a "skill-free" introduction, meaning you won't need to write with a broad-edged pen. The suggested exercises at the end of the chapter only ask you to write the letters and words with a pencil or monoline pen. It is mostly about understanding the letters.

There are 22 letters in the Hebrew *aleph-bet*. Five of those letters have a different form when they appear at the end of a word, making for a total of 27 different characters. (See the illustration on the following page for how medial and final forms are related). Each letter of the Hebrew *aleph-bet* can be written

Relation between the five regular (medial) forms and final forms.

In Rabbinic tradition four of the five regular forms (except for *mem*) are referred to as "bent" (*k'fufah*) forms, whereas the final forms are called "simple" or "straight" forms (*pshutah*). If you take the final form of *khaf, nun, peh* or *tzadi* and "bend" the descending stroke to the left, you get the medial form. Paleographers maintain that this represents a cursive quality as the stroke was "bent" in order to lead the pen into the next letter. The medial form for *mem* is called *mem ptuchah* (open form) and the final form is *mem stumah*, closed form, for obvious reasons.

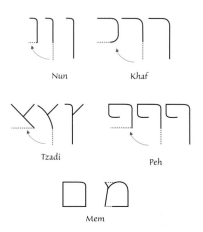

in an almost infinite variety of ways. However, for a letter-form to be successful, it must retain a certain skeletal shape that in a sense defines the letter, giving it its unique personality. It is important to understand what the fundamental components of each letter are. And though it is true that letter designers often question and play with these boundaries, one must understand what the rules are before one can even think of challenging them.

Grouping the Letters

Historically, there is no system for fitting Hebrew letters neatly into a rigid geometric grid. Letters were written freely, hanging from a single, top guideline. It is tempting to present the letters in such a free manner, but instead I have chosen to organize the letters into groups. They are written over graph paper so you can easily understand how wide each letter is supposed to be and the relation between the different elements of each letter. The body height of the letters in this *aleph-bet* is 3 boxes tall and the group's number refers to the width of the letter—the letters in group 1 are one box wide, 2 will be 2 boxes wide, 2.5 will be 2½, etc. Note that by far the largest group is group 3, meaning that most letters fit roughly into a square 3 boxes tall by 3 boxes wide. (Indeed, this script is based on forms that are termed by paleographers as the Hebrew Square Script). Having said that, even within this group there are small but important deviations, which are described in the letter by letter notes which begin on page 10. There you will find a description of each letter's essential characteristics. *Please read these carefully*, as many letters might appear to have the same shape but differ only in their proportions. Understanding this is most essential.

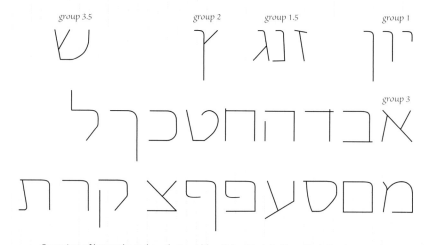

Grouping of letters based on their widths (© Izzy Pludwinski and Ruth Bruckner 1989)

After you have had a good look at the above *aleph-bet* and have read and understood the material in the notes, try the suggested exercise. It might appear tedious but I believe it to be very important and useful, even if you are already familiar with the *aleph-bet*.

Please note that Hebrew is written and read from right to left, though the individual strokes within each letter are written from left to right.

EXERCISE 1: WRITING THE SKELETAL ALEPH-BET. Materials: graph paper, 2H or H pencil, HB pencil or any black, fine-pointed marker, ruler

Take out a sheet of graph paper. Rule penciled guide lines 3 boxes high with your 2H pencil. Using an HB pencil or a fine pen or marker, copy each of the letters exactly as they appear above. Make sure your lines are straight and the proportions are exact. One and a half boxes means 1½ boxes and not 1¾ boxes. Calligraphy at this stage requires exactness, and accuracy is crucial. Until you are familiar with the limits of each letter, even small, apparently unimportant deviations might cause one letter to be confused with another. This is especially true in Hebrew, where many letters appear to have the same shape but differ only in the proportions of the stroke lengths within the letter, for example, *reish* and *vav* (see "Notes on Letters" section starting on the following page).

After you have succeeded writing the letters accurately on graph paper, try repeating the exercise on plain white paper. Rule guidelines 1½ cm. or ¾ inch tall and aim to reproduce the letters as accurately as possible.

Terms Used to Describe the Hebrew Letters

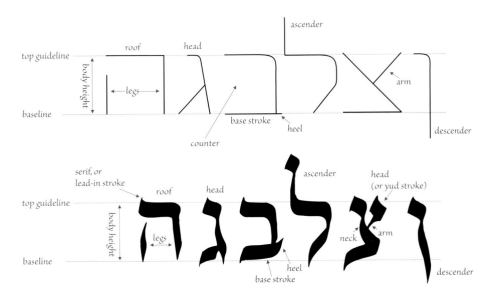

Body height: The height between the horizontal roof stroke and the baseline (which generally corresponds to the bottom of the leg stroke, in a letter that is not a descender).

Roof: The wide, top stroke of the letter. Can be horizontal or sloped.

Head: When the top stroke is narrow it is called the head.

Arm: A short stroke that connects the head with another stroke.

Leg: A stroke descending from the head or roof, often reaching down to the baseline.

Ascender: A letter that ascends significantly above the top guideline.

Descender: A letter that descends significantly below the baseline.

Serif: A lead-in or finishing stroke appearing at the beginning or end of a main stroke. For our purposes it will mainly refer to a lead-in stroke.

Counter: The white space inside the letter.

* The terms used here are descriptive rather than technical. Many of the terms are borrowed from the Rabbinic literature describing the laws of the sacred letters of the STaM script (the script used, for example, in the writing of a Torah scroll).

Notes on the Letters of the Skeletal Aleph-bet

It is essential for the calligrapher to have a thorough understanding of the shapes and proportions of each letter of the *aleph-bet*. Each letter, no matter whether it is part of a formal, informal or even abstract script, deserves the dignity of having its own identity, not to be confused with another letter. These notes refer specifically to this particular skeletal *aleph-bet*, though most of the comments are applicable to other scripts as well.

ALEPH: Its unique feature is the diagonal. There is great variation where the "arm" and "leg" meet the diagonal but the spot where the left leg hits the diagonal must be above where the right arm meets the diagonal. Care must be given to the balance of this letter. In general, the letter appears more stable when the upper triangle (formed by the diagonal and arm) is smaller in area than the lower triangle (formed by the leg and diagonal).

BET: The key characteristic is the "heel" on the bottom right, jutting past the vertical stroke. It must be clear, otherwise the letter will be confused with *khaf*.

GIMMEL: This letter must be clearly distinguishable from *nun*, so be sure to leave enough white space at bottom of letter, where the bottom leg joins with the vertical stroke. *Gimmel* should be wide enough to accommodate the left leg which should jut out just a bit from the head. Still it is a narrow letter. Care must be taken to balance the elements so the letter is upright and not leaning either forwards or backwards.

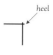

DALET: Care must be taken in order to differentiate *dalet* from *resih* which it greatly resembles. Therefore it ought to have a clear "heel" on the upper right corner, jutting past the join with the vertical leg. In this script the vertical also rises slightly above the guideline to help in clarity. The leg should not be placed too much towards the center of the letter; otherwise it may resemble a *zayin*.

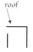

HEH: One of two letters in the *aleph-bet* that are made up of two disconnected strokes (the other is *kuf*). There should be ample space between the left leg and roof to clearly differentiate from *chet*, yet have enough presence so it appears as a strong parallel to the right leg. Top right corner is sometimes curved rather than angular.

VAV: Must be narrow—too wide and it will resemble a *resih*.

ZAYIN: Care must be taken that *zayin* is not confused with *vav*. The leg should join the head either at the head's center or to the left of center. The head can be straight or sloped.

CHET: Same as *heh* but left leg is connected. Note that it is a full square's width.

TET: The right head can be a circular stroke, as it is in this script, or be made more horizontal. Either way, it should join smoothly with the base stroke.

YUD: Must be both short (between a third and half-way down) and narrow. Too long and it resembles a *vav*. Its width usually equals its height.

KHAF: Its important characteristic is its roundness—both at top right and bottom right, in order to differentiate it clearly from *bet*. Its width is the same as the counter of *bet*, thus it is slightly narrower than a full square. The left edges of its top and bottom horizontals should align.

KHAF SOFIT: Same shape as *khaf* but the vertical goes straight down two squares below the baseline instead of curving to the left. (Except for *mem*, the only difference between the final and regular forms of a letter is that the final form has a straight leg while the regular form has a "bent", turned-in stroke).

LAMED: The only ascender in the Hebrew *aleph-bet*—should be at least two boxes higher than a regular letter but can be more. (See Dead Sea Scroll *lameds!*) In most *aleph-bet*s the shape of the bottom of *lamed* relates to that of *kuf*.

MEM: In Rabbinic literature this letter is described as a *vav* attached to a *khaf*. In this *aleph-bet* however, the leg of *vav* is sloped, and the right side is a symmetrical arch.

MEM SOFIT: Make sure the bottom left is angular. This is important as in many formal scripts final *mem* can be easily confused with *samech*.

NUN: Think "narrow" in order that it should not resemble a *khaf*. The bottom leg juts out just a bit past the beginning stroke of the roof, otherwise the letter leans forward. If it juts out too much, you will have trouble spacing the next letter.

NUN SOFIT: A descender, two boxes below bottom guide line. In this script it has the same basic shape as an elongated *vav* (in other scripts it sometimes has the shape of an elongated *zayin*).

SAMECH: Note the similarity between the bottom strokes of *tet*, *samech* and *shin*. They all consist of a slanting vertical on the left, a short horizontal on the bottom and a sloping upwards stroke on the right. Think "curve" at the bottom left, to clearly differentiate it from *mem sofit*.

AYIN: Left "leg" touches near to the mid point of base stroke. If too close to the right then it could appear as *tzadi*. If too close to the left edge of base it could appear as *tet*. Note the bottom stroke dips below the baseline.

PEH: A *khaf* with an upside-down *yud*. When this letter is written with a broad - edged pen, there is often not enough room to squeeze in the upside down *yud* and so the bottom horizontal stroke needs to be placed below the base line.

PEH SOFIT: A descender, its shape is that of *khaf sofit* with an upside-down *yud* down the left side of the roof. Do not come down too low with the *yud* part.

TZADI: When writing *tzadi* with a broad-edged pen, the diagonal can often present a problem as it can cause a "dark spot" within the letter. But here, in skeletal form, the letter is pretty straightforward. Do not allow the right arm to hit too low lest the letter resemble an *ayin*.

TZADI SOFIT: A *nun sofit* with an attached arm.

KUF: In most scripts, the leg is separated from the roof, but in some they are connected (see *Yerushalmi* script). In either case it should be clear which one you are doing, i.e. don't put it too close if you intend to have them separate.

REISH: Make sure there is a nice curve at the top right in order that it should not be confused with *dalet*. In order to compensate for the very large open counter within the letter, which would allow in too much white space, this letter should be made narrower than a full square. Of course it should never be so narrow as to be confused with *vav*.

SHIN: The widest letter—in order to incorporate the inner arm. Related to shape of *tet*. In different scripts the middle arm can join either to the left arm as in this *aleph-bet*, or to the point where the left arm hits the base, or even directly to the base. It should not however hit the base to the right of the base's center.

TAV: Think of it as a *reish* (a full three boxes wide, though) with a *nun* shape attached to its end. The bottom leg should not jut out more than a bit (if at all) past the left edge of the roof as it will be difficult to space the next letter properly.

Designing with a Monoline Pen

Even before we begin working with the broad-edged pen it should be noted that interesting designs can be created using just a monoline pen, such as a simple felt tip pen. Below is the work of Lynn Broide, in a playful piece using both square and semi-cursive forms in an improvisational manner. On the following page are other works utilizing monoline letter forms.

Lynn Broide. Detail from *Aishet Chayil,* incorporating freely written monoline forms

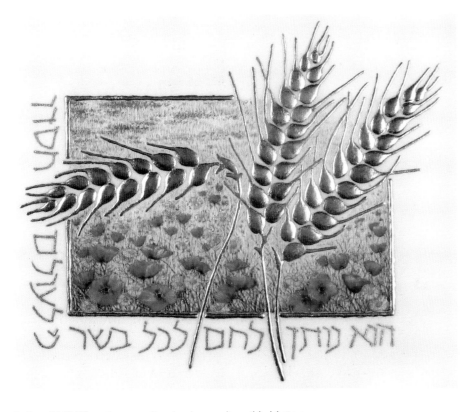

Barbara Wolff. *Wheat*. Incorporating simple monoline gilded letters

Cover design for *The Koren Siddur*,
designed by Ada Yardeni

Going Too Far?

Below are some examples where the designer has tested (ignored?) the boundaries of the integrity of the letter in order to, in my opinion, force originality. In the example on the left, the basic structure of the *aleph*—having the right arm hit the body of the letter at a point above where the left leg hits the letter—has been undermined. A similar example (center) is found in the present corporate identity of the Egged bus company. The letter *aleph* has been distorted into an X, completely ignoring the integrity of its basic skeletal structure. In the examples to the right, there is ambiguity in the *mem* (or is it *peh*?) shape which might confuse the reader.

The "H" shape is
supposed to be an *aleph*

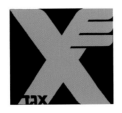

Egged logo. The X shape is
supposed to be an *aleph*

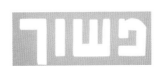

m'shoch, or p'shoch?

Chapter 2

Spacing & Rhythm

Fred Pauker, *Each man has a name*, 1984

CALLIGRAPHY MEANS beautiful writing. Beautiful writing means more than just beautiful letters. Often, too much emphasis is placed on writing the (so called) "perfect" letter and too little on what to do with all those letters. That means taking into account how the word is spaced—how letters are put together to form a word, how words are put together to make up a line, and no less important, how the lines are put together to form a text block. I would even venture to say that poor letter forms that are consistently spaced will look better than nice letter forms used with bad spacing. The eye of the viewer, trained or untrained, first notices pattern or rhythm. Only afterwards will the viewer go deeper and look at the letters themselves and analyze their worth. If the pattern is not a pleasing one, if the spacing or build-up of the text block is poor, then the viewer will have little incentive to be drawn into looking at how beautiful your letters might be.

But the issue isn't only one of esthetics. Good spacing aids the viewer to read efficiently, helping the eye travel in a definite direction without ambiguity. If letter spacing is not consistent it causes, even if only for a fraction of a second, a hesitation and questioning—does this gap indicate a jump to a new word? If proper line spacing is not used, the reader might need to hesitate before determining where the next line begins. An even rhythm makes for a more pleasurable and efficient reading experience. In this chapter we will analyze the ingredients that make for good letter and word spacing. Line spacing will be taken up in a later chapter.

Letter Spacing

How much space does one leave between letters? Unfortunately, there is no one answer to this question. We want our letters to look evenly spaced, to have an even "color" throughout the word and line, an even rhythm of black and white. This occurs when the total area of white space between letters appears equal. Measured spacing, i.e. measuring equal linear distances between the edges of the letters, will paradoxically give us uneven looking spacing. This is because of the different shapes of the letters; some of the letters are "open" such as *reish*, and the eye takes in some of this space within the letter (the space within a letter is called a "counter") in addition to the measured space between the edges of the letter. Some letters, such as *chet*, are closed and block off the inner white space within the letter. So, for example, a letter following a *reish* would have to be placed closer than the same letter placed after a *chet*.

Take a look at the spacings of the word *cherut (freedom)* below. See how equal measured spacing gives uneven and awkward results. In (a) the measured distance between the *chet* and *reish* and between *reish* and *vav* is the same (the gray rectangles are of equal length). However, *visually* the *reish* looks closer to the *chet* than to the *vav*; there is a gap within the word—see (b). This has been corrected in (c). The measured distance between *chet* and *reish* in (d) is more than the measured distance between *reish* and *vav* but optically the spacing looks even. This is because the eye takes in some of the white space of the open counter within *reish*. Our aim is for even, optical spacing and this can only be done by eye.

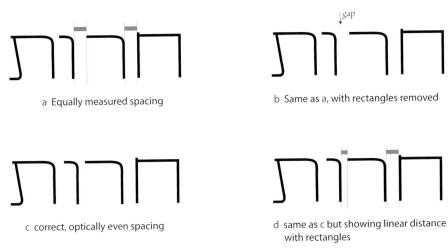

a Equally measured spacing

b Same as a, with rectangles removed

c correct, optically even spacing

d same as c but showing linear distance
 with rectangles

A good general principle to follow is:

1. Leave the most distance between two upright strokes.

2. Leave relatively closer space between an upright and a curved (or diagonal) stroke.

3. Leave even closer space between two curved strokes.

Using an invented, purely geometric Hebrew *aleph-bet* based on curves and lines, we can see all three points illustrated in the Hebrew words *susson yam* (seahorse), shown here with *nikkud* *:

*As will be discussed in more detail in Chapter 15, Hebrew does not usually use letters as vowels. In certain cases pronunciation is facilitated by the addition of vocalization marks called *nikkud*.

To demonstrate clearly these spacing principles, look at the words below, this time without the *nikkud*:

a equal, measured spacing b same as a but with rectangles erased

The measured spacing in (a) (all the gray rectangles are the same width) gives you (b). See how that paradoxically gives you a look of unequal spacing. The two vertical letters at the end of the first word look too close to each other, creating a darker "color" at the end of the word.

c corrected, "optical" spacing

In (c) you now see the word with corrected optical spacing. The letters with verticals in both words have been moved farther apart so that the total white space between letters is equal and the "color" of the word is even throughout.

Exercise: Making Words with the Skeletal Aleph-bet

When you feel you have understood the principles detailed above, try writing some words. The words below were chosen because they represent interesting spacing challenges.

Materials: Plain white layout paper, 2H pencil, ruler, any monoline writing tool—pen, pencil, marker.

Holding the paper horizontally, rule guidelines 1½ cm. high or ¾ inch high. Write out the following words with optically even spacing. If you see your spacing is off, redo the word— this is the best way to improve. When you think you have it right, go on to the next word. Tip: if you are unsure about your spacing, turn the page upside down and view it that way. When the letters are thus unrecognizable it is sometimes easier to judge the spacing.

Sometimes it is easier to see the faults in spacing when the word is turned upside down:

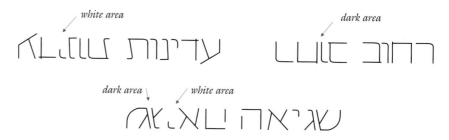

white area dark area

dark area white area

Word Spacing, and its Relation to Letter Spacing

How much space to leave between two words? This too unfortunately gets an "it depends" answer. It will usually fall between one and two "*yuds*" width, but it must be noted that word spacing is not independent of letter spacing nor even the type of script one uses. Our aim is to allow the reader to easily recognize when one word ends and another begins. On the other hand we do not want the eye to have to "jump" long distances to get to the next word; too much space leaves patches of white in the middle of our line and disturbs the horizontal travel of the eye. See (b) below for how little space is actually needed to differentiate a new word. However if the spacing within the word is loose (d) we will need more space between words (e).

Sentence (a) below is considered normal spacing though notice that even if word spacing is reduced (b), the individual words can still be easily differentiated. In (c) there is too much space between words. This makes the words seem like separate entities instead of units in a line of writing and the eye would have to jump too far to read the next word. In (d) the letter spacing is loose and the separate words cannot be differentiated easily. With loose letter spacing, word spacing needs to be increased (e) in order to facilitate the recognition of separate words.

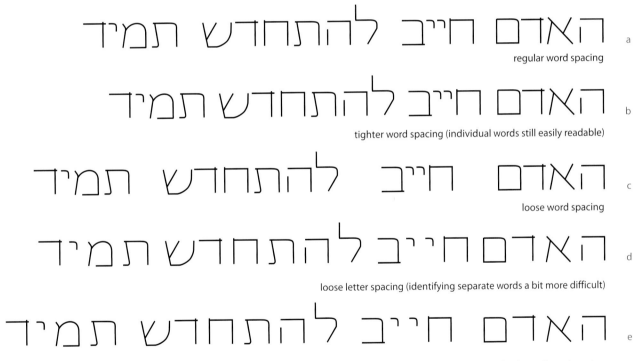

a — regular word spacing

b — tighter word spacing (individual words still easily readable)

c — loose word spacing

d — loose letter spacing (identifying separate words a bit more difficult)

e — loose letter spacing with adjusted word spacing

Now that the basic principles of arranging letters have been understood it is time to move on to making those letters with a broad-edged pen. (That doesn't mean we are finished with our discussion of spacing. The important subject of interlinear spacing and making a text block will be discussed later, in Chapter 11, "Layout and Design".)

Chapter 3

Tools & Materials

CALLIGRAPHY AT ITS ESSENCE requires only the simplest of materials—pen, paper and ink. A good understanding of their many varieties will help you choose the right combination.

Pens

The tools we use to write with no doubt influence how our letters look. Although reed pens and quills of bird feathers were the traditional tools of the pre-industrial age, the modern calligrapher will most likely find it more convenient to begin with a metal-nibbed pen. This in no way is meant to imply that metal pens are superior. The experience of writing with a sharp, newly-cut turkey quill on a beautifully prepared piece of vellum calfskin is a sensual and calligraphic experience not to be missed. But this chapter will be addressed to the typical beginning calligrapher, and so our discussion will be limited to metal nibs.

Reed pen, turkey quill

Metal nibs can be broadly classified into pointed nibs and broad-edged nibs. With pointed nibs one varies the thickness of the line according to the pressure one places on the nib. With broad-edged nibs, the important factor is the pen angle and pen direction. We will talk about this extensively throughout the book. Since almost all the scripts taught in this book are formed with the broad-edged nib, we will limit our discussion in this chapter to these types of nibs.

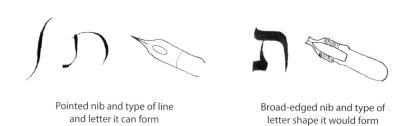

Pointed nib and type of line and letter it can form

Broad-edged nib and type of letter shape it would form

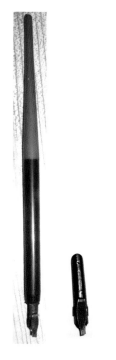

Broad-edged pen with Brause nib

Metal broad-edged pens can be divided into two major categories, fountain pens and dip. Each has its advantages. Fountain pens are convenient: they have cartridges that hold large amounts of ink, the ink flows evenly and one doesn't have to fiddle with messy first attempts of dipping a pen into a bottle of fresh ink. Dip pens, which consist of a nib with a relatively small reservoir attached to a holder, require more patience in the beginning to master. However, once one gets the hang of it, the advantages of the dip pen considerably outweigh the initial inconvenience. Firstly, the nibs for dip pens

are sharper than those of fountain pens and will give crisper, better-defined letters. Secondly, in order for the ink to flow easily, fountain pen inks must necessarily be thinner, more watery, less viscous; the letters produced by them will appear less vibrant. Likewise, if one wants to write in color, the colored inks usually used in fountain pens appear watery and transparent. More importantly colored inks are for the most part not lightfast, meaning they fade in time. I have seen works where the letters written in colored inks have vanished completely after just a few years. With dip pens one can use gouache and watercolors and thus you have available a wide range of strong, lightfast colors.

So it is my strong recommendation that the beginning calligrapher start right away with dip pens (though if all you have available is a fountain pen set, don't let this hinder you. Use your largest size nib to begin with). As mentioned above, dip pens consist of a nib which fits into a holder. The nib comes with a reservoir which in most instances is adjustable and removable. Brause, Mitchell, Speedball and Tape are some of the companies producing good quality metal nibs, with Brause nibs being the stiffest, and Mitchell the most flexible. I find the Speedball pens (C series) to be fine for large writing but their smaller sized nibs do not give sharp enough letters for formal writing. The Speedball pens have their reservoir permanently attached. The reservoirs on Brause and Tape are attached above the nib and in the Mitchell they are beneath the nib; in all three of the latter the reservoirs are detachable.

For convenience sake, in this book I will be referring to the Brause nibs for the exercises, as their sizes are numbered according to their width in millimeters, but one should also try the others to see what best fits your hand. Someone with a light touch might prefer the Mitchells, one with a heavier hand the Brause. Whatever you choose I recommend you get a full selection of sizes. At some point in your calligraphy you will want to write both large and small and everything in between.

When buying or ordering these nibs you will notice that they are offered in different "cuts", meaning the angle of the nib edge. Some are cut square, some are cut right-oblique (called simply oblique) and some are left-oblique. You can write with any of them, though for some Hebrew scripts, such as the Ashkenazic, which require a very steep pen angle, you might find the left oblique nibs to be the easiest to write with, whether you are right or left-handed. In general, for Hebrew, the left oblique allows the arm and hand to be in the most natural position, next would be the square cuts (called "Roundhand" in the Mitchell series—Brause nibs do not cut come square-cut), with the right-obliques requiring some arm adjustment to maintain the correct pen angles.

Pen Holders

Pen holders come in different sizes and shapes. Choosing one is really a matter of personal taste so try a few to see what feels best. I suggest you choose a perfectly rounded shape for the barrel as some holders force you to fit your

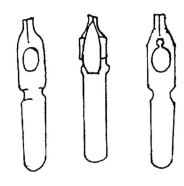

Different cuts. From left to right:
Left-oblique, Right-oblique, Straight cut

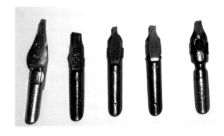

Commercial nibs. From left to right:
Speedball, Tape, Brause left-oblique,
Brause right-oblique, Mitchell left-handed

fingers into their predetermined shapes which might not necessarily be the best place for your particular hand. I use a very simple, inexpensive one, the Caran d'Ache 114 holder, which is a rounded barrel with "serrations" to aid the grip.

Paper

The texture and deckled edges of this Israeli handmade paper adds visual interest to a simply designed ketubah by Izzy Pludwinski.

Papers come in all sizes, shapes, weights, textures and colors. For practice, a good layout pad will be useful, such as Boris #37 by Borden and Riley. The surface of these papers have a bit of "tooth", and "grab" the ink better than plain photocopy paper and will give you sharper letters, though good quality photocopy paper might suffice in a pinch. For final pieces you will want to look into finer papers. There are several characteristics that a Western calligrapher looks for in a paper. One is that it will hold the ink sharply and not bleed. The ingredient that is put into papers by the manufacturers to prevent bleeding is called size. Not all papers are sized the same so you will have to experiment a bit. Another very important characteristic you want in your paper, especially for permanent works, is for it to be archival. Wood-pulp based papers for example have a high acidic content and will discolor or disintegrate relatively quickly with time (think of old newspapers). So when buying a paper make sure to ask for an acid-free, or pH neutral paper.

Papers can be handmade or machine made. Handmade papers often have more "personality", while machine papers will have a more even consistency. Handmade papers are made one sheet at a time and will have four natural deckled edges. Machine papers that are produced continuously in a roll will have four straight edges, whereas machine-mades that are produced one sheet at a time (mould-mades) have two deckled and two straight edges. Handmade papers are not necessarily better than machine-mades. It all depends on what fits your purpose best.

Machine papers have a grain direction which you need to be aware of if you are planning on folding the paper (e.g. for a book or a greeting card). Only fold in the direction of the grain. To find out the direction of the grain, loosely fold over the paper and press gently (being careful not to crease the paper) first in one direction then the other. You will find that it folds easier (less resistance) in one of the directions. This is the grain direction. Handmade papers do not have a single grain direction and may be folded either way.

Above and below: Writing on rough paper can add interesting texture to the edges and inner parts of your strokes.

Papers also have different surface textures. Some are smooth (as a result of the paper being pressed between rollers after it is made), some will have a slight toothy texture, and some will be rough. Smooth papers with a bit of tooth are probably the best papers for traditional writing—you will get the cleanest line and crispest edges with them. There might be occasions though when you prefer a rough look to your letters, making a rough paper the better choice.

Papers also come in a plethora of colors. The calligrapher is not limited to light colored papers as one can write with light-hued gouache even on black papers. See the section "Writing with Color", in chapter 13.

Inks

Start with a black ink. There are many inks on the market and you will probably begin with what your local art supply store can offer you (a list of some online supply stores are given at the end of the book). We want the ink to be rich in its blackness, flow nicely from our pens, and be able to give us sharp strokes and thin hairlines. For practice, one might want to start with an easy-flowing, non waterproof ink such as Higgins Eternal. For more serious work I recommend liquid sumi, which will give you a much darker black. (I use a liquid sumi made by Yasutomo but there are many other brands). If you really want control over the thickness and blackness of your ink, try a Chinese or Japanese stick ink, which is ground over a slate stone with a small amount of water. One should be aware that these sumi inks dry waterproof. Although you should always be meticulous in caring for your nibs and not allow inks to dry in them, this is especially true for waterproof inks. To clean your nib, remove the reservoir if possible, dip in water and wipe dry. Do the same for your reservoir. If necessary, scrub with an old toothbrush to remove any remaining ink.

Until you find one that works best for you, I urge you to constantly try out different inks as each have different properties, and new ones continue to appear on the market.

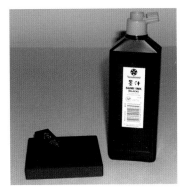

Stick ink with round suzuri (grinding stone), and bottle of liquid sumi

Other Equipment

In addition to the above, you will need a good ruler. The units given in this book are in millimeters; choose a ruler with clear and accurate markings. I find the easiest rulers to read are white ones with black markings.

You will need a few different pencils. Pencils are graded according to their hardness. HB being of medium hardness, then getting harder going from 1H to 9H. Likewise, the Bs get softer going from 1B to 9B. You will need a 1H (or simply H) pencil for ruling lines and an HB or 2B for the skeletal *aleph-bet* exercises. Always keep your pencils sharp!!!!

You also might want an inexpensive round or pointed brush for filling your pen with ink. Also have a lint-free rag for wiping your nibs, and a good non-abrasive eraser for erasing penciled guidelines.

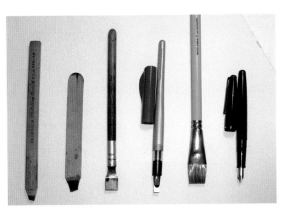

A variety of other broad-edged tools. From right to left: fountain pen, flat-edged brush, "Parallel Pen" (a fun tool that combines some of the better qualities of dip pens and fountain pens), Automatic pen (for writing large letters), Popsicle stick, Carpenter pencil

Chapter 4

Getting Started

Posture and Body Awareness

I TAKE IT AS A GIVEN that in life we would like all of our movements to be as efficient and as effortless as possible, with our breathing soft and free of tension. Calligraphy is not an activity separated from life and thus these ideals naturally apply to the way we write. Since calligraphy can be, especially in the beginning, an act that demands intense concentration, it is important not to lose awareness of our body in the process.

Much has been said about the importance of posture in writing. Posture however is not to be thought of as a single, correct, static position that the body must maintain at all times. Posture is a dynamic state requiring ever-changing skeletal and muscular alignments as we move. Ironically, trying to maintain a correct static posture while moving often forces us into moving in a stiff manner that can have adverse effects on our body.

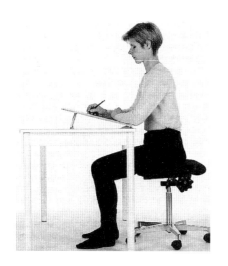

Relaxed body position for writing.
From *Body Know-How* by Jonathan Drake

Thus it is recommended that from the outset one pay careful attention to how one writes. On a personal note, early on I developed bad writing habits and even today, after 30 years as a calligrapher, I still need to be constantly aware of writing properly. "Properly" means all your muscles are working for you in an efficient manner, movement is natural and effortless, breathing is not impaired by slouching, and you do not waste energy and create tension by gripping the pen tightly as if daring someone to grab it out of your hands.

During writing, try from time to time doing a "body scan", starting from the top of the head, moving on to the facial muscles, neck, shoulders, back, rib cage, continuing methodically all the way down to the toes, all the while asking yourself such questions as: Am I unduly tightening up any muscles? Am I holding my breath? Am I slumping? Are my shoulders raised unnecessarily, causing tension in the neck? If you do find yourself tensing a part of your body, then pause, isolate that part of your body in your mind, and softly exhale into that part while letting go of the tension.

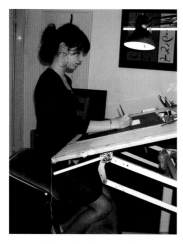

Sitting at a kneeling chair

Often tension is caused by the anxiety of needing to succeed. Try to place the emphasis on enjoying the act of writing for its own sake rather than the result. (See "Attitudes" below). I also join the many teachers who recommend deep breathing exercises as preparation before writing. For a deeper understanding of proper body-use one can benefit from studying a proper body-use discipline such as the Alexander or Feldenkreiss method.

Setting Up Your Work Surroundings

Position your paper centered in front of your body (left-handers see below). If you are using a conventional chair, then both feet should be resting on the ground, your weight evenly balanced on your buttocks. (I personally use a kneeling chair which I find most comfortable, prevents slouching and relieves strain on the lower back). Your chair and table should be at a height which allows you to sit up straight—table not too low where you need to slouch or bend over excessively, nor too high where you need to raise your shoulders. You might find it more convenient (and certainly easier on your back) if your writing surface is sloped. How much so is a matter of preference. 45 degrees is a good starting point. In general, flatter surfaces will increase the speed of ink flow. If you are a beginner you might want to simply place a writing board sloped over some books. Later on you might want to invest in a portable drafting board or drafting table.

One should not write directly on a hard surface, but rather place a few sheets of paper underneath the actual paper you will be writing on. These can be taped with masking or drafting tape to the table. This will make things easier on your hand and also provide for a little "bounce" to you letters.

Adjustable-angle drafting board, side view

You do not want your hand to actually touch the paper you are writing on, as oils from your skin get on to the paper and will prevent your letters from being sharp. Therefore one should have another piece of paper, either taped or loose, covering the area not being written on, acting as a shield between the bottom of your hand and the actual paper. I also have a scrap piece of paper nearby which I write on to "get the ink going" before starting my letters.

Your workspace should have adequate lighting. Light should come in from the top left if you are right-handed, top right if you are left-handed.

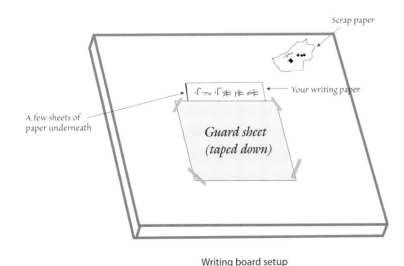

Scrap paper

Your writing paper

A few sheets of paper underneath

Guard sheet (taped down)

Writing board setup

Attitudes

If this is the first time you are picking up a calligraphy pen, realize you are embarking on what will hopefully be an extremely enjoyable adventure, yet one that can be frustrating at times, especially at the beginning. The virtue of patience cannot be overstated. Getting good at calligraphy takes time and lots and lots of practice. My advice is, from the very beginning, to focus on the simple pleasure to be had in the very act of writing. When I first started learning calligraphy, I remember the joyous sensations I felt—feeling the glide of the pen on the paper; the feel of the ink flowing out of the nib, its edges working together to produce anything from solid thick lines to the thinnest of hairlines; the wet, jet black color slashing and enlivening the white of the paper. It is important to try to retain that simple and humble pleasure, keeping it separate from the inner critic that will be judging the quality of your letters. There will be inevitable frustrations that occur in the beginning trying to get your letters to look like the exemplars, and you should be demanding in what you seek in forming your letters, but do not let your enjoyment rest solely on whether you create that perfect letter or not. Calligraphy is meant to be an enjoyable act and every stroke one makes has that potential to give us joy.

Getting Started with the Pen

ASSEMBLING THE PEN

Attach the nib securely to your holder between the metal grips and the barrel, making sure it cannot wiggle. Nibs, when new, are covered with a very thin film of wax in order to prevent any rusting while they sit on the store shelf. We need to remove this layer. The simplest way is to dip the tip of the nib into a glass of near boiling water for around five seconds, and then immediately dip it into a glass of cold water. Wipe dry with a lint-free rag.

Position the reservoir by sliding it so that its tip is about 2 mm from the edge of the nib. Mitchell reservoirs are flexible enough to be shaped (see image at left). Make sure the reservoir does not "pinch" the nib, distorting its shape. Use tweezers if necessary to loosen the reservoir's grip on the nib.

PEN GRIP

For maximum control, the pen is gripped not too close to the nib, nor too far—somewhere about 1 cm from the bottom of your pen holder. The pen holder is gripped between thumb and slightly bent forefinger, while resting on the middle finger. You thumb and forefinger should not be touching. Keep your finger pressure to the minimum required for control—otherwise cramps and calluses might result.

EXERCISE:

To get over the fear of the blank white page, think of this exercise simply as "play". Take a clean sheet of paper, dip your nib (use a size 2 mm Brause nib or larger) into the bottle of ink and just begin making marks. Go in all directions.

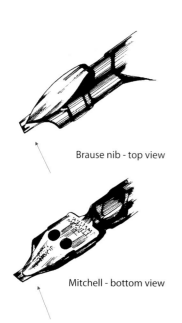

Reservoir should be in contact with nib.

Side view of Mitchell nib. Note how the reservoir is shaped to allow for controlled flow of ink.

Brause nib - top view

Mitchell - bottom view

Proper placement of reservoir, around 2 mm from nib edge

Make horizontal strokes, vertical strokes, curved strokes, circular strokes, small strokes and large. How long can you make your straight stroke last before the ink runs out? Did your ink come out cleanly or as a blob in the beginning? Try dipping the pen deeper or shallower into the bottle when filling to give you a more efficient use of ink. Clean your nib with your rag as often as necessary. Try to get your first stroke to begin with a clean, sharp edge. If the ink is stubborn in coming out, try making (on scrap paper) quick back and forth "scratch" marks along the thin edge of the pen and then immediately make a thick stroke with the full nib. Do not allow the ink to dry in your nib as you will not be able to get a clean stroke that way. If the ink has dried in the nib, dip the nib edge in water and dry thoroughly. (Only dip till the end of the reservoir. Do not let water get into the grips of the pen holder.) You can run a slip of paper between the reservoir and nib to absorb the excess of water. Only clean nibs will give you sharp strokes!

Pull your strokes from left to right, then try pushing the pen from right to left . (Lefthanders will be pulling from right to left and pushing from left to right). Does the pen go easier in one direction versus the other?.

Pay attention to what part(s) of your body are involved in forming your strokes. Try this exercise: Make a straight stroke using only finger movements, without moving your wrist. How long can you keep your line straight without it curving? Now try again using motion by the wrist but keeping your shoulder locked. And finally let your motion come from a freed up shoulder. Hopefully your straight lines became increasingly longer. Be aware of these three ranges of motion as all three can come into play in your calligraphy.

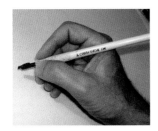

Relaxed grip

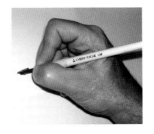

Grip too tight

What about Lefties?

The good news for left-handers is that you have a certain advantage in writing Hebrew calligraphy. There is less of a chance you will smudge the letters you have just written, and no less important, your view of your writing is unimpaired, which will help you immensely in your spacing. Having said that, left-handers do have a general problem in calligraphy. If you keep your paper upright and directly in front of you, you will see that it is not possible to keep the correct, relatively steep pen angle (see "Pen Angle" below) required for Hebrew calligraphy without uncomfortably bending back your wrist. Using a left oblique nib (available for the Mitchell, Brause and Speedball nibs) will certainly help. In addition, you will have to make some position adjustments in order to write comfortably with the correct angle. See below for three possible positions.

Method a. TURNING THE PAPER ON ITS SIDE: This is the method I was first taught and still use. The paper is turned 90 degrees to the side. Your writing direction will be from the bottom up rather than from right to left. The disadvantage is the unusual visual perspective. However, once one gets used to this, there are many advantages. First, the wrist is in a

completely natural position. Secondly, one has an unobstructed view of the work so that spacing is much easier; and thirdly, since the hand falls below the line of writing there is no danger of smudging.

Method b. THE WRIST - TWIST: In this method the paper is held somewhat to the left of the body. The paper might also have to be slightly tilted towards you in a clockwise direction. In order to maintain the correct pen angle the wrist must be twisted back. Personally I find this extremely uncomfortable and I am not fond that the body is in an unnatural position. Having said that, there are many left-handed calligraphers who use this method successfully.

Method c. THE HOOK: In this method the paper lies directly in front of you. Because the pen must be pulled in order for the ink to flow properly, the only way to write with the hook position is to reverse the stroke direction. Horizontals go from right to left, verticals from bottom to top. This is an unnatural way of forming the letters as one loses the natural organic rhythm in the structure of each letter. I would only try this as a last resort, though admittedly, spacing is relatively easier with this method.

Obviously there is no one perfect method. Each has advantages and disadvantages and it is only by trying them all out that one can know what works best for you.

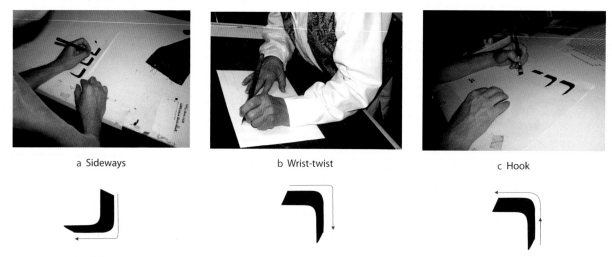

Three methods for left-handers and how a *reish* would be written with each one—sideways, wrist-twist, hook

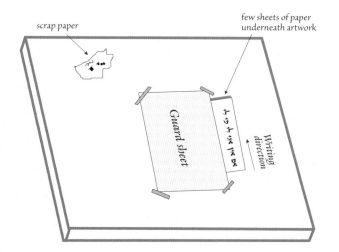

Writing board setup for left-handers
using the sideways position

PEN ANGLE

The obvious difference between writing with a broad-edged pen and a ball point pen is that the former can give you thick and thin strokes. The control of these thick and thins is one of the skills that will be essential for you to develop. You might have noticed in the previous exercise that you change the thickness of your lines depending on the pen angle and direction. *Pen angle is the angle the edge of the pen makes with the horizontal line of writing.* We will now investigate this methodically.

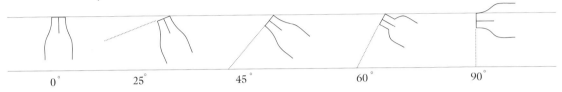

Holding the pen at different angles

If you hold the pen such that its edge is perpendicular to the line of writing—in other words at a 90 degree angle—and make a horizontal line, you will get the thickest line possible with that particular pen. Conversely, if while holding the pen at the same angle you make a vertical line, you will get the thinnest line possible with the pen (See Figure a below).

If you now slightly flatten the angle, let's say to 60 degrees, and draw a horizontal line, the line now becomes slightly thinner. Conversely, if you hold the pen at the same 60 degrees to the line of writing and make a vertical stroke, the vertical line is wider than the one drawn at 90 degrees (b).

If you flatten the pen angle further and hold it at 45 degrees, then again the vertical line becomes thinner and the vertical line broader. Notice that at 45 degrees, your horizontal and vertical strokes will be the exact same thickness (c).

If you flatten the pen angle to less than 45 degrees, let's say 25 degrees, the horizontal strokes become even thinner—the vertical stroke is now thicker than the horizontal (d), and finally, at 0 degrees, the horizontal becomes the thinnest line possible and the vertical the thickest (e).

Much of beginning calligraphy involves controlling these pen angles, as it is the contrast between thick and thin strokes which gives broad-edged calligraphy its distinctive beauty.

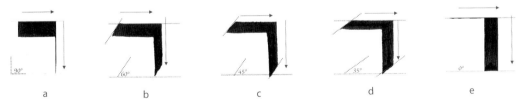

Figures a-e. Horizontal and vertical strokes made with different pen angles

In most Hebrew calligraphic scripts, the horizontal strokes are thicker than the vertical strokes (which is opposite of most Latin calligraphy scripts) and so we will be working at pen angles greater than 45 degrees.

GUIDELINES AND PEN WIDTHS

Calligraphers rarely write directly onto a blank piece of paper. Most calligraphers use guidelines to help keep their letters an even height. In the beginning you will need to rule both top and bottom guidelines with a pencil. (As you gain in proficiency and experience you might choose to dispense with the bottom guideline as traditionally Hebrew letters were written "hanging" from the top guideline). Some beginners (and admittedly some not so beginners) view ruling guidelines as a tedious, mechanical task but I find it beneficial to use this time to relax and center myself and prepare mentally for whatever project I am about to embark upon.

How far apart we rule the guidelines depends of course on what height we want our letters to be. The letter height depends on the size of the nib/pen we will be using. To better understand the relationship between letter height, letter weight and nib size we need to introduce a simple unit of measurement—the "pen width" (abbreviated p.w.). This is also sometimes called "nib width" or "nib unit". A nib unit is simply equal to the width of your pen nib, which is also the width of the thickest line you can make with that nib. (Brause nibs are sized in this manner—its 2 mm nib is 2 mm wide.) This unit is very useful, as any particular alphabet will be set at a height of a specific number of pen widths. For example, our first alphabet will be set at a letter height of 3½ pen widths. So if I am using a Brause 2 mm nib I know my letter height will be 7 mm tall (3½ x 2=7), and I will rule guidelines 7mm apart. If I want a smaller sized letter, I would use a smaller sized nib; for a 1 mm Brause nib (for this particular alphabet) my letters would be 3½ mm tall and I would rule my guidelines accordingly 3½ mm apart. A 4 mm nib would have letters 14 mm tall.

If you are not using a Brause nib, you can figure out your pen width by holding the pen at exactly 90 degrees and forming short, horizontal strokes, each one just below the other. Then measure from top stroke to bottom stoke. For half units measure till half the bottom stroke.

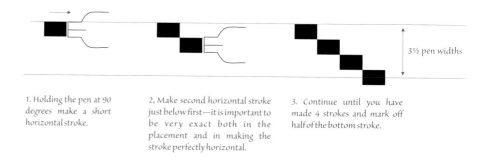

3½ pen widths

1. Holding the pen at 90 degrees make a short horizontal stroke.

2, Make second horizontal stroke just below first—it is important to be very exact both in the placement and in making the stroke perfectly horizontal.

3. Continue until you have made 4 strokes and mark off half of the bottom stroke.

There are many different methods to ruling up your paper. If you have an exact measurement for your letter height, 14 mm for example, simply place the ruler down the right side of the page and tick off small, pin-point dots with your H pencil 14 mm. apart. Do the same down the left edge of the page and then rule sharp, thin lines connecting the two dots. If you have a parallel rule or T square you will need only one set of dots. If you are not using a Brause nib and/or it is

RULING YOUR PAGE

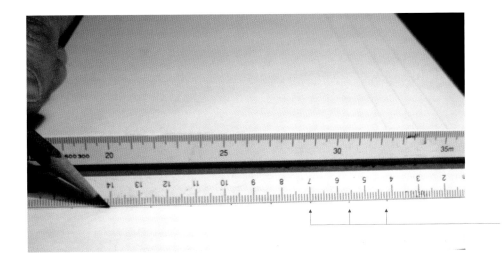

Marking off small pencil "dots" at regular intervals along the side of the paper with a ruler. This is done on both edges of the paper.

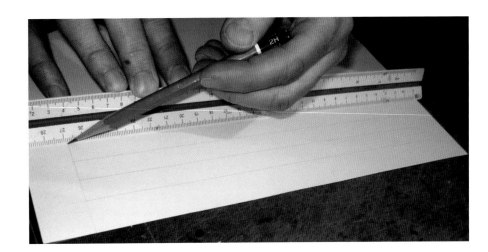

The dots are then accurately connected by drawing light, thin lines with a 1H or 2H pencil.

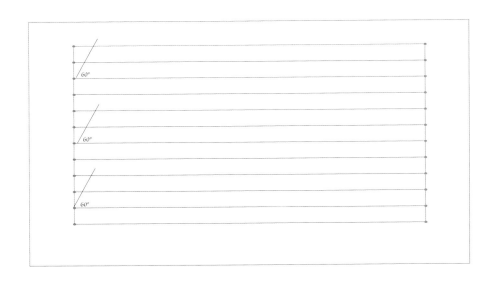

Diagram on left clarifies what a ruled up practice sheet, with margins, might look like. Optional 60 degree pen angles to act as guides were added. These can be easily constructed with a protractor.

Divider

Ames lettering guide

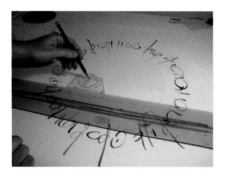

Ruling with the Ames lettering guide.

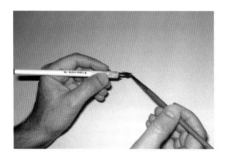

Filling nib with a brush

difficult to obtain an exact measure of your letter height with a ruler you can mark off the top and bottom edges of your letter height (as determined by the method described above) onto a blank piece of paper and "tick off" the markings onto your writing paper and rule accordingly. Or you can use a metal divider to step off the marks. Another very useful and inexpensive tool that can make ruling much simpler is an Ames lettering guide. See illustration.

Exercise: Making Geometric Shapes at Different Pen Angles

Tools: Pen with Brause 2 mm nib (or any other brand nib of equivalent size), 1H pencil, ruler, black ink, round tipped, size 4 or 5 nylon brush

Since our first alphabet will be at 3½ pen-widths tall we will also do this exercise at that height. Rule up a blank piece of paper 14 mm apart if you are using a Brause 4 mm nib (If using a different nib rule up your paper at 3½ pen widths tall with whatever size nib you will be using. Use a larger rather than smaller nib for this exercise). Fill your pen reservoir around halfway with ink. (This is just a starting point—you might want to fill it more or less than this depending on what ink you are using, what paper you are writing on, the slope of your writing board, etc. etc.). There are two ways to fill your pen— either by dipping the pen directly into your ink bottle or filling it with a brush. I use the second method as it gives me more control over how much ink is added. Holding the brush in my non-writing hand I fill the reservoir halfway. (You do not have to use a good brush for this although I do find the better the brush, the more pleasant the experience. A day's work of writing might involve dozens and dozens of ink fillings and we want each stage of our work to be pleasant). If you dip your pen you might have excess ink which you might want to dispose of by writing on a scrap sheet which you should have handy near your writing paper. Once you get a clean stroke on your scrap paper go to your good paper as soon as possible as the ink can dry fairly quickly in your nib and pausing for too long might prevent you from getting a crisp stroke right away.

While holding your pen at a 90 degree angle, place the top edge of your nib just touching the top pencil line and make a horizontal stroke approximately 3½ pen widths wide. Without changing your pen angle (do not twist your wrist), make a vertical stroke. The horizontal stroke should be the thickest possible line you can make with this pen. The vertical should be the thinnest possible line—a mere hairline. Now place the pen back exactly overlapping where you began your first stroke and again come straight down in a thin vertical stroke. Without stopping, come straight across the bottom guideline until your stroke hits the right vertical.

Do the same exercise while holding the pen at the different angles—60, 45, 25 and 0 degrees, copying closely the squares in the exemplar. At 45 degrees your horizontal strokes and vertical strokes should be of the same thickness.

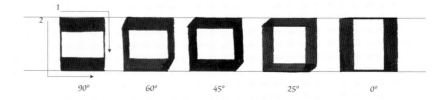

| 90° | 60° | 45° | 25° | 0° |

Now try making circles, holding the pen at different pen angles. A circle is made in two strokes as it is easier to pull the pen than to push it. Start with a pen angle of 0 degrees and continue making circles gradually steepening the angles as in the exemplars below. Notice how each circle and square will have a slightly different look depending on the pen angle. Notice also how the shape of the inner white circle changes as your angle gets steeper. Keep a constant pen angle while making each shape. Keep your hand moving as a whole; the wrist does not twist at all.

You can also experiment by changing the *weight* of your shapes by using smaller and larger nibs while keeping the height the same. (This obviously changes the number of pen widths—the fewer the pen widths, the bolder the letter, or heavier the shape.)

You can practice the 45 degree angle in the following exercise. Hold the pen at 45 degrees and make diagonal strokes sloping at 45 degrees. This will give you a zig zag pattern of very thick lines and very thin hairlines.

Experimenting with pen made shapes can also lead to decorative possibilities.

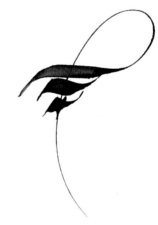

Writing Letters—Finally!

Once you get the hang of the idea of pen angle we are ready to begin a Hebrew letter. Again rule up a page with 14 mm pencil guidelines. It is most important that your pencils be sharp and your ruling very accurate. (14 mm means 14 mm, and not 14½ or 13¾ mm!) Otherwise your letters will differ in size and this will destroy their unity and the rhythm of your writing. You should leave a little bit of margin on all sides of the paper—right, left, top and bottom, even on your practice sheets. We will discuss margins in more detail later on but we would like to get into the habit of being sensitive to esthetics—even if it is "only" on our practice sheets.

We are going to begin with the letter *reish*. Remember, Hebrew is read from right to left, so our first letter will be at the top right of the page. Within each letter, though, the strokes will be formed going from left to right, as it is easier to pull the pen than to push the pen. We want to begin with a sharp edge so it is important that the ink flow properly from the very start. I find it helpful to first test it out on the scrap paper. Make quick, short back and forth strokes along the thin edge of the pen till the ink flows freely and follow this by a full stroke. This will also give you information on how quickly the ink flows, if the pen is overinked, etc. Adjust as necessary. As soon as you have the ink flowing nicely on the scrap paper go directly to your good paper. Hold the pen at a 60 degree angle to the line of writing and place the top of your nib just touching the top guideline and make a horizontal stroke about 3 pen widths wide. Without stopping begin a gentle curve and then come straight down. Again, the 60 degree angle must be maintained at all times. (You might find it useful to draw a 60 degree line on your page so you can continually check the angle. You can do this with a protractor or, if you have the software, by computer.) Be careful not to twist the wrist as your hand comes down for the vertical. When the bottom of your nib hits the baseline, release the pressure and lift the pen. You have now made the letter *reish*.

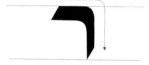

Now, let's analyze the letter:

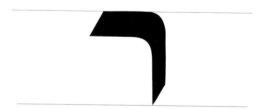

1. The horizontal stroke should be straight and just touch the guideline throughout.

2. Beginning and ending of strokes should be sharp

3. Line should be smooth and not wobbly on either edge

4. Curve should be smooth and rounded

5. Downstroke should be perfectly vertical

6. Pen angle does not change throughout the entire stroke.

7. Overall width of letter should be about 3 pen widths wide (and 3½ p.w. tall)

TROUBLESHOOTING SOME COMMON PROBLEMS:

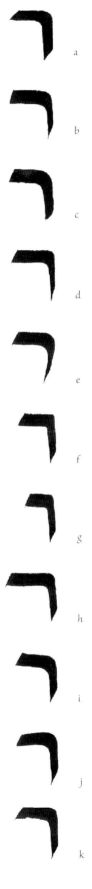

Here are some common problems that beginners often have. By looking at the examples to the right you can critique your own work and make any necessary corrections.

a. Pen angle too flat, making horizontal too thin and vertical too thick. If you have problems finding the correct angle to begin with you can construct a 60° angle at the edge of your paper and place your pen against it to feel the angle.

b. Pen angle too steep, making horizontal too thick and vertical too thin. For correction see above.

c. Blobby letter, beginning and end of stokes not sharp. Wipe off excess ink from top of nib, fill reservoir less, or ink up your nib with brush instead of dipping into the bottle. Try writing on your scrap paper first until ink comes out properly. It might help to use a rapid back and forth motion along the edge of the nib till the ink releases. Then make a short stroke with the full width of the nib on the scrap paper and then as quickly as possible begin your stroke on your good paper.

d. Pen angle changes: This *reish* started with the correct pen angle in the horizontal stroke but as the vertical stoke was made, the pen angle became steeper. This happens when the wrist turns in a counterclockwise direction as you move into the vertical. Remember to keep wrist "locked" (but not stiff) and loosen your arm to allow motion to come from your shoulder.

e. Too curvy. After the curve downwards began the stroke continued curving inwards. If this is happening often, try pausing after the initial curve is made and then remind yourself to come straight down in a vertical stroke.

f. Too angular. We are aiming for a gentle curve. Look at the shape of the inner white space and compare with the correct shape of *reish*.

g. Letter too narrow. Can be confused with *vav*. Make sure letter should be at least 3 pen width's wide.

h. Letter too wide. Even though this is still technically a *reish*, the classic proportion of *reish* has its horizontal and vertical stokes similar in length.

i. and j. Horizontal stoke not following the guideline. Practice, slow down. Sometimes it helps to focus on the white space you are forming rather than the black stroke itself.

k. Wobbly edge: This can happen when you are trying to make a straight line and your focus is solely on the top guideline. If you place pen pressure on the top of your nib only, the bottom of the nib can lift up slightly off the paper. Make sure when you are making your stroke that you feel both edges of the nib firmly touching the paper.

Now that you have made your first letter, it is time to begin your first *aleph-bet*.

Chapter 5

Hebrew Foundational Script & Variations

WE ARE NOW READY to begin our first pen-made *aleph-bet* which I call a Foundational *aleph-bet*, as it is concerned with the basic characteristics of each letter at its simplest; it is a no-frills *aleph-bet*. The point is that if you can write this *aleph-bet* correctly—meaning sharp, properly proportioned letters with good spacing—then it will be easier to go on to the more complicated *aleph-bets*. By eliminating all the non-essentials here, you can concentrate on the fundamentals of good calligraphy. This is a basic *aleph-bet*, which will give you plenty of practice making perfectly horizontal and vertical strokes. The ability to control the pen is a necessary skill and so this script should not be skipped over by beginners. More experienced calligraphers might want to go directly to the "Variations" section in this chapter.

The exemplar letters shown starting on page 36 are each presented within a geometric square. They were written with a Brause 4 mm nib. Also shown is the ductus for each letter (the order and direction of strokes), and some common errors to be aware of. Practice each letter in the order presented, as this will allow you to see how the letters relate to and build on each other. Once all the letters of the aleph-bet have been worked on, go on to the practice words, and then to the suggested sentences. Be sure to review the section on spacing when judging your work.

Yerahmiel Shechter. Proposed logo design for the Hebrew University (?)

(From the Shechter Collection, in the possession of the Department of Graphic Design at Emunah College. Reproduced with permission)

אבגדההוזחחטי

כךלמםנןסע

פףצץקרשת

Hebrew Foundational Script

קליגרפיה עברית

Features of the Foundational

Pen angle is generally a consistent 60 degree angle. There are a few strokes where the pen angle needs to be changed; these are noted when each letter is discussed on the following pages. This *aleph-bet* is written at a body height of 3½ pen widths.

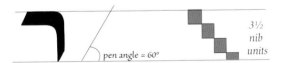

pen angle = 60° 3½ nib units

Letter by Letter Construction

REISH. The *reish* is made in one stroke, meaning the pen is not lifted throughout the letter. While holding the pen at a 60 degree angle, make a clean horizontal stroke approximately 3 nib units wide. Continue and make a gentle curve without changing the pen angle (do not twist the wrist; you are only changing the direction of stroke, not the angle of the pen!) and then come straight down till your nib just touches the bottom guide line. The total width of the *reish* is somewhat narrower than a perfect square. This is to minimize the white space caused by the openness of the letter shape.

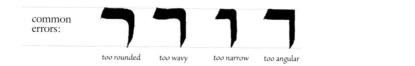

common errors:

too rounded too wavy too narrow too angular

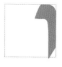

VAV. The *vav* follows the same pattern as the *reish*. The only difference being the width of the letter. Make a clean horizontal stroke along the top guide line. At around a nib unit and a quarter's width begin a gentle curve and come straight down. The shape should be identical to the *reish* except for the width of the stroke which should be a maximum of 1½ nib units wide.

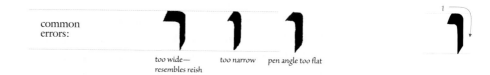

common errors:

too wide— resembles reish too narrow pen angle too flat

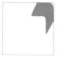

YUD. The *yud* is the smallest letter of the *aleph-bet*, being both narrow and short. *Yud* starts the same as *vav* but its height is only 1½ nib units high, suspending from the top guide line.

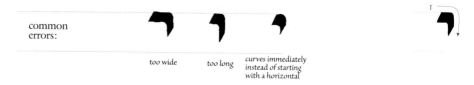

common errors:

too wide too long curves immediately instead of starting with a horizontal

NUN SOFIT. This form replaces the "regular" *nun* when *nun* appears at the end of a word. It is a descender. In our present *aleph-bet* the final *nun* has the shape of an elongated *vav*. Proceed to write a *vav* and continue 2 nib units below the line. This is a particularly long stroke, and unless you are writing very small you will need more than just "finger movements" to keep it straight while maintaining the correct pen angle, so be sure not to lock your wrist, and keep your arm, and even your shoulder free and loose.

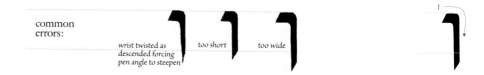

common errors:

wrist twisted as descended forcing pen angle to steepen too short too wide

CHAF SOFIT appears only at the end of words. It is a descender and in our script resembles an elongated *reish*. The letter is formed exactly as a *reish* however it continues 2 nib units below the bottom guide line. See *nun sofit* above for advice on keeping the vertical stroke straight.

common errors:

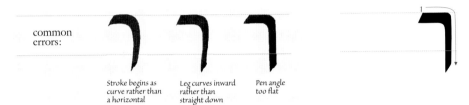

Stroke begins as curve rather than a horizontal | Leg curves inward rather than straight down | Pen angle too flat

CHET is the first of our two-stroke letters. Stroke 1: Begin with a horizontal 3½ nib units wide (a full squares width) but instead of a gentle curve make a sharp angular 90 degree turn to come straight down. You may pause and lift the pen before you make the downstroke. Stroke 2: Place the pen so that the upper edge of the nib slightly enters the bottom of the "roof" of the '*reish*" and the left edge of the nib lines up with the left edge of the roof. Make a clean vertical stroke. (Note that this letter is wider than the *reish*. Keeping it the same width as *reish* would make the enclosed white space too small, giving a "blacker" appearance to the letter.)

common errors:

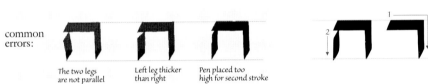

The two legs are not parallel | Left leg thicker than right | Pen placed too high for second stroke

HEH is very similar to *chet*, the only difference being that its left vertical stroke does not touch the roof of the letter. Stroke 1: Same as for *chet*. Stroke 2: Start this stroke just lower than for *chet*, leaving space between it and the roof—slightly higher than 2 nib units from the bottom. This shorter leg must not appear too close to the roof, lest it be confused with *chet*, nor too short where it will look "stumpy". The look of the second stroke should be that of a strong parallel to the right leg.

common errors:

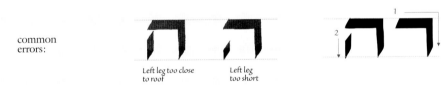

Left leg too close to roof | Left leg too short

DALET is a simple two stroke letter. Stroke 1: Begin with a top horizontal line three and a half nib units wide (a full square's width). Stroke 2: Lift the pen and place it just above the line and around a half nib unit in from the right corner. Make a vertical stroke straight down. The white space within this letter should be similar to that of the *reish*.

common errors:

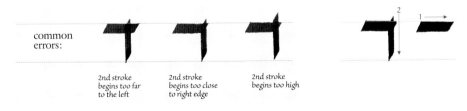

2nd stroke begins too far to the left | 2nd stroke begins too close to right edge | 2nd stroke begins too high

PEH SOFIT. This form is used when *peh* appears at the end of a word. It is made in two strokes. Stroke 1 is the same shape as for final *chaf*, but a tad wider. Stroke 2: Lift pen and place exactly as for 2nd stroke of *chet*. Come straight down with a short stroke and gently curve in and make a horizontal 1½ nib units wide. This horizontal should run parallel to your first horizontal stroke. Note that this second stroke is an exact upside down *yud*.

common errors:

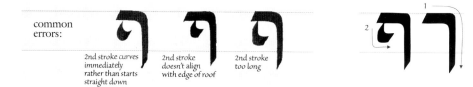

2nd stroke curves immediately rather than starts straight down

2nd stroke doesn't align with edge of roof

2nd stroke too long

KHAF. Stroke 1: Begin similarly as for *reish*, keeping the same type of curve—not rounder, nor more angular, and end the downstroke around ¾ of a nib unit before reaching bottom guideline. Stroke 2: Lift pen and place on the bottom guideline at a point exactly beneath where you began your first stroke. Make a straight horizontal stroke which ends cleanly at the join with the "leg" of the first stroke. There should be a slight overlap of the two strokes. Make sure your two horizontals are parallel. Since two relatively thick horizontals make quite a strong "black" impression, this letter is also slightly narrower than a full square.

common errors:

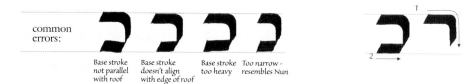

Base stroke not parallel with roof

Base stroke doesn't align with edge of roof

Base stroke too heavy

Too narrow - resembles Nun

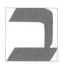

BET. This letter is very similar to the *khaf*. The distinguishing feature is the "heel" at the bottom right. Stroke 1: Make the first stroke exactly as for *khaf*. Stroke 2: The second stroke also begins exactly as for *khaf* but instead of stopping at the join; continue just past the leg to form the "heel". The heel should not be too prominent—just enough to easily distinguish *bet* from *khaf*.

common errors:

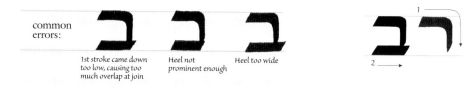

1st stroke came down too low, causing too much overlap at join

Heel not prominent enough

Heel too wide

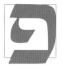

PEH. A three stroke letter. Stroke 1: Make a *reish*. Stroke 2: Bisect the baseline with your pen, making a horizontal stroke which joins the leg with a slight overlap similar to *khaf*. Stroke 3: Same as stroke 2 of *peh sofit*. You should have equal white space above and below the inner stroke. All three strokes should align on the left.

common errors:

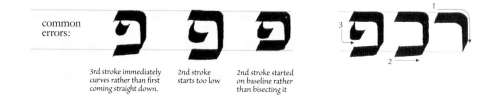

3rd stroke immediately curves rather than first coming straight down.

2nd stroke starts too low

2nd stroke started on baseline rather than bisecting it

MEM SOFIT. This form is used when *mem* appears at the end of a word. Unlike all the other final forms, the *mem sofit* in our script is not a descender. It is written in two strokes. Stroke 1: Make a *reish* type stroke 3½ p.w.'s wide and again stop around ¾ of a nib unit before reaching the bottom guideline. Stroke 2: Place pen as you did for second stroke of *chet*. Come straight down till you hit bottom guideline, then change direction sharply with a 90 degree angular turn to make a horizontal along the bottom guideline and join cleanly with the right leg. Keep the bottom left angular and not curved. This is an important characteristic of the *mem sofit*.

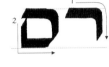

common errors:

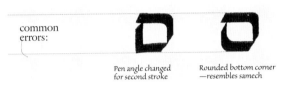

Pen angle changed for second stroke Rounded bottom corner —resembles samech

MEM in this *aleph-bet* resembles a *khaf* with an attached *vav*. It is a letter slightly wider than a square—around 4 nib units. Stroke 1: Make an exact *vav*. Stroke 2: Place the pen so that its left edge touches the *vav* and make the exact first stroke of *chaf*. Stroke 3: Place the pen on the bottom guideline approximately a half nib unit to the right of the first stroke and join to the leg of first stroke.

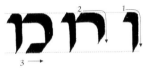

common errors:

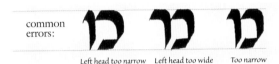

Left head too narrow Left head too wide Too narrow

TAV. Stroke 1: Make a *reish*. Stroke 2: Place pen touching the roof stroke and slightly in from the left edge and come straight down till just before the baseline (similar to downstroke of *khaf*). Stroke 3: Place pen on baseline just past starting point of your first stroke and connect to the left leg with a short horizontal. This last stroke can also be done as a push stroke. To make a push stroke, after completing stroke 2 and without lifting the pen, slide along the thin edge of the nib. When you reach the baseline, push straight out in a short, horizontal stroke. A light touch and nicely flowing ink will help this stroke be successful. Regardless of method, be careful not to jut out too far past the left edge of the first stroke or you will have problems spacing the next letter.

common errors:

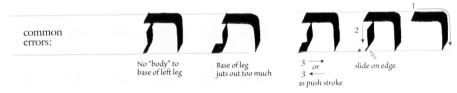

No "body" to base of left leg Base of leg juts out too much 3 or 3 as push stroke slide on edge

NUN should be thought of as a very narrow letter; if it is too wide it can resemble a *khaf* in our script. Stroke 1: Begin making a *vav* but stop just short of the baseline (similar to the distance you stopped at for *khaf* and *bet*). Stroke2: Beginning on the baseline and just a tad past the left edge of your roof stroke, make a horizontal stroke to join with stroke 1.

common errors:

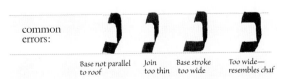

Base not parallel to roof Join too thin Base stroke too wide Too wide— resembles chaf

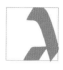

GIMMEL. Stroke 1: Begin this stroke as for *vav*—a short head and then a curve but instead of coming down in a straight vertical, slope the leg to the right. Continue down till you slightly cut the baseline. Stroke 2: Place pen on baseline on a line slightly to the left of your beginning stroke and connect with a horizontal stroke till it joins and slightly overlaps the leg. The exact slopes and distances will come from closely looking at the example, and from practice.

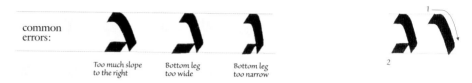

common errors:

Too much slope to the right Bottom leg too wide Bottom leg too narrow

ZAYIN. Stroke 1: The *zayin* is a narrow letter, so make a short horizontal stroke — maximum two nib units wide (any wider and it can resemble a *dalet*). Stroke 2: The second stroke requires a slightly steeper pen. Steepen your pen angle to around 75 degrees, and place the nib such that the upper point touches the bottom of the first stroke at its center and make a very slight sloping stroke. Stop at baseline.

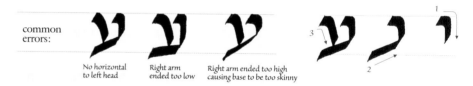

common errors:

Leg not joined to center of head Head too wide and leg slopes too much

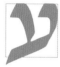

AYIN literally means eye—in the Ancient Hebrew Script the ayin's shape is circular. Stroke 1: Begin with a *yud* stroke but descend a bit lower—2/3 of the way down. Stroke 2: Place the pen such that it bisects the baseline, at a point between 3½ and 4 nib units from the right edge of your first stroke, and stroke up in a sloping straight line till it overlaps cleanly with your first stroke. (To smooth the join, try gradually lifting the pen off the paper as the two strokes overlap.) Stroke 3: Starting a tad to the right of where your second stroke began, make a stroke similar to that of *gimmel*—a short horizontal, then gentle curve sloping slightly till you hit your second stroke. The total width of this letter is a square.

common errors:

No horizontal to left head Right arm ended too low Right arm ended too high causing base to be too skinny

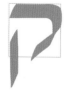

KUF. A three stroke letter. Stroke 1: Begin as for *mem sofit* but only come half way down. Stroke 2: Steepen pen angle to approximately 80 degrees. Place pen a tad below the baseline, halfway into the width of the letter and make a diagonal stroke to make a nice join with your first stroke. Stroke 3: Place pen under the beginning stroke, leaving distance from the roof (similar to *heh*) and make a clean vertical stroke descending not more than two nib units below the guideline.

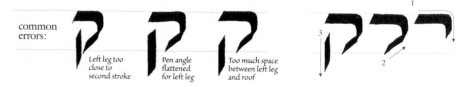

common errors:

Left leg too close to second stroke Pen angle flattened for left leg Too much space between left leg and roof

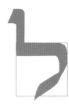

LAMED. The shapes of *lamed* and *kuf* are related. The *lamed* is the only ascender in the *aleph-bet*. Think of it as a *vav* sitting on top of a *kuf* (minus the last stroke of *kuf*). Stroke 1: Starting at least two nib units above the line, begin a *vav* stroke. Stop when the top of your pen hits the top guideline. Pause (lift the pen if necessary), and continue with the same stroke you started for *kuf*—make a horizontal, then a gentle curve stopping halfway down. Stroke 2: Steepen pen angle to around 80 degrees and place pen on bottom guideline, halfway into the width of the letter and make a diagonal going up and to the right to join with your first stroke.

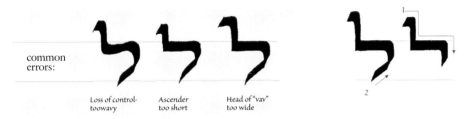

common errors:

Loss of control- too wavy · Ascender too short · Head of "vav" too wide

ALEPH. Stroke 1: Begin with the diagonal. Steepen your pen angle to approximately 75 degrees and, beginning a tad above the top guideline, come down and to the right, a full square's width. (The reason for the steepened pen angle is to decrease the thickness of the stroke which would otherwise darken the letter.) Stroke 2: The right "arm" begins slightly above the guideline and runs parallel to the first stroke and then curves in to hit the diagonal just below its midpoint. Stroke 3: Place pen under the diagonal, just touching it. The left edge of the nib should line up with the left edge of the diagonal. Come straight down and curve gently to the right. Don't come too close to the diagonal. If turned upside down this stroke should appear as a slightly elongated upside down *yud*.

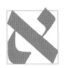

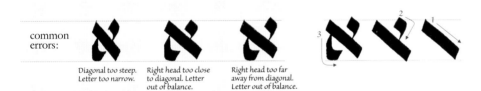

common errors:

Diagonal too steep. Letter too narrow. · Right head too close to diagonal. Letter out of balance. · Right head too far away from diagonal. Letter out of balance.

TZADI SOFIT. Stroke 1: Begin with an exact *nun sofit*—a short horizontal and then descend till two nib units below the baseline. Stroke 2: This stroke is similar to the right arm of *aleph*. Begin a tad above the guideline and slope downwards before curving and hitting the leg around midway between top and bottom guidelines. The head should be around the size of the head of the *yud*. After you curve in, it might be necessary to gradually twist the pen counterclockwise as you make the join in order not to have a long, overly thin join.

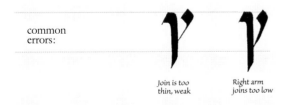

common errors:

Join is too thin, weak · Right arm joins too low

41

TZADI is, in my opinion the hardest letter to negotiate as it in theory calls for a join between two heavy strokes. We shall try to minimize the blackness at the join. Stroke 1: Begin by holding the pen at a slightly steeper angle—around 75 degrees. Make a short horizontal and then gently curve into a sloped downstroke (similar to but wider than you would for *gimmel*). Come down till a tad more than ¾ of the way down and gently curve in to the left. Stroke 2: Bisecting the baseline, come up to connect with your diagonal stroke. Stroke 3: Make right arm similar to that of *aleph*. Starting slightly above the guideline slope downwards and curve in to join the diagonal at approximately its midpoint. The two heads are rather close to each other. The head should not extend beyond the right edge of the diagonal.

common errors:

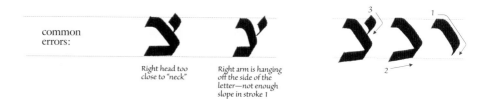

Right head too close to "neck"

Right arm is hanging off the side of the letter—not enough slope in stroke 1

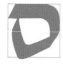

SAMECH. Note that *samech*, *tet*, and *shin* (see below) are related in regard to the left downstroke which slopes down to the right, cuts the baseline and rises to form the base stroke. *Samech* though should have a rounded feel as it curves at the baseline. Stroke 1: Begin a horizontal a full square's width, curve gently and come straight down till a bit past the halfway point. Stroke 2: Steepen pen angle and place pen under beginning of first stroke, left edges lined up. Come down on a slight slope till you just cut the baseline, slightly curve as you change direction to come up to join nicely with your first stroke. The amount of overlap at the join should be similar to the overlap on *khaf* and other similar letters.

common errors:

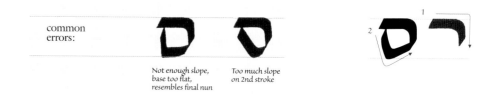

Not enough slope, base too flat, resembles final nun

Too much slope on 2nd stroke

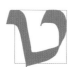

TET. Stroke 1: Begin a short horizontal, then curve and come downwards on a slight slope (similar to *samech*) till you just cut the baseline. Stroke 2: The base stroke, which begins just a tad under the baseline, will be a rising horizontal, rising at an angle similar to *samech*. Stop when you reach around half-way up. (Tip: gradually lift the pen off the page as you finish the stroke rather than stopping abruptly). Stroke 3: Leaving around one nib's width space to the right of the left "head", begin a horizontal stroke slightly wider then a *yud* (appx. 1½ p.w.) that gently curves to a straight vertical until it hits and slightly overlaps the base stroke.

common errors:

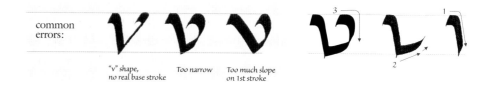

"v" shape, no real base stroke

Too narrow

Too much slope on 1st stroke

SHIN. Strokes 1 and 2: Same as for *tet*, though bottom stroke should be a tad wider. Stroke 3: Leaving a generous amount of space to the right of the left head (around 2 pen widths), form a *yud* stroke (narrower than that of *tav*), which will connect with your base stroke. Stroke 4: Just cutting the top guideline and with the pen slightly steepened, immediately slope downwards and curve to connect at the point where you changed direction in the first stroke. The feeling should be that the three heads of *shin* all have the same "presence".

common errors:

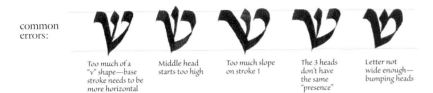

| Too much of a "v" shape—base stroke needs to be more horizontal | Middle head starts too high | Too much slope on stroke 1 | The 3 heads don't have the same "presence" | Letter not wide enough—bumping heads |

Joins and Overlaps—a Closer Look

It is important to pay attention to the joins connecting the legs and bases of your letters, as these affect the strength of the letter's structure. Joins in the Foundational script should never be weak; they should not "barely touch". Rather they should have a slight overlap. This applies to *bet, tet, khaf, lamed, mem, mem sofit, nun, samech, peh, ayin, tzadi, kuf, shin* and the left leg of *tav*. See examples to the right.

Similarly, make sure the joins at the tops of letters (e.g. *zayin, chet*, the join between the two tops of *mem*, and the top joins of *samech, peh* and *tav*) are strong and not just barely touching.

overlap better join too weak

overlap better join too weak

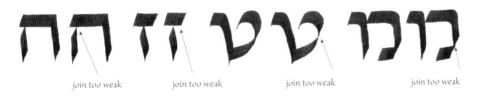

join too weak join too weak join too weak join too weak

"But I Can't See What I'm Doing, and Why is My Hand So Messy?!"

Right-handers (and some left-handers, depending on the method you are using) often have trouble spacing Hebrew because the writing hand blocks the view of the previous word or letter. To make matters worse, not seeing can also cause you to smudge what you have already written.

Unfortunately, there is no simple solution. You will have to play a bit with your writing position and make small adjustments to enable you to see better. However, two things can help. First, make the slope of your writing board steeper. The steeper it is, the lower your hand will be on the page which will help you to see better. Secondly, changing to a left-handed nib (even if you are right-handed) will also affect where your hand will rest, reducing the chances of a smudge.

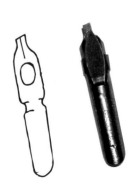

Switching to a left-oblique nib can help you to see your work better, keep your hand cleaner and help you to maintain the steeper pen angles required for Hebrew calligraphy.

43

Practicing the Foundational

SPACING EXERCISE: These practice words follow the order of the presentation of the letters above. Review the chapter on "Spacing" and try writing these words with correct optical spacing. Then move on to the practice sentences.

יין, יון, הון, רון, חיוך, חוף, חורף, דחף, דחף, הוד, הידד, הדף, ידיד

במה, בימה, פרבר, תורה, כיתה, כיפה, כפיה, תיבה, פרפרים,

בונה, זגג, מזון, מזוזה, הגיגה, חוזה, גינה, גזוז, מדוזה

טיסה, שוטה, שרטוט, שורש, סביבון, מסילה, שלום, קישוט, נשיקה

צדיק, איש, אשה, עצין, אפשר, אפשריים, קיצון, חפץ, מיץ, פיצה

PRACTICE SENTENCES. The first is particularly good for practicing "*shin*"s!

שיר השירים אשר לשלמה

אם אשכחך ירושלים תשכח ימיני

האדם חייב להתחדש תמיד

Try duplicating the sentence below. This sentence is a pangram which I modified to include all the final forms as well. Try writing it in 2 lines. If you want to begin practicing a layout, try centering the 2 lines. We will discuss layout later on in the book but if you want to give it a try now, first write the 2 lines separately on a practice sheet, measure the 2 lines and then try writing it again on a separate sheet of paper centering the 2 lines. This was originally written with a 4 mm nib at a body height of 14 mm, with space of 16 mm between lines. The whole was then reduced 50% to appear as below.

דג סקרן בשם יוסף שט בים מאוכזב,

אך לפתע צץ חברו התנין.

Variations on the Foundational

Now that you have some familiarity with the Foundational we are going to build on that "foundation", varying different elements to give us a wider repertoire of scripts. I recommend trying these variations only after you can write the Foundational with a fair amount of consistency.

1. VARYING THE WEIGHT

You can easily expand your calligraphic repertoire by varying the weight of the letters. You can make the script bolder by decreasing the height of the letters while keeping the same pen nib (i.e. decreasing the number of pen widths). Conversely, we can make the script lighter by increasing the body height, making the letters taller (increasing the number of pen widths). See below the words "Hebrew calligraphy" written at 2½ p.w. and at 5 p.w. Note some changes that needed to be made. For example, in "*peh*" at the bolder weight, the base stroke needed to be completely below the baseline to allow room for the inner *yud* stroke. Conversely, in the lighter weight, the baseline of *peh* and of *ayin* did not have to descend below the line. Try the practice words given in the previous chapter at different weights—anywhere from 2 to 6 p.w.s—and then try writing a sentence for each of these variations. Don't rush through this exercise.

Foundational Script written at 5 (above) and at 2½ pen widths (below)

2. SERIF ADDITION

In this variation, we will again keep the letter forms the same but simply add a serif to the beginning strokes. The serif here is a lead-in stroke. Besides adding a bit of personality to the letter, it serves a useful function as it is helps to "get the ink going" before making the actual body of the letter. To learn proper serif formation it will be beneficial to take our first glance at the Sephardic script. There is much to be learnt from studying Sephardic (literally from Spain but later denoting an entire culture not limited to geography) manuscripts, but for now we will just focus on the serif that appears on some of the letters on this 15th century manuscript. Take a look at the serif of the *heh* on the top line in the photo to the right. Notice some important characteristics of the serif:

1. The serif is an integral part of the letter—it is not an element that is artificially added on.

2. The serif has shape. It is not a thin spike jutting out of the body of the letter.

3. It is short, starting approximately a half nib-unit above the line.

serif

Sephardic manuscript showing serifs

SERIF CONSTRUCTION:

To make the serif, have your pen at a 60° pen angle and, beginning a half p.w. above the line (a), slide down at a slope steeper than 60 degrees (otherwise you will be getting a hairline stroke which would give you a spiky serif). Just as the top of the nib hits the top guideline sweep across in a slightly curved motion (b) and continue with the horizontal.

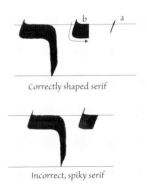

Correctly shaped serif

Incorrect, spiky serif

3. VARYING THE PROPORTIONS

Our basic foundational script was based on a square in the sense that the width of the full letters (such as *chet, heh* and *tav*) was equal to their height. Traditionally though, full letters were made narrower than a square, fitting rather into a rectangle roughly ¾ wide as tall. (See manuscript *heh* and a modern specimen of the letter *heh* in the Narkissim font). This probably made reading more efficient and also gave a bit more of an elegant shape to the letters. (It also most likely saved money as the words took up less space which meant using less parchment).

Heh from *Narkissim* font *Heh* from manuscript Foundational *heh*

Below is a variation on the Foundational script with the previous two changes —adding serifs to the beginning strokes and narrowing the proportions so the full letters fit into a rectangle ¾ wide as tall.

אבגדההוזחהטיכךלמם
נוספעףצץקרשת

קליגרפיה עברית

Condensed Foundational Script with serifs

Needless to say, other variations can be created with different proportions, ranging from very condensed to very wide. Extra care must be taken when condensing and stretching certain letters in order to insure that they do not begin to lose their essential characteristics. A condensed *reish* for example can easily be confused with *vav*; a stretched *nun* can be mistaken for a *khaf*. Review the "Notes on Letters" starting on page 10 and also see the section "Stretching Letters" on page 109.

4. SLOPING HEADS, SLOPING ROOFS

In this next variation of the Foundational we break up the strong horizontal emphasis of the tops of many of the letters. If you look at Sephardic manuscripts, for example the one on page 54, you will see that the short heads on

many of the letters, such as *vav, tzadi, nun, shin* and *mem*, have a sloped head rather than a horizontal one. Below, this feature is applied to other letters of the Foundational as well.

To make this sloped head, place the pen slightly above the top guideline and stroke down and to the right. There then exist several possibilities to join the next stroke, which are listed below:

a. Make the sloped head and curve the corner to produce a short hairline stroke. The next stroke begins by overlapping the thin stroke.

b. Alternately, the first stroke can end abruptly before curving, and the second stroke joins just below it. This gives a more angular look.

c. Alternately, you can form the head and leg all in one stroke, giving a smoother and slightly less formal look to the script. To try this, form stroke 1, curve to slide on the edge of the pen and just as the top of your pen passes the bottom of stroke 1 come down for the "leg".

Note: these join variations can also be applied to straight heads as well.

IMPORTANT: Whatever type of join you choose, *remain consistent with that method for all the other letters!*. Otherwise you will lose uniformity of rhythm.

OPTICAL ADJUSTMENT OF SLOPED HEADS: It was mentioned above that the heads should jut slightly above the top guideline. This is so the letter should not appear to start lower than a letter that has a straight horizontal top stroke. In figure (a) below, because the sloping head of *yud* only touches the top guideline at a single point, it gives the impression that it is lower than the letters adjacent to it. In (b) this has been compensated by placing it slightly above the line. In (c) it has been placed too much above the line and so looks too high.

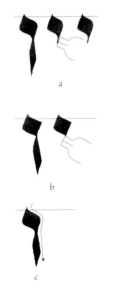

Making the sloped head stroke

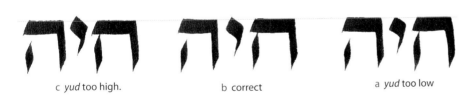

c *yud* too high. b correct a *yud* too low

The sloped upper stroke feature can also be applied to a full-width roof and not just the shorter heads. The popular typeface Koren, although not based specifically on our Sephardic manuscript, certainly used this element to help break the strict horizontal roofs used in most formal Hebrew typefaces and to help differentiate between similar looking letters. Compare the roofs of *khaf* with *bet*, and *reish* with *dalet*.

The Koren typeface

5. SHAPING THE LEG—THE "SUBTLE CURVE" STROKE

In this variation we are going to replace the straight vertical stoke of the Foundational with a SUBTLE curve stroke. Sometimes the entire stroke is a subtle curve and sometimes the curve begins only towards the end of the vertical downstroke.

For letters whose verticals are formed in one stroke together with the roofs (e.g. *reish*, *tav*,) begin the letter in the same manner as for the Foundational, i.e. form the roof, curve, and come straight down in a vertical; but then around 3/4 of the way down, slope SLIGHTLY and SUBTLY down and to the right till you reach the baseline (a). This shape can also be applied to the letter *bet*. To make *bet* (b), begin with the form of the "new" *reish*. For stroke 2, form the base and end it just at it overlaps the downward slope of your first stroke. This overlap forms the heel of the *bet*.

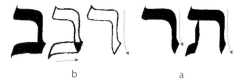

b a

First come straight down and then curve

For letters whose legs are formed with a separate stroke from the roof (some of which are demonstrated below), we will replace the entire straight line vertical (on the right leg only) with a VERY SUBTLE convex curve (c). (This curve often happens naturally as a result of speed.)

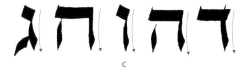

c

Many other letters can incorporate the subtle curve, as you can see in the exemplar on page 50. A few of the letters that require special attention are described below:

ALEPH AND TAV: The subtle curve can be substituted in place of the straight vertical downstroke on the left sides of *aleph* and *tav* (d). Additionally, you can add (either by pulling or pushing) an optional short base stroke to the left leg of *aleph* similar to *tav* (e). A shorter, compacted version of this curve and push stroke can be used in the inner stroke of *peh* and final *peh* (f).

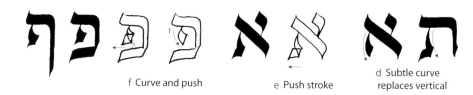

f Curve and push e Push stroke d Subtle curve replaces vertical

MEM: The left "*vav*" part of *mem* also incorporates a subtle curve. Think of the left side of *mem* as a *vav* leaning slightly backwards (similar to the Sephardic manuscript *mem* below), i.e. its shaped leg comes out to the left and curves back. To form the right side of *mem*, place nib with its left edge just touching the right edge of the head of *vav* (make sure the top of the nib is slightly above the top guideline), slope to the right and change direction to a straight vertical. The base of the letter remains the same.

Sephardic manuscript *mem* Varied Foundational *mem*

Additional Notes and Tips regarding Joins and the Subtle Curve

It is sometimes useful to think of letters as architectural structures. Most Hebrew letters have heavy upper horizontal strokes. The legs must somehow "hold up" these heavy structures. If there are weak joins the letter will not be structurally sound. Avoid having overly thin, stringy strokes as joins between heavy strokes.

weak join

Similarly, with the subtle curve stroke, to strengthen the structure of the letter it is best to begin the "subtle curve stroke" either at the top of or at least a bit "into" the top stroke.

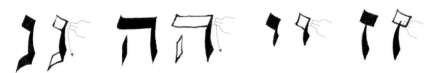

Begin the "subtle curve" stroke a bit "into" the head to strengthen the join.

If the leg shape is curved too much (see examples below), it will not have the vertical strength to uphold the roof. In each pair in the examples below the left letter shows correct use of the subtle curve. On the characters on the right the curve is too pronounced and the structure is weakened.

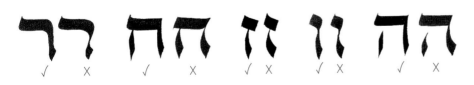

49

Putting It All Together

Below is an *aleph-bet* where many of the variations introduced above have been applied to the original Foundational script: The serifed lead-in stroke, the shaped leg and the subtle curve.

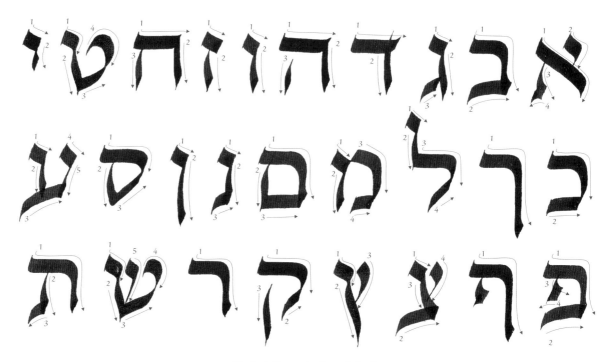

Varied Foundational Script

Detail from the *Moriah Haggadah*, displaying a script similar to the Varied Foundational. Artist: Avner Moriah. Calligraphy: Izzy Pludwinski

GUIDELINE FOR FURTHER EXPERIMENTAL WORK *

Indeed, the possibilities for variation are endless. Having said that, when working on any new variation, it must be remembered that *aleph-bets* consist of a family of letters, all related to each other. Work on a new script should continue until all the letters appear to belong to and contribute to the unity of that family, with no one letter standing out as being foreign. Only that will create a pleasing and effective rhythm to your work. Keeping the above in mind, here are a few more suggestions for you to experiment with.

1. Try an "italic" version of the *Aleph-bet*, i.e. giving a forward slant to all the letters.

2. Try to duplicate a Gothic (blackletter) texture by varying the Foundational.

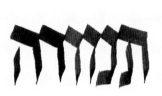

3. Instead of horizontal bases for letters such as *bet, khaf, mem* and *nun*, try giving them a sloping base (similar to the *ayin* and *tzadi* of our basic Foundational). See how many different letters you can apply this to.

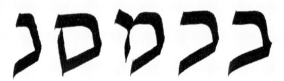

A script called *Rolit* in L.F. Toby's book (see "For Further Reading" on page 188) gives the letters a cursive and even slightly Arabic flavor, with a light hook to some of the base strokes. Again, see how many different letters you can apply this to.

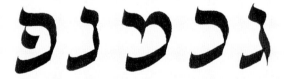

*Note: Only try these exercises once you have a mastery of the Foundational and its variations. It would be counterproductive to vary further what has not been mastered yet.

"Pauker" Script

אצילי הקהלות רוזבי הנדינה

One can see similarities between the serifs on Pauker's script and those from this 11th century manuscript.

Fred Pauker was a Viennese-born and British-raised graphic artist and calligrapher who lived and worked in Jerusalem. To develop a working script for his Hebrew work, he looked closely at many different historical manuscripts. (The type of manuscript letter form he might have been influenced by is shown to the left.) Below is an exemplar of his script, here interpreted and lettered by calligrapher Ruth Lubin, using a Speedball C0 nib (equivalent to a Brause 5 mm). You will find similarities between it and some of the Foundational variations.

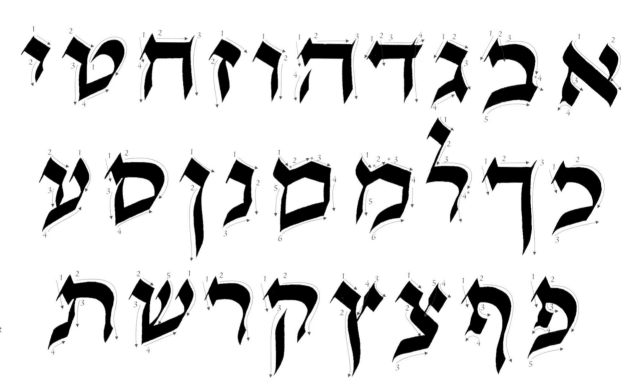

* Denotes where strokes may be combined without a pen lift.

Features of Pauker Script

Pen angle: Varies between 60° and 65°.
Weight: 3 p.w.

A "slab", almost diamond-shaped serif at beginning of horizontal roof strokes.

Curved shape to some of the roofs (*bet, lamed, peh, tav*).

Forming the serif

SERIF FORMATION. Most horizontal strokes begin with a very thin stroke which slides along the edge of the pen (1). (For clarity's sake this stroke is not included in the exemplar above.) Then form a slab-like lozenge stroke (2) which comes down at an approximately 75 degree slope. The serif will need to jut out a bit above and a bit below the horizontal stroke. Place pen inside serif (3) and continue with horizontal.

Fred Pauker. Certificate, 1984

Fred Pauker. *Travel Prayer* for El Al Airlines travel folder, 1975

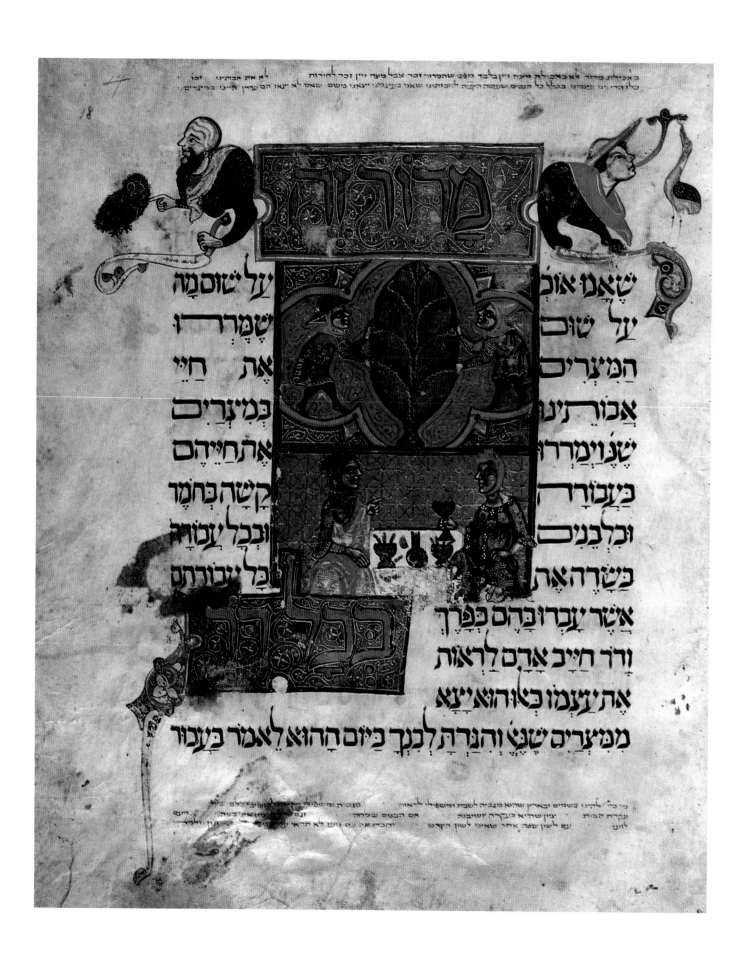

כאכילת מרור לא בברכה לא טעה יין בלבד מפני שהמרור זכר אבל מער יין זכר לחרות לא את אבותינו זכו
כלומר דיינו עמנו בכלל כל הנסים שעשה הקבה לאבותינו שאני בינינולנו יגאנו מאם שאם לא יצאו הם עדין חיינו אנו במצרים

מחזרה

על שום מה שאמ או....

שמרו על שוב

את חיי המצרים

כמצרים אבותינו

אתחייהם שנוימרו

מעבור קשה בחמר

ובכל עבודה ולכנים

כל יבודתם משרה את

אשר עברו בהם בפרך

כל דבר

ורד חייב אדם לראות

את עצמו כאו הוא יצא

ממצרים שנ' והנרת לבנך ביום ההוא לאמר בעבור

כי כה' אלהינו בשמים ובארץ שהוא מנביה לשבת ומשפילי לראות מנוגה וזמ... פכ... וזבריהם
עקרת הבית ציון שהיא בעקרה ישוביבה אם הבנם שבחה מיינ
ועם עם לישון שפר אחר טאינו לשון הקדש והבריאה את גום לא תרא ...
לוים

Chapter 6

The Sephardic Script

THE SEPHARDIC SCRIPT is based on the formal letter forms found in medieval manuscripts originating in Spain and other Sephardic communities. It is presented here as the first historical script to be studied because many of the fundamentals practiced in the Foundational hand, such as the 60 degree pen angle, can be carried over directly to this script. Also, many of the letter forms learnt in the Variations section bear a similarity to Sephardic letter forms.

Have a look at the manuscript on the facing page which is from a beautiful 14th century Haggadah from Spain, commonly called the "Brother" to the Rylands Haggadah. Looking at the actual historical models from whence the modern exemplars are derived allows you to absorb the spirit of the original script. (Needless to say, looking at the original manuscripts, if you have the opportunity, is always better than viewing reproductions). This is no less important than a geometric analysis of its elements (which we will do in the chapter on "Analyzing Historical Manuscripts"). Keep in mind that this script was written with a reed pen on vellum, which gives a specific flavor allowing for subtleties that are difficult to replicate with our harsher, metal nibs working on paper. Get a feel for the shapes and color of the letters, their arrangement in space, their content, their context within the page. Allow this "feeling", this spirit of the script, these intangibles, to penetrate you before jumping to the exemplar on the following page.

Opposite: "Brother" to Ryland's Haggadah. Spain, 14th century. Above: Detail
© The British Library Board, OR. MS 1404 folio 18

The script shown below is an exemplar of a Sephardic script. It is not a replication of the historical script shown above, nor is it based on any one single manuscript, but rather of elements chosen after looking at many different manuscripts. It would be incorrect to assume that there exists a single Sephardic script.

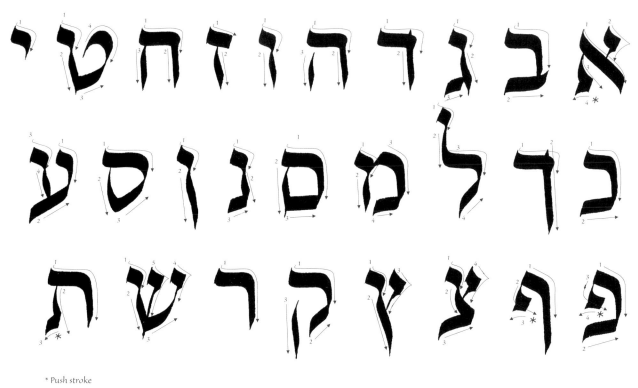

* Push stroke

A Sephardic Script

A Pangram:

דג סקרן בשם יוסף שט בים
מאוכזב אך לפתע צץ
חברו התנין.

Features of the Sephardic Script

Basics

Pen angle—60 degrees for most strokes, steepening to approximately 80 degrees for diagonals such as in *aleph* and *tzadi*.
Weight: 3½–4 pen widths. The exemplar above was written with a Brause 4 mm nib at a body height of 15 mm (making for 3¾ pen widths).

Letter Form

Just about all of the letters of the Sephardic script contain subtleties of form as compared with the Foundational, so careful attention should be paid to the exemplar. Note that almost all letters begin with a serif. Review serif formation from the *Variations* section in the "Foundational Script" chapter. We will detail below construction of two new strokes:

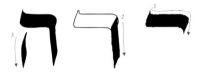

Sephardic *heh* Foundational *heh*

1. CORNERS: Notice the join at the top right corner on several of the letters, where the horizontal and vertical strokes meet. Whereas in the foundational we have kept this join fairly simple, i.e. a simple perpendicular stroke, the classic Sephardi corner is slightly more complicated. The diagram below demonstrates how this join is constructed for the letter *heh*.

Construction: 1. Begin with a serifed horizontal. Towards the end of the stroke, curve slightly down and slightly inwards. 2. Place pen inside roof and come straight down. 3. Form second leg as in Foundational.

Construction of Sephardic *heh*

2. JOINS leading from right heads of *aleph, tzadi, final tzadi* and right and middle heads of *shin*.

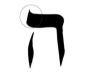

Note that all letters begin with a serif

Construction: 1. Form sloped head starting a tad above the top guideline and pause. 2. Go slightly back into the head in a push stroke and curve outward and down to join to adjacent stroke. Since the stroke to which you will join the head will not be in the same, identical position in the different letters, the exact shape and length of this stroke will slightly vary from letter to letter. But regardless, this joining stroke should always have movement throughout; it should not thin out too soon, connecting with just a weak, thin, line.

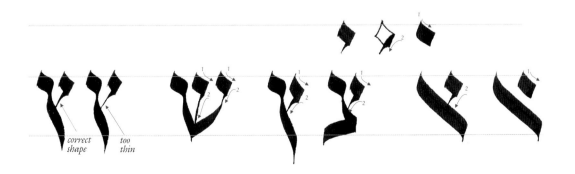

correct shape *too thin*

Some Considerations Regarding Specific Letters

Aleph: Think of both the right head and the left leg as running parallel to the diagonal stoke. When making the diagonal, steepen your pen angle to 80 degrees or more in order not to have the stroke too thick. *Peh and peh sofit*: Inner *yud* should run parallel to roof stroke. *Lamed, kuf*: Steepen pen angle to 80 degrees or more for legs/base strokes. *Ayin*: Slightly steepen pen angle for base stroke. *Tzadi*: Steepen pen angle (p.a.) to 80 degrees or more when making the sloped "neck" stroke; also give a slight curve to this stroke in order to help balance the meeting with the base stroke. The base stroke can be sloped upwards rather than running horizontal in order to "lighten" the join between these two thick strokes.

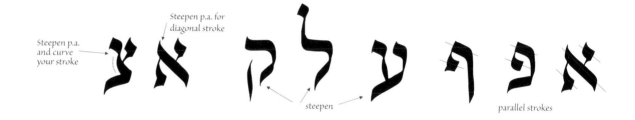

Related Forms:

Sometimes it helps to see how the letters are related to each other by grouping them by common elements. Here is one way of grouping the letters in the Sephardic script.

1. Sloped "yud-shaped" heads—*gimmel, vav, tet, yud, lamed, nun, final nun, ayin, tzadi, final tzadi, shin.* Make sure these begin slightly above line in order not to look lower than letters with horizontal top strokes. Same applies to diagonal of *aleph*.

2. Curved right corner join—*dalet, heh, chet*

3. Legs of *kuf* and *lamed*

4. Shape made by left vertical and base of *tet, samech, shin.*

5. Parallel sloped stroke in *aleph, peh* and *peh sofit*

6. Short push stroke in *aleph, peh, peh sofit* and *tav.*

Common Errors

	Errors	Correct shape

Aleph: a. Unbalanced letter—right arm too high and left leg too low on the diagonal, causing letter to lean forward. b. Diagonal doesn't jut above line—letter looks too low compared to next letter.

Bet: a. Heel of *bet* too pronounced. b. Heel of *bet* not pronounced enough.

Gimmel: Not enough "clearance" at base, looks too similar to *nun*.

Zayin: Leg of *zayin* coming out of right side, can be confused with *vav*.

Tet: "V" shape, which weakens letter. We want a more asymmetrical shape. Keep slope of left leg steeper and give more horizontal emphasis to the base stroke.

Ayin: a. Both heads should have equal "presence". b. Right leg too thin—weakens structure of letter.

Peh: Not enough space around inner "*yud*" of *peh*—baseline stroke needs to be lower.

Peh Sofit: Inner "*yud*" too low

Tzadi: Right arm hits too low, too close to base stroke—looks like *ayin*.

Shin: a. Not wide enough—middle stroke crowded. b. Middle head too high and of different shape. c. Three heads not the same width. d. Middle head too low.

Tav: Left base stroke not pronounced enough.

Sloped letters begin too low—need to cut the top guideline. (see section on sloped heads in "Variations on the Foundational")

All letters—spiked serif

I have been privileged to work on many Haggadot over the years. Two of them stand out in their uniquenes—*The Jerusalem Haggadah*, with artist Yael Hershberg, and *The Moriah Haggadah* with artist Avner Moriah. Below are some script samples where I have used a variation of the Sephardic script.

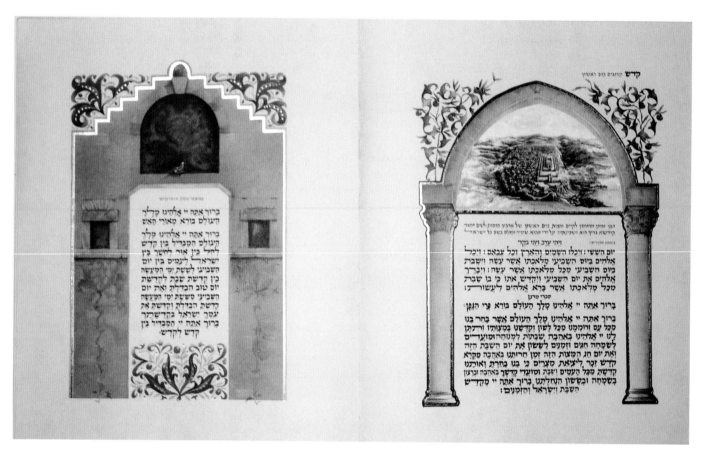

Double-spread from *The Jerusalem Haggadah*, using a modified Sephardic Script
Illustrations: Yael Hershberg. Calligraphy: Izzy Pludwinski

Detail

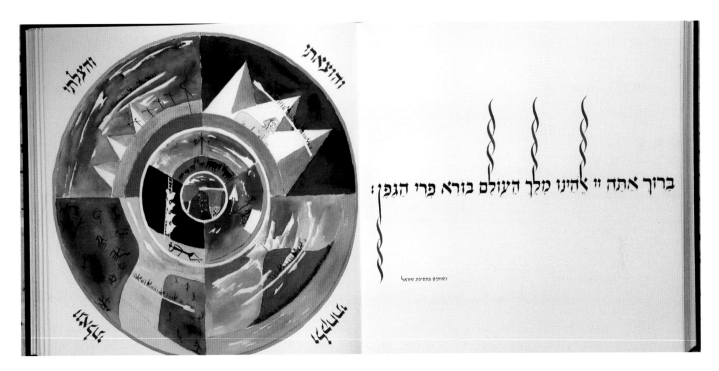

Modified Sephardic script from *The Moriah Haggadah*
Illustrations: Avner Moriah. Calligraphy: Izzy Pludwinski

Detail
Notice the *aleph-lamed* ligature (the only common one in Hebrew), starting the fourth word. This ligature is often used when writing God's name, *Elohim*, in non-sacred texts.

61

Deed, from the time of the Bar Kochba revolt, 134 CE
Photo Tsila Sagiv, Courtesy Israel Antiquities Authority

Chapter 7

The Yerushalmi Script

ONE OF THE MORE POPULAR SCRIPTS in the Hebrew calligrapher's repertoire is the Yerushalmi Script. The origin of the script's name is not clear. The script clearly has some elements seen on some of the letters found on the Dead Sea Scrolls, most notably the style of serif found on many of the letters, but there are also later influences.

Before we go into specifics, have a look at the manuscript below and take some time to absorb the spirit of the writing in the Dead Sea Scrolls. The scrolls date beginning from mid-3rd century BCE and are among the first full texts written in the "square" Hebrew script. The script of course is not as sophisticated and stylized as the one we saw in the Sephardic manuscript (understandable, as it was written almost 2000 years before!), yet there is a certain beauty to be found in its simplicity and directness, and many of the scrolls were obviously written by very skilled scribes. Most of the scrolls were written on animal skin, most likely with a reed pen. Notice the formality, or lack of, in the writing, the distance between lines, the exaggerations of the ascender stroke in *lamed*. Even though the Yerushalmi exemplar will formalize and unify the shapes, perhaps, once the forms are mastered, you can allow some of the spirit of the Dead Sea Scrolls back into your writing. As a curiosity, note the letters in the Ancient Hebrew script on the bottom line in the Habbakuk Commentary manuscript below. These spell out the Tetragrammaton. In the manuscript to the left you see a nice specimen of the same script written a few hundred years later, on papyrus, during the Bar Kochba revolt in 134 CE.

The Tetragrammaton in the Ancient Hebrew script. Commentary on Habakkuk, Qumran, 1st cent. BCE Shrine of The Book. Photo © The Israel Museum, Jerusalem, by David Harris

אבגדהוזחחטי
כלמנסעפצק
רשת דסווץ

Yerushalmi Script (Stroke construction on p. 67)

Features of the Yerushalmi Script

Basics

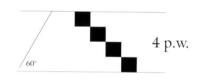

4 p.w.

The script on the Dead Sea Scrolls was most likely written with a blunt writing tool which did not greatly distinguish between thick and thin strokes. We could create a Yerushalmi script using a 45 degree pen angle which would also give us equal horizontal and vertical strokes, but I prefer, as a matter of personal taste, to keep the pen angle here too at 60 degrees, changing to a steeper angle for the diagonal in *aleph* and the "neck" stroke of *tzad*i. The script works well at anywhere between 2½ to 4½ nib widths. The script above was written at 4 pen widths.

Serifs

Triangular serifs in the
Habakkuk Commentary

Take a look at the triangular serifs on *vav, yud, and bet*, circled at left, from the *Habakkuk Commentary*. It is this feature more than any other which has been singled out in the formation of the Yerushalmi script. In the exemplar above, notice that each letter has this distinctive serif, and while most of the letter forms in the Yerushalmi are very similar to those in the Foundational, the distinctive serif and some of the different shapes give a unique flavor to this script.

זוקים כסף צרוף אחרים כנגדן סך הכל מאה זקוקים
עו אחריות שיער כתובתא דא נדוניא דן ותוספתא
להתפרע מכל שפר ארג נכסין וקנינין דאית לי
אנא למקנא נכסין דאית להון אחריות ודלית להון
אין לפרוע מנהון שיער כתובתא דא נדוניא דין

Detail from ketubah written in an informal Yerushalmi script. This was written rather small (body height less than 2 mm) and fast.

SERIF CONSTRUCTION

There are two methods for forming the serif, one when it precedes a vertical stroke (such as *vav*) and one when it precedes a horizontal stroke (such as *reish*).

.

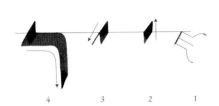 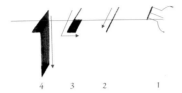

Serif formation for serifs preceding a horizontal stroke

For *bet, khaf, reish* and *left sides of dalet, heh* and *khaf sofit*

1. Place pen just under guideline, with the top of your nib touching the guideline.

2. Push pen straight up, till bottom of pen just touches guideline.

3. Slide pen on its thin, sloping down and to the left, till top of pen hits guideline.

4. Make horizontal stroke.

Please note that all the above strokes are written continuously. There are no pen lifts when forming this serif. (In fact, the whole letter *reish* is written in one stroke.)

Serif formation for serifs preceding a straight vertical stroke

For *vav, yud, lamed, mem, nun sofit*

1. Place pen just over top guideline with the bottom of the nib touching guideline.

2. Slide nib along its thin edge down and to the left, till top of nib just touches guideline.

3. Make a very short horizontal stroke, stopping when right side of nib aligns with right side of your first pen placement.

4. Lift pen and place it exactly where you started the first stroke and come down with a perfect vertical.

Steps 1-3 are done in one stroke. Lift pen to form step 4.

For letters with a sloped vertical, such as in *gimmel, nun, tzadi*, left sides of *tet, ayin, tzadi* and *shin*, follow the same steps as for a straight vertical, but in step 3 the horizontal stroke must "overshoot" the starting point— otherwise a notch will be formed when you come down with the vertical.

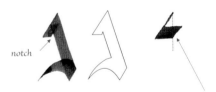

For sloped verticals, the horizontal stroke of the serif must "overshoot" the starting point, otherwise a notch is formed.

For some letters, such as *chet, mem sofit, kuf, tav* and right side of *dalet*, there is no need to form the serifs separately, as they are formed automatically with regular strokes.

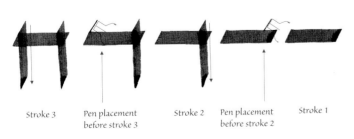

Stroke 3 | Pen placement before stroke 3 | Stroke 2 | Pen placement before stroke 2 | Stroke 1

Letter Forms

Unique shapes to the Yerushalmi: *lamed* and *kuf* have short legs that come to a point; the base of *gimmel* comes directly out of the right leg; the short left leg of *mem;* the leg of *zayin* comes out of the left side rather than the middle of the roof. In fact, the shape of the letter *zayin* repeats itself in several letters of the Yerushalmi *aleph-bet* and its construction is worthy of closer attention.

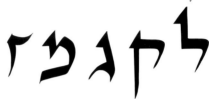

Construction of *zayin* stroke: For the actual letter *zayin* begin with a horizontal stroke. This stroke may have a very slight concave curve shape to it. For the second stroke begin at the starting point of stroke 1 and come very slightly in and curve down, also with a *very slight* concave curve shape. It is most important to view these strokes as curving very slightly off a straight line—too much curviness will greatly weaken the letter.

Construction of zayin stroke

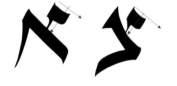

Head and joining stroke run perpendicular to each other

This "*zayin*" shape appears in the right heads of *aleph, ayin, tzadi, tzadi sofit* and *shin*. The only difference in these cases will be that both strokes are shorter and in some letters the orientation is tilted rather than parallel to the line of writing. The second stroke should run perpendicular to the head no matter the orientation.

Common Errors Specific to the Yerushalmi Script

Correct form

Zayin shape—curves of both the head and the leg too exaggerated. The curve must be subtle!

Correct form

Make sure serifs are reasonably close in size. Right serif here begins too high.

Correct form

Leg of gimmel should extend out in order to end in a thin, not curve back which causes an awkward thickening in its end.

Horizontal stroke of serif in gimmel is too short. Notch is formed. Care must be taken to extend the horizontal stroke for all sloped vertical letters (gimmel, nun, tzadi, left sides of tet, ayin and shin).

STROKE ORDER FOR CONSTRUCTING THE LETTERS. The letters below were written with a Brause 3 mm nib. It is sometimes helpful to place and move your pen over the strokes in the exemplar with a dry nib to understand the pen angle and stroke direction. The formation of serifs and other unique strokes are detailed on the previous pages.

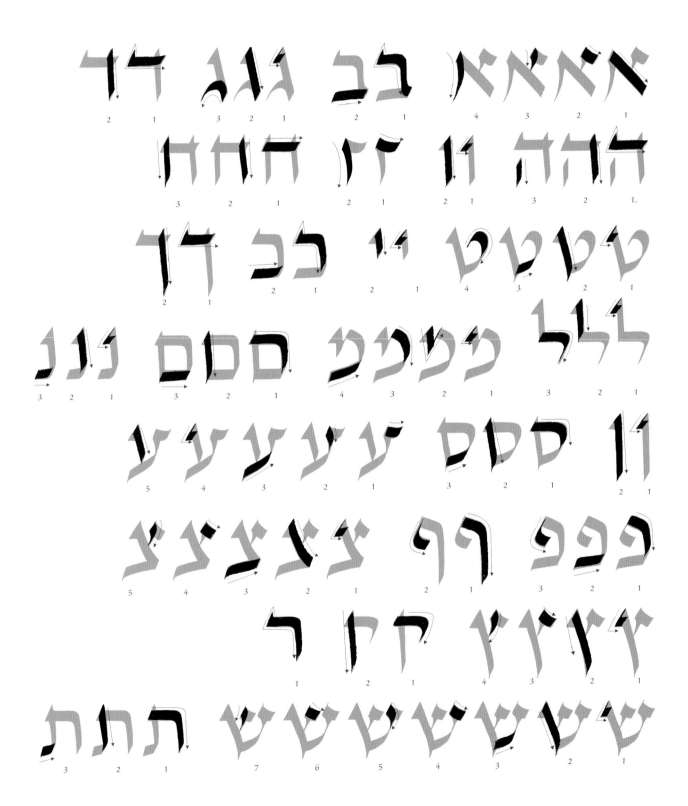

Here are some contemporary examples incorporating the Yerushalmi script and variations thereof.

Yerachmiel Shechter. *Chad Gadya*

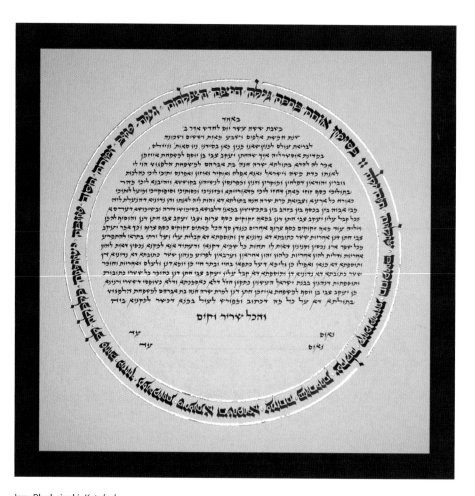

Izzy Pludwinski. *Ketubah*
The body text is in Yerushalmi script. The border text is in a variation of the Foundational.

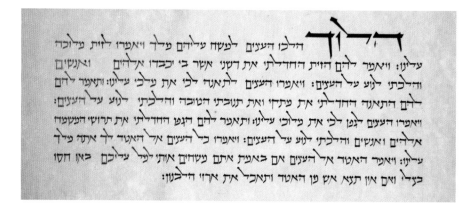

Page from calligraphic book,
from the Shechter Collection

Calligraphic book

This work, as well as the *Chad Gadya* and the bottom work on the facing page are from the Shechter Collection, in the possession of the Department of Graphic Design at Emunah College. Reproduced with permission

Izzy Pludwinski. *Peace to you.* The border writing utilizes a Yerushalmi font developed from the author's calligraphic script. (See "Digitizing your Calligraphy" on p. 103)

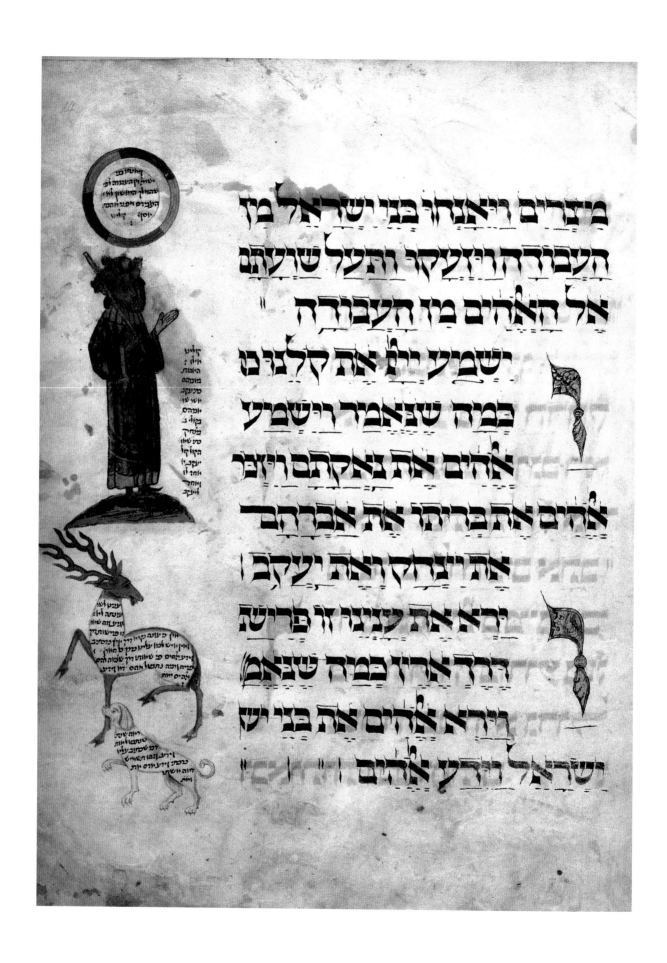

מצרים ויאנחו בני ישראל מן
העבודה ויזעקו ותעל שועתם
אל האלהים מן העבודה
שמע ייי את קולנו
כמה שנאמר וישמע
אלהים את נאקתם ויזכר
אלהים את בריתו את אברהם
את יצחק ואת יעקב
וירא את ענינו זו פרישת
דרך ארץ כמה שנאמ'
וירא אלהים את בני
ישראל וידע אלהים

Chapter 8
The Ashkenazic Script

THE ASHKENAZIC SCRIPT is a beautiful, traditional and majestic script. The term "Ashkenazic" is today used to describe the Jewish culture of Germany and Eastern Europe, and the script, which originated in Germany, refers to letterforms that are written with a very steep pen angle, emphasizing the contrast between thick horizontals and thin vertical strokes.

Ashkenazic manuscripts were traditionally written with a quill, which has a very strong influence on the shapes of the letters. There are letter forms that come naturally when written with a quill (especially utilizing the corner of the nib, sometimes called the *shpitz*). To duplicate those forms with the broad-edged metal pen would require you to use more strokes and much pen manipulation. Because of its complexity and many variations, we will give a considerable amount of attention to this script.

Just as we did for the Sephardic script, first take some time to look at the Ashkenazic script in the exquisite manuscript shown on the facing page and below. Get a feel for its texture, the shapes and color of the letters and their arrangement. (Keep in mind that these were written during what is known as the Gothic period—think of Gothic architecture and its influence on the styles of writing in the Latin scripts). Again, allow this "feeling", the "spirit" of the script to penetrate you before jumping to the exemplar on the following page.

Opposite and above: From *The Ashkenazi Haggadah* (named after the scribe, Joel Ben Simon Faivusch Ashkenazi, and not for the script). Mid-15th century
Add.MS.14672 folio 14a. © The British Library Board

The following exemplar shows a simple version of the Ashkenazic script. We will then build on this to get to more complex variations. The stroke construction for this *aleph-bet* is illustrated on the following page.

אבגדהוזחטי

כךלמםנןסע

פתצץקרשת

Simple Ashkenazic Script

Features of Ashkenazic Script

The extreme contrast between thick horizontal and thin vertical strokes and the lozenge (diamond) shape of the legs on many of the letters.

The weight of the script is heavier than those we have looked at until now, closer to 3 nib units, although this too differs in different manuscripts. The "roofs" of the letters are written with the pen held at 90 degrees, and the legs, which are lozenge shaped, are written at approximately 80 degrees (depending on the weight of the letter).

Pen angle: Roofs are 90°, lozenge shapes are approximately 80°

Weight: 3¼ p.w.

The exemplar above was written with a Brause 4 mm nib at a height of 13 mm.

Constructing the Letters

The letters on the following page were written with a Brause 4 mm nib. It is sometimes helpful to place your pen over the strokes in the exemplar with a dry nib to understand the pen angle and stroke direction, especially on letters that require pen manipulation. Complex strokes are explained and demonstrated in detail further on in this chapter.

STROKE ORDER FOR ASHKENAZIC LETTER CONSTRUCTION

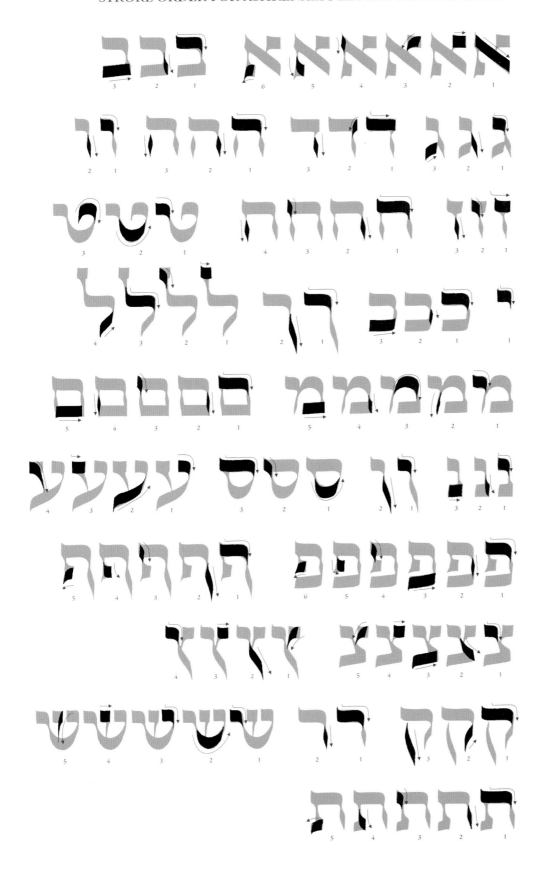

Stroke Construction and Grouping of Similar Elements

As can be seen from the previous page, many similar strokes are repeated throughout the *aleph-bet*. Here is a detailed breakdown of many of them.

ROOFS: All letters in the Ashkenazic script except for *aleph* have a horizontal stroke along the top guideline, curving into a very short vertical ending in a hairline. For some letters this horizontal will be a long stroke, for others, not more than a *yud's* worth.

Construction: Hold the pen angle at 90 degrees, begin slightly above the line in a very short lead-in stroke, come down and turn in a relatively sharp curve to form the horizontal stroke. Without stopping, begin to curve downwards and stop once you have formed a definite hairline.

LOZENGE (DIAMOND) SHAPED LEGS: *dalet, heh, vav, zayin, chet, mem sofit, peh, reish, tav*: After making the horizontal stroke (1), change your pen angle to 80 degrees (2), connect the upper edge of the pen to the hairline endpoint of your first stroke and form a lozenge, diamond-like stroke by coming down on a slope to the right (3). To get the correct shape, make sure the bottom edge of your pen hits the baseline at a point exactly underneath the point where the leg stroke started (4). For the *heh*, duplicate the last stroke to form the left leg (5). For *chet, peh and final mem* and *tav*, after you have made the right leg, make another lozenge shape within the roof (see following group) and then continue.

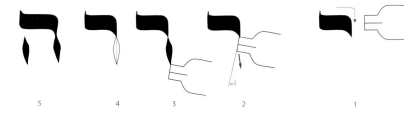

Critiquing the Lozenge Stroke—Common Errors:

Undefined shape to the lozenge stroke.

Shape not correct: this stroke was curved too far to the right rather than coming straight down on a slight slope.

Join too weak—leg cannot structurally "hold the roof up". Placement of pen needs to be higher, at the point the roof stroke turns into a hairline.

Shapes of legs don't match—right diamond is thin, left diamond thick.

LOZENGE STROKES STARTING WITHIN ROOF: *aleph, chet, mem sofit, peh, peh sofit, tav*:

These letters all have lozenge shapes coming down their left sides. Starting completely within the left side of the roof stroke, or in the case of *aleph* within the top left corner of the diagonal, and holding the pen at approximately 80 degrees, form a lozenge shape by coming down and very slightly to the right until you just begin to get a thin point at the bottom. Alternatively, you can use the curved stroke used in the head of *zayin* (see below) for a softer shape instead of the lozenge). For *chet* and *mem sofit*, continue with yet another lozenge stroke to the left baseline. For *aleph*, the left side of *peh* and *peh sofit* and *tav* you will continue with a "curved and to the right" backstroke.

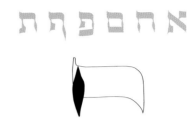

Alternatively, use a curved stroke (see *zayin* below) instead of the lozenge.

"HEAD" CONSTRUCTION for *zayin, lamed* and the left head of *ayin*. Begin with a square, horizontal stroke (1) (for *zayin* add serif). Then place the pen where you began your first stroke and stroke to the right while curving down (2). For *zayin* and *lamed*, stop when your stroke forms a point and continue with a lozenge stroke. In *ayin* continue with the thin stroke until you connect with base.

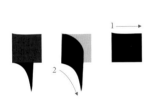 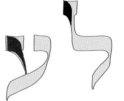

DESCENDERS: For descenders begin with a 80° pen angle as if forming the lozenge shape. As you descend, steepen the pen angle by manipulating the pen counterclockwise till you end in a point. Descenders should end around 2 pen widths below the baseline.

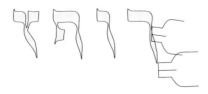

BACKWARDS CURVE STROKE:

Bet, mem and *nun* have a backwards curve stroke following the roof stroke that reaches down to the baseline. After the roof stroke (1) is made, pause, then come down (2) in a slightly curved and sloped-down-to-the-right stroke till you reach the baseline (3). Baseline stroke should smoothly join with this stroke (4). The amount of backstroke will differ from letter to letter. *Mem* needs less of a heel than *bet* so its horizontal backstroke will be narrower. For *peh* and *peh sofit* the backstroke is what forms the inner shape so they will need a more prominent horizontal. Similarly for *aleph* and *tav*.

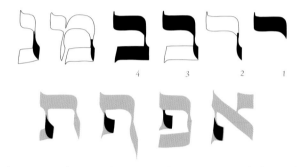

PUSH STROKE 1:

Aleph, peh, final peh and *tav* all have a push stroke following the backwards curve. After completing the backwards curve, push out to the left while curving very slightly down and outwards. It is easiest to do this when there is a good amount of wet ink applied to the previous stroke and/or in your pen. If too dry, pushing can be difficult and even dangerous as ink could splatter. If the conditions make it difficult to push, you may reverse the direction and form the shape from left to right with a regular pull stroke.

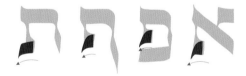

PUSH STROKE 2:

Right heads of *aleph, tzadi* and *tzadi sofit*: These letters have a short horizontal stroke the shape of a square followed by a second push stroke which exits the square in a thin hairline by manipulating the pen.
Step 1: Make a horizontal square stroke.
Step 2: Without lifting the pen, push out going over your first stroke while manipulating the pen clockwise till you push out in a thin hairline to join to adjacent stroke.

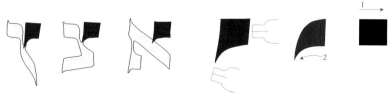

ARC on *mem*, *tet*, *samech* and *shin*: Pen angle changes constantly throughout the making of these arcs. For *mem* begin the arc with an approximately 60 degree angle (adjust your angle so that the join is as even as possible), gradually steepening the pen to 90 degrees at the midpoint of the arc and then continuing to about 100 degrees before returning to 90 for the downstroke (all without stopping!). For bottom arc of *samech*, *tet* and *shin* the reverse: begin at about 100 degrees (again aligning your pen to give you the smoothest join to the previous stroke), reach 90 at the midpoint of the arc and then flatten till approximately 60 degrees.

Building on the Simple Ashkenazic

Once you have mastered writing the strokes of the simple Ashkenazic script, you can add new elements to make for more complex forms and variations.

1. STRENGTHENING THE JOIN:

Heh, *chet*, *final khaf*, and in some variations, *dalet*.

A characteristic element found in most Ashkenazic manuscripts is a stronger join between roof and leg strokes. To strengthen this join an extra stroke is added coming out of the roof. After making the roof, hold pen angle at approximately 75 degrees and begin a second stroke from within the roof a little in from the right edge. Make a short, sloped stroke down and to the right while twisting pen counterclockwise to end up at the same point as your first roof stroke. Continue lozenge shape for leg same as before. Some find it easier to add this extra stroke after making the leg.

| Completed letter | Adding join after making the leg | Twist the pen counter-clockwise as you come down when making the join | Adding the join after roof stroke |

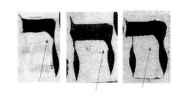

Manuscript letters showing strengthened join

One can vary the shape and placement of the two strokes, giving different shapes to the corners. Whatever shape is chosen, maintain consistency throughout.

A more angular corner A more rounded corner A slightly different shape for the roof stroke

Sharp corners, from the *Ashkenazi Haggadah*

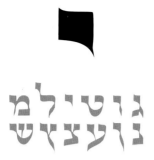

2. COMPOUND SQUARE HEADS: *gimmel, vav, yud, lamed, nun* and *nun sofit* as well as the left heads of *tet, mem, ayin, tzadi, tzadi sofit* and *shin.*

Rather than the curved-corner of the simple Ashkenazic heads, these are formed in two strokes:

Step 1: Make short horizontal stroke.

Step 2: Place pen where first stroke began and sweep over the entire first stroke while coming down in a very slight curve. For *vav, nun and nun sofit* you will keep the pen at a constant 90 degrees. For all other letters slightly twist the pen in a counterclockwise direction while making the second stroke (Figure 1), till you exit at a greater than 90 degree angle. Your hairline should then point down and to the right. The next stroke (Figure 2) should begin at the same angle you ended with to ensure a smooth join. To reach the base of *ayin* in a thin stroke, as you come out of the stroke in a hairline turn onto the corner of your nib and continue the rest of the stroke with the corner of your nib (Figure 3). This is not a simple stroke but with practice, patience and eventually with speed you will manage to do this smoothly.

Compund head in manuscript *tzadi*

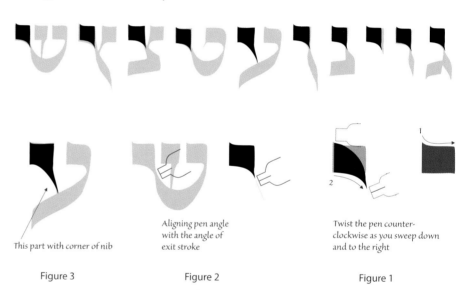

This part with corner of nib

Aligning pen angle with the angle of exit stroke

Twist the pen counter-clockwise as you sweep down and to the right

Figure 3

Figure 2

Figure 1

3. CURVED FACE: Another unique feature of the letters found in many Ashkenazic manuscripts is the curved "face" on the left edge of the roof strokes. This occurs naturally when writing with a quill, as in order to get a clean edge on his letters, the scribe would begin a horizontal stroke with a very short vertical hairline using just the corner of the quill. With speed the straight vertical line would tend to curve. The horizontal stroke that follows abuts this hairline giving the stroke a curved edge. In order to replicate this look with our metal pens one has to go through some pen acrobatics, as it is very difficult to begin a stroke with just the corner of a metal nib. Below is one method of construction but if you really want to replicate these shapes it is worth learning to cut and write with a quill (see section in "The Art of the Sofer" chapter).

Curved "face"

Step 1: Beginning just above the top guideline and holding the pen at about 110 degrees, make a sloped to the right stroke.

Step 2: Using the top corner of your nib and starting at the starting point of your first stroke, make a concave curve at the face of the letter no more than one pen width long.

Step 3: Holding the pen now at 90 degrees, position the pen abutting the curved stroke you just made and make the roof stroke of *heh*. Continue to complete the letter.

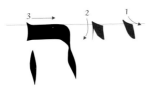

To write with the top corner of your nib, slightly rotate the pen away from your body. Demonstrated here using a Parallel Pen.

To form the head of *gimmel*, begin with steps 1 and 2 as above. For step 3 follow the same directions but stop when you have formed a square horizontal. Step 4 will be similar to the end stroke of the square heads—place pen back on the left side of the head and come down and to the right. Complete the *gimmel*.

We will end the acrobatics with the letter *lamed*. Looking through different manuscripts one sees many, many variations for the shape of the head of *lamed*. With the strokes learnt above you should be able to replicate most of them. Here is the construction for one I particularly like:

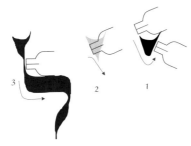

Step 1 Begin with a 110 degree pen angle and come down and to the right a short distance, then manipulate the pen by twisting clockwise as you make a *very* short horizontal. This stroke ends at an approximately 65 degree angle. If you wish, as you complete the stroke turn onto the top corner of your nib and drag out a hairline.

Step 2. Hold the pen again at 110 degrees and placing it over the beginning of your first stroke, come down and to the right in a slight curve.

Step 3: Place pen at 90 degrees and descend into the roof stroke.

Less Formal Styles

LEG VARIATION: In many manuscripts the Ashkenazic script takes on a more "written" form where some strokes seem to be abbreviated. In the manuscript below one sees simpler right legs replacing the carefully constructed lozenge shapes in letters such as *heh,* and *chet*.

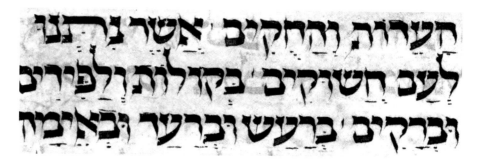

To form these legs, make your first stroke same as for the simple Ashkenazi, then place pen back inside the right side of the roof and, first holding the pen at 80–85 degrees, come down sloping slightly to the right in a straight line while manipulating the pen counterclockwise.

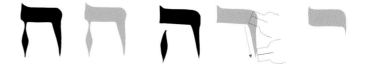

OTHER VARIATIONS: In some manuscripts one finds less formal shapes in various other letters. For example, the left leg of *mem* might only come down half-way while the base is extended; the left leg of *ayin* might not attach to its base.

Below is a verse from Psalms written with some of the variations discussed.

Chris Moench. *Meditational prayer wheel*
Calligraphy: Izzy Pludwinski.
Client: Jacob Engelstein

Facing page: From illustrated *Chumash* demonstrating informal Ashkenazic ▶
script. Illustration Avner Moriah. Calligraphy: Izzy Pludwinski

וישלח

לֵה

אתו ׃ וַיֹּאמֶר לוֹ אֱלֹהִים שִׁמְךָ יַעֲקֹב לֹא
יִקָּרֵא שִׁמְךָ עוֹד יַעֲקֹב כִּי אִם יִשְׂרָאֵל יִהְיֶה
שְׁמֶךָ וַיִּקְרָא אֶת שְׁמוֹ יִשְׂרָאֵל ׃ וַיֹּאמֶר לוֹ
אֱלֹהִים אֲנִי אֵל שַׁדַּי פְּרֵה וּרְבֵה גּוֹי וּקְהַל גּוֹיִם
יִהְיֶה מִמֶּךָּ וּמְלָכִים מֵחֲלָצֶיךָ יֵצֵאוּ ׃ וְאֶת
הָאָרֶץ אֲשֶׁר נָתַתִּי לְאַבְרָהָם וּלְיִצְחָק לְךָ
אֶתְּנֶנָּה וּלְזַרְעֲךָ אַחֲרֶיךָ אֶתֵּן אֶת הָאָרֶץ ׃ וַיַּעַל
מֵעָלָיו אֱלֹהִים בַּמָּקוֹם אֲשֶׁר דִּבֶּר אִתּוֹ ׃
וַיַּצֵּב יַעֲקֹב מַצֵּבָה בַּמָּקוֹם אֲשֶׁר דִּבֶּר אִתּוֹ
מַצֶּבֶת אָבֶן וַיַּסֵּךְ עָלֶיהָ נֶסֶךְ וַיִּצֹק עָלֶיהָ
שָׁמֶן ׃ וַיִּקְרָא יַעֲקֹב אֶת שֵׁם הַמָּקוֹם אֲשֶׁר
דִּבֶּר אִתּוֹ שָׁם אֱלֹהִים בֵּית אֵל ׃ וַיִּסְעוּ מִבֵּית
אֵל וַיְהִי עוֹד כִּבְרַת הָאָרֶץ לָבוֹא אֶפְרָתָה וַתֵּלֶד
רָחֵל וַתְּקַשׁ בְּלִדְתָּהּ ׃ וַיְהִי בְהַקְשֹׁתָהּ בְּלִדְתָּהּ
וַתֹּאמֶר לָהּ הַמְיַלֶּדֶת אַל תִּירְאִי כִּי גַם זֶה לָךְ
בֵּן ׃ וַיְהִי בְּצֵאת נַפְשָׁהּ כִּי מֵתָה וַתִּקְרָא שְׁמוֹ
בֶּן אוֹנִי וְאָבִיו קָרָא לוֹ בִנְיָמִין ׃ וַתָּמָת רָחֵל
וַתִּקָּבֵר בְּדֶרֶךְ אֶפְרָתָה הִוא בֵּית לָחֶם ׃ וַיַּצֵּב
יַעֲקֹב מַצֵּבָה עַל קְבֻרָתָהּ הִוא מַצֶּבֶת קְבֻרַת
רָחֵל עַד הַיּוֹם ׃ וַיִּסַּע יִשְׂרָאֵל וַיֵּט אָהֳלֹה

וַיֹּאמֶר אֱלֹהִים אֶל יַעֲקֹב קוּם עֲלֵה בֵית אֵל
וְשֶׁב שָׁם וַעֲשֵׂה שָׁם מִזְבֵּחַ לָאֵל הַנִּרְאֶה אֵלֶיךָ
בְּבָרְחֲךָ מִפְּנֵי עֵשָׂו אָחִיךָ ׃ וַיֹּאמֶר יַעֲקֹב אֶל
בֵּיתוֹ וְאֶל כָּל אֲשֶׁר עִמּוֹ הָסִרוּ אֶת אֱלֹהֵי הַנֵּכָר
אֲשֶׁר בְּתֹכְכֶם וְהִטַּהֲרוּ וְהַחֲלִיפוּ שִׂמְלֹתֵיכֶם ׃
וְנָקוּמָה וְנַעֲלֶה בֵּית אֵל וְאֶעֱשֶׂה שָּׁם מִזְבֵּחַ
לָאֵל הָעֹנֶה אֹתִי בְּיוֹם צָרָתִי וַיְהִי עִמָּדִי בַּדֶּרֶךְ
אֲשֶׁר הָלָכְתִּי ׃ וַיִּתְּנוּ אֶל יַעֲקֹב אֵת כָּל אֱלֹהֵי
הַנֵּכָר אֲשֶׁר בְּיָדָם וְאֶת הַנְּזָמִים אֲשֶׁר בְּאָזְנֵיהֶם
וַיִּטְמֹן אֹתָם יַעֲקֹב תַּחַת הָאֵלָה אֲשֶׁר עִם
שְׁכֶם ׃ וַיִּסָּעוּ וַיְהִי חִתַּת אֱלֹהִים עַל הֶעָרִים
אֲשֶׁר סְבִיבוֹתֵיהֶם וְלֹא רָדְפוּ אַחֲרֵי בְּנֵי יַעֲקֹב ׃
וַיָּבֹא יַעֲקֹב לוּזָה אֲשֶׁר בְּאֶרֶץ כְּנַעַן הִוא בֵּית
אֵל הוּא וְכָל הָעָם אֲשֶׁר עִמּוֹ ׃ וַיִּבֶן שָׁם מִזְבֵּחַ
וַיִּקְרָא לַמָּקוֹם אֵל בֵּית אֵל כִּי שָׁם נִגְלוּ אֵלָיו
הָאֱלֹהִים בְּבָרְחוֹ מִפְּנֵי אָחִיו ׃ וַתָּמָת דְּבֹרָה
מֵינֶקֶת רִבְקָה וַתִּקָּבֵר מִתַּחַת לְבֵית אֵל תַּחַת
הָאַלּוֹן וַיִּקְרָא שְׁמוֹ אַלּוֹן בָּכוּת ׃ וַיֵּרָא
אֱלֹהִים אֶל יַעֲקֹב עוֹד בְּבֹאוֹ מִפַּדַּן אֲרָם וַיְבָרֶךְ

Manipulate pen counterclockwise and gently lift off as you rise to the join

Pen manipulation on bottom strokes

Refinements

Although an attempt has been made to analyze and dissect the Ashkenazic script into clearly defined elements, it should always be remembered that mature scripts such as the Ashkenazic are fluid rather than rigid; the whole is greater than the sum of its parts. One should always be flexible enough to refine the strokes in order to produce a livelier letter. As an example let us take the join between the bottom strokes of *ayin*, *lamed* and *kuf* to their respective right side strokes. Compare the join of the bottom strokes in each pair of the letters below. On the right side of each pair there has been no pen manipulation. The resulting join is stiff. When stroking upwards do not keep the pen rigid but gently manipulate the pen counterclockwise to taper the stroke. Then, as you enter the right stroke to join, slightly lift the pen off the paper. This will allow the join to be smoother and produce a more vital letter form.

 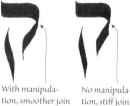

With manipula-
tion, smoother join No manipula-
tion, stiff join With manipula-
tion, smoother join No manipula-
tion, stiff join With manipula-
tion, smoother join No manipula-
tion, stiff join

Decoration

There are elements in the Ashkenazic script that lead naturally to decorative possibilities. Since there is often a thin point where two strokes meet in many of the Ashkenazic letters, this join is often strengthened by adding a decorative element, such as a small circle, which serves both as decoration and to structurally strengthen the join. In addition the *lamed*, which is the only ascender in the Hebrew *aleph-bet*, often stimulates the imagination of the calligrapher/scribe to play with this ascension. Use of decoration or flourishing should be done with discretion, when there is call for an emphasis.

Following are some examples, both historical and modern.

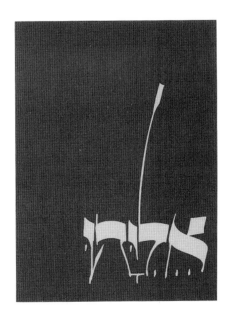

Lynn Broide. *Eliyahu*, Bar Mitzvah logo.
Free style interpretation of Ashkenazic script

Z'ev Lippmann. *In Memory of Rudolph Koch*,
1937. Stylized Ashkenazic writing, emphasizing
Gothic Blackletter elements

Sigmund Forst. *Mitzvot*

Avraham Borshevsky. *The Lord is my strength
and song (from Exodus 15)*. Decorative
Ashkenazic script, (cropped image)

The more one studies different Ashkenazic manuscripts, the more variations
one sees. It would be beyond the scope of this book to discuss all of them. For
an excellent compendium see the various publications showing different script
specimens put out by the Israel Academy of Science and Humanities (See *For
Further Reading*, p.188).

Yerachmiel Shechter. *Chad Gadya* roundel

(From the Shechter Collection, in the possession of the Department
of Graphic Design at Emunah College. Reproduced with permission)

Chapter 9
Semi-cursive Scripts

WE NOW TEMPORARILY LEAVE the formal square forms to have a look at the less formal and less rigid semi-cursive scripts. Hebrew does not have a true cursive script, in the sense that even in handwriting there is no formal system for joining the letters (though joins do sometimes occur spontaneously) but we can look to the plethora of examples of medieval semi-cursive scripts for inspiration and for a wealth of new/old forms to add to our calligraphic repertoire. In this chapter we will look at 3 forms—Rashi script, a modified version of Rashi, and modern Hebrew handwriting. A variety of other semi-cursive textures can be found in the "Plates" section in Chapter 18.

Rashi

The most familiar semi-cursive script seen today is known as Rashi script. This is not the script written by Rashi (classical Biblical and Talmudic commentator, born 1045) but rather a typeface (font). The first appearance of this typeface was in the printing of Rashi's commentary on the Bible in the late 1400s and so it has become popularly known as Rashi script. In modern printing of Bibles (and the Talmud), the main text is usually set in a square script font while the commentaries are printed in a "Rashi" script font. The forms for Rashi script are based on the handwritings used at the time, most notably Sephardic semi-cursive hands (see below and on page 169), whereas Rashi himself, being from France, most likely wrote in an Ashkenazic semi-cursive hand.

Below on the right is an example of Rashi's commentary as it would appear in a Bible today. To the left is an example of semi-cursive handwriting from Spain around the time of the development of the Rashi typeface.

Calligraphically, using this style would usually imply you are writing a religious text.

וְלֹא תִזְנֶה הָאָרֶץ. אם אתה עושה כן, [אין]
מזנה את פירותיה לעשותן במקום אחר ולא בל
וכן הוא אומר, וַיִּמָּנְעוּ רְבִבִים וגו' (ירמיה ג ג) (תו'
(ל) וּמִקְדָּשִׁי תִּירָאוּ. לא יכנס לא במקל
במנעלו ובאפונדתו, ובאבק שעל רגליו (יבמות ו:
על פי שאני מזהירכם על המקדם, ואת שבתותי תו
אין בנין בית המקדם ב דוחה שבת (סס ו.) : (ל)
תִּפְנוּ אֵל הָאבֶת. אזהרה לבעל אוב ג וידעוג
אוב זה פיתום, המדבר משחיו, וידעוני, המכניי
סיה שטמה ידוע ד לתוך פיו, והעלס מדבר (תו"כ
סנהדרין סה:): אַל תְּבַקְשׁוּ. להיות עסוקים

Left: Semi-cursive writing from Spain

Right: Rashi's commentary as printed in a Bible. The square script set in bold letters quotes the biblical text that Rashi is commenting on. The commentary itself is set in a "Rashi" font.

Features of Rashi Script

Rounded shapes; unique forms for some of the letters; slight push stroke on leg endings of many of the letters.

Pen angle: Varies between 75 and 85 degrees.

Weight: 4 p.w.

The exemplar was written with a Brause 3 mm nib at a height of 12 mm.

The exemplar below is a calligraphic rendering of the Rashi typeface. Note the unusual (to the untrained reader) forms for some of the letters, particularly *aleph*, *mem sofit* (which looks like a *samech*), *samech* (which looks like a *mem sofit*), both forms of *tzadi*, and *shin*.

* Denotes push-stroke which is made without lifting the pen. Alternately you may lift the pen and pull the bottom stroke.

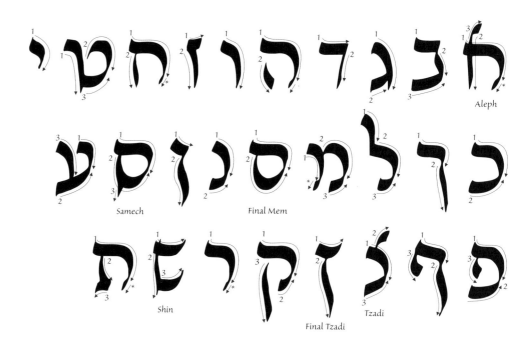

"Rashi" Script

This script does not require any new strokes not already covered. The one thing to pay attention to is the very short base stroke on many of the letters—*aleph*, *heh*, *chet*, left leg of *mem*, *reish* and *tav*. One can make this stroke in a short push stroke without lifting the pen or lift the pen and pull the stroke.

CONTEMPORARY USES OF RASHI SCRIPT

Churva-Keshet. Artist/calligrapher Malla Carl using Rashi script in her work

Detail

Doron Nuni. *Tagged Aleph-bet* and its derivations from Rashi script
(Project done for the calligraphy course given at the Department of
Visual Communication, Shenkar College. Reprinted with permission)

Bezalel student work
From the Shechter Collection at
Emunah College. Reproduced with permission

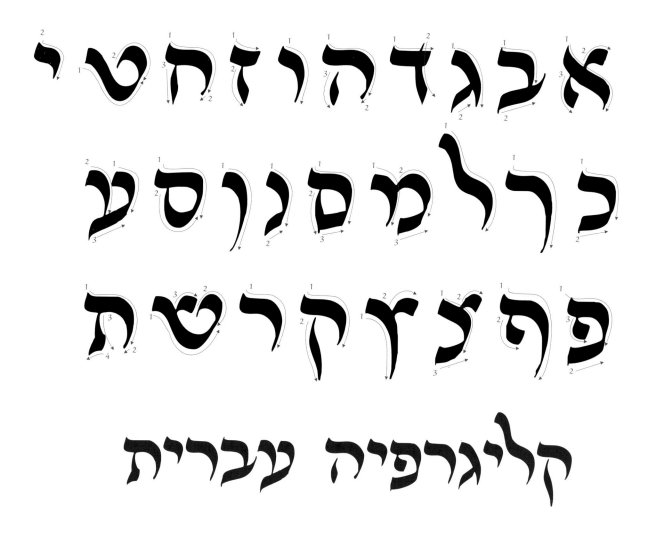

From *The Rothschild Mahzor*. Florence, 1492. A full page of this manuscript is presented in the "Plates" section of this book. See Chapter 18

"Modernized" Rashi Script

This semi-cursive script is similar to Rashi script, but I have used forms that would be more recognizable to the modern reader who might not be familiar with some of the shapes in Rashi script—particularly, *aleph, mem sofit, samech, tzadi* and *shin*. (One of the manuscripts I looked at in developing the script is the beautifully illuminated and written Rothschild Mahzor, shown to the left, though one can easily see that that script is much rounder.)

Features of "Modernized" Rashi Script

The weight of the script is a bit bolder than the previous Rashi script, so note that it is written at a body height of three and a half nib units (this of course can be varied). Pen angle is 60 degrees.

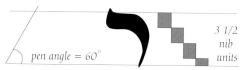

Pen angle: varies between 75° and 85°

Weight: 3½ p.w.

The exemplar was written with a Brause 4 mm nib at a height of 14 mm.

Izzy Pludwinski, *Rav Kook's "Quartet"*. Although this is a "religious" text, it is very poetic in its language and it was felt that a more personal treatment than the traditional square scripts was required, and so this script was "developed" by looking at manuscripts such as the *Rothschild Mahzor* shown on the previous page and in the Plates section.

Detail of script

Wall hanging. Design and embroidery by Adina Gatt
Lettering: Izzy Pludwinski (See detail to right)

Modern Handwriting

As stated in the book's introduction, modern Hebrew handwriting developed from medieval German semi-cursives. The *aleph-bet* below shows the skeletal forms, which were written with a monoline pen.

ת ש ר ק צ פ פ ע ס נ מ ל כ י ט ח ז ו ה ד ג ב א

Alternate forms for
final peh

Using the skeletal forms as a basis, one can experiment writing the script with different tools. Below is the same script freely written with a Tape 1.5 nib without reservoir. Writing without a reservoir allows for easier push strokes, which is useful when writing a handwriting script as we would like to lift the pen as little as possible. The script was written freely *between* 2 guidelines 1 cm apart. Writing this way, without aligning the letters directly on, or hanging from, the guidelines, allows for more spontaneous movement and livelier letters.

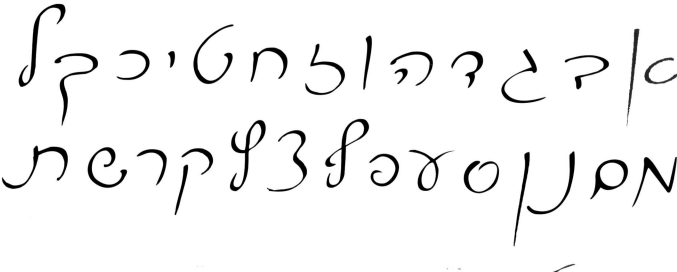

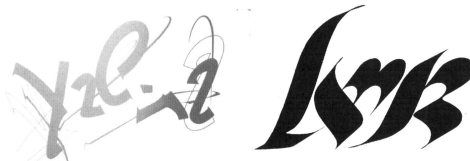

Adi Stern. Logo for the Batsheva Dance Company, utilizing "handwriting" forms

Lynn Broide. *Daniel.* "Handwriting" forms can of course be written with a broad-edged pen too. Here, cursive forms are combined together with "square" forms in this lovely logo.

Here are two pieces written with a broad-edged pen in a "handwriting" script.

Hadass Bar Yosef Gath. *Simchat Afar*
Poem in handwriting style written with
broad-edged pen, 1959

Avital Levitin, *Tzfardeiya*. Poem in handwriting
style written with broad-edged pen, 1959

Brush Writing

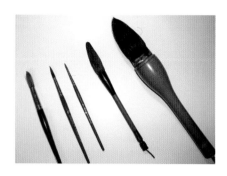

Rounded or pointed brushes for Western writing on the left. Oriental brushes on the right

Strokes are made with the side of the brush.

All the scripts presented in this book until now, aside from the skeletal *aleph-bet*, were written with a broad edged pen. The script below, written by calligrapher/artist Sharon Binder, was written with a pointed brush.

Brush writing has not been part of the Hebrew calligraphic tradition. When one thinks of brush writing it is usually Far-Eastern calligraphy that comes to mind. Having said that, it is an interesting challenge to write Hebrew forms with different tools and the pointed brush is one tool that is so versatile, it can offer interesting variations to work on.

Writing with a pointed brush requires a lot of control which can only be achieved with plenty of practice*. Unlike the broad-edged pen, the amount of pressure you place on the brush will determine thick and thin strokes. Use the side of the brush to give a soft straight edge to your letters.

Choose a brush that has a bit of spring to it—one that will snap back to a point after pressure is placed on it. Brushes made of Kolinsky Sable are considered to be the best. There are also good quality synthetic brushes that might give satisfactory results. Gouache or ink may be used as your medium.

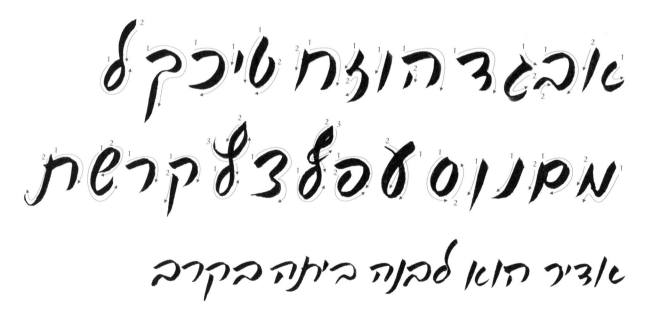

"Cursive" Brush Script. Sharon Binder

*To adequately explain the different methods and subtleties of brush lettering is beyond the scope of this book, which is dedicated primarily to broad-edged pen writing. Please see "For Further Reading" (p.188) for recommended books on brush lettering.

THE FLAT-EDGED BRUSH. Another tool available to the calligrapher is the flat-edged brush. Strokes are made similar to those made with the broad-edged pen. Aim for as crisp an edge as possible, holding the brush quite vertical.

Like the pointed brush, here too pressure is an important variable. This on the one hand makes writing a bit more difficult but on the other hand you can introduce subtleties that were not possible with metal pens. Below right is an artwork by Sharon Binder where she has used both flat brushes (for the larger writing) and pointed brushes (for the cursive letters in the background).

Flat-edged brush

Detail

Izzy Pludwinski. Ferman Ketubah with freely written "handwriting" using a monoline pen for the main text. Heading done with pointed brush

Sharon Binder. *Rimon Panel,* from *7 species* series, demonstrating both flat-edged and pointed brush techniques.

Detail: Pointed-brush writing

Detail: Flat-brush writing

93

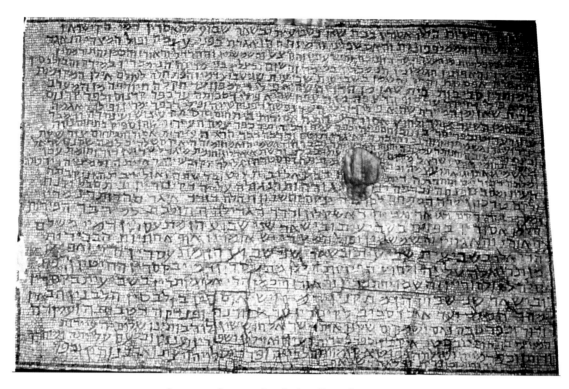

Synagogue floor mosaic at Rechov. Circa 6th century CE
Collection of Israel Antiquities Authority. Photo © The Israel Museum, Jerusalem

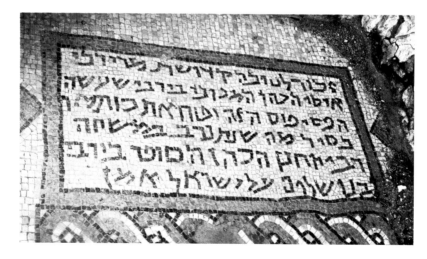

Lettering from the synagogue courtyard at Susya, 4th to 7th century CE
Courtesy of The Susya Tours and Education Center. Reprinted with permission

Chapter 10

Monoline Scripts

Inscriptional

IN ADDITION TO MANUSCRIPTS, calligraphic inspiration can also be derived from lettering that was not directly written. Possible sources include inscriptional letters such as those found carved on ancient ossuaries and ostraca (ceramic shards), as well as the mosaics found on many synagogue floors from the Roman and Byzantine periods. These letters usually do not display a strong contrast between thick and thins and are more monoline in nature.

The script below, by calligrapher Lynn Broide, was inspired by 6th century synagogue floor mosaics. It is a near-monoline *aleph-bet* where, except for serifs, the pen has been manipulated in most cases to give the thickest (or near-thickest) stroke possible, no matter the direction of pen movement.

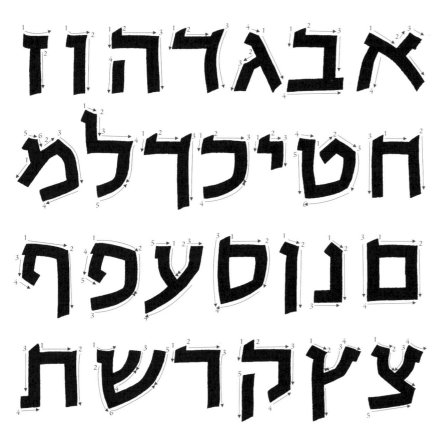

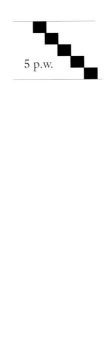

5 p.w.

Monoline Script. Lynn Broide

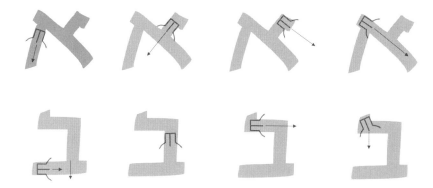

Notice how pen position changes for each stroke

Arnona Rozin. Pages from "Greek Mythologies". Monoline Hebrew with a Greek flavor

Moshe Chatumi.
Book of Lamentations, 1960

Modern Sans Serif

In the past it was the typographers who looked to the hand-written forms of scribes to draw inspiration for creating their typefaces. One might say that the situation today in Israel has been reversed. There has been much innovation and creativity (not all of it good, unfortunately) in Hebrew typography over the last decade, and calligraphers can certainly be stimulated in new directions by perusing a Hebrew font catalogue. (I would be hard pressed to say though that this a two-way street and that Hebrew typographers look towards the work of modern Hebrew calligraphers for inspiration.)

One of the Latin typefaces that has had an influence on modern calligraphy is Neuland, created in 1923 by Rudolph Koch. It is a bold, sans serif, monoline face that has been revived in many different versions. It has had an indirect influence on Hebrew typefaces too. Below is an informal sans serif *aleph-bet*. It is much easier to draw letter forms such as these than to write them directly, as it requires an almost constant changing of the pen angle in order to keep the strokes even in thickness, though some stroke thicknesses were adjusted to avoid too heavy a feel. I would suggest trying this script as an exercise and something to stimulate you toward experimentation rather than to use as an exemplar from which to copy exactly, as it was written in a playful manner and improvised changes occur every time I write it anew. (This is actually in line with Koch's Neuland as he cut the letters directly into metal and changed his forms for each different size.)

This script would most likely be best used as a heading or for a small amount of text. Because of its "chunkiness" an interesting texture can be obtained using tightly packed spacing.

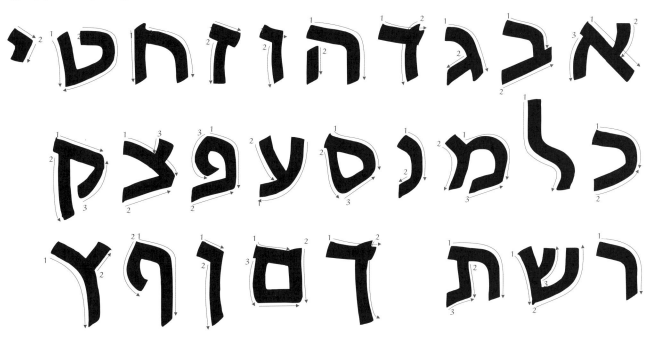

Modern Monoline

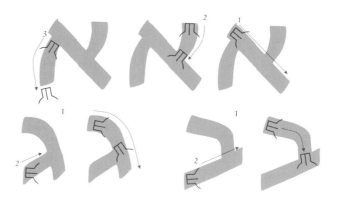

Notice how pen angle needs to constantly be adjusted to obtain an even stroke thickness. *Peh* in particular presents a challenge as it requires constant manipulation as you are making the tight curved inner stroke (2). You might need to reposition your paper and hold the pen handle rather vertically.

Another way to write Monoline letters is to try the A or B series Speedball nibs, which have either square (A series) or round (B series) tips "bent" at right angles to the plane of the nib. These pens give you even-thickness strokes no matter the direction you are moving the pen. You will lose however the option of varying the thicknesses slightly as is done for example at the join in *mem* and the slight tapering in the "arm" of *tzadi*.

Speedball A and B series nibs

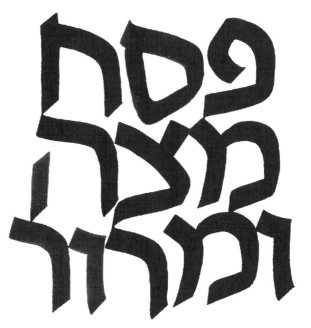

Freely written with a size 4 Automatic pen. Image reduced

Touch Ups

In work that is done for reproduction you might want to touch up subtle points that perhaps did not come out exactly to your liking in the original. In the calligraphy shown above, there were a few such instances. For example in the original writing there was a short lead-in stroke to *mem* that I felt took away from the texture. Unwanted marks may be covered up by brushing on a white pigment such as Dr. Martin's Bleed Proof White.

The stroke to be removed

Brushing on Dr. Martin's Bleed Proof White

You can also touch up by addition. Below I felt the join where the two strokes of *peh* met was a bit too angular. I used a pointed nib (a very thin pointed brush could also be used) dipped in the same ink to touch up the edge. You can also use the corner of your nib to fill in areas during the actual writing.

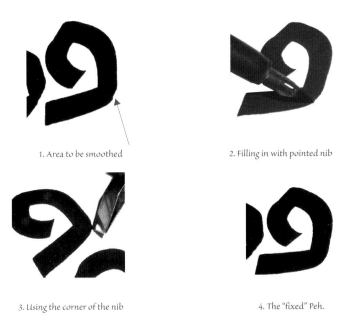

1. Area to be smoothed

2. Filling in with pointed nib

3. Using the corner of the nib

4. The "fixed" Peh.

Corrections on original work (not for reproduction) will be taken up in more detail at the end of the next chapter, "Layout and Design".

Chapter 11

Layout & Design

Designing a Simple Quotation

ONCE YOU HAVE ATTAINED a reasonable consistency in your writing and spacing, I suggest trying a simple project, such as designing a short quotation. Choose a favorite saying or verse—it should be long enough so you have at least 3 lines of writing.

Centered layout

Before beginning to write the quotation you need to consider several questions. For example, what script to use? This is not an arbitrary choice, as each script has its own "spirit". The type of text it is (e.g. religious? poetic? whimsical?), and how you want to represent it (e.g. formal or informal, colorful or austere?)—all this needs to be considered, and an appropriate script chosen. Another question that needs to be asked is in what physical space will the piece most likely be seen—will it be hung on a wall in someone's home, will it be on a billboard, or will it be held in the hand in a small-book format? This will inform and limit your choice regarding the size of your writing.

Flush right

Read the text out loud. Note how you break up the text when reading. Ask yourself if there are any words or phrases that you feel ought to be emphasized? Should color be introduced? The answer to these questions will give you an initial idea for how you might arrange the text.

If you are computer literate you might want to go straight to a page-layout program at this point and begin trying out different layouts. For those who are not, I will outline some first steps in manually laying out a text.

Flush left

Preparing a Layout Manually

You will need layout paper, cartridge paper (bristol), glue stick (repositionable is preferred), plus your basic writing materials.

Step 1: Write out the quotation as consistently as possible on layout paper. You will have to make a decision on the size and weight of your letters. You might want to test out a few different sizes and scripts. If there are any words you feel you want emphasized, then write those words separately at a few different larger sizes and weights. Be sure to also include the attribution—the source or author of the quotation. This may be written in a smaller size.

Aligned left and right (Block)

Step 2: After you have written out the entire quote to your satisfaction on layout paper, make two or three copies (photocopies) of your work.

Step 3: Unless you will be presenting the entire quotation in one line, you need to consider how to break up the lines. This must be in line with the meaning and rhythm of the quotation. Recite the quotation out loud and see where you naturally pause to break up the words. You might feel there are several ways to break up the text.

Take one of the copies and cut out each line according to the way(s) you decided to break up the text and lay it out it on a piece of cartridge paper (bristol pad), arranging the lines and attribution in a satisfying manner. (Examples of different layout possibilities follow below). The color of the bristol should be the same as the layout paper. Once an arrangement looks like a possibility, glue down the layout to the bristol with a glue stick. Glue sticks that do not stick permanently are preferred as you can then peel off and rearrange if necessary. Do the same with your other copies, trying different arrangements, until you have one that looks just right. Below is a list of some of the more common layout possibilities.

SOME TYPES OF LAYOUTS

1. Centered layout. Centered layouts are usually a safe way to lay out a text. The length of each of the lines of your text will most likely differ and one must be aware of the shape the lines are forming. In general one wants to avoid what is known as Christmas tree shapes— i.e. a pyramidical look. They are obvious and are bottom heavy. Reverse pyramids are conversely top heavy.

2. Flushed right. This is the easiest layout to write out in Hebrew as one has only to be concerned to start on the same right margin. One does need to be aware of the shape that being is being formed on the left edge of the writing, which should have a pleasing movement about it.

3. Flushed left In flush left layouts one has to be concerned that one ends each line at the same point. This can be a little bit more difficult to execute if one has not reached consistency in writing. Two factors make this a bit easier in Hebrew. One can, at least with a small amount of text, write "backwards"—in other words begin writing at the left edge and work your way backwards, to the right (see illustration). One has to be especially aware of spelling the words correctly (see "Correcting Mistakes" below). Secondly, in Hebrew one can stretch certain letters, if you find yourself falling short of your left edge. (see section on "Stretching Letters" at the end of this chapter.)

4. Asymmetric layout. Asymmetric layouts are often the most interesting visually, yet require the most skill to design properly. Asymmetry does not mean anarchy. We still aim for strength and balance but with asymmetric movement. To try such a layout move the lines of writing trying to *avoid* having two edges align, until you arrive at a satisfactory arrangement, playing with both their positioning and the distance between lines. A strong "spine" in the layout, meaning an overlap of text along the vertical axis, will strengthen the design. Compare the two asymmetrical layouts (a) with (b): one more successful than the other because of the stronger spine. (This is where having photocopies helps, as you can compare a few layouts side by side at the same time.)

Centered layout. Try to avoid obvious shapes such as pyramids and reverse pyramids

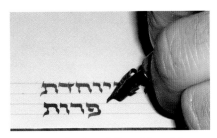

Writing "backwards" from left to right

Asymmetrical—strong spine

Asymmetrical—weak spine

A good deal of this discussion has been devoted to the horizontal placement of the lines. The important topic of interlinear spacing is discussed in detail in connection with writing a text block, at the end of this chapter.

EMPHASIS AND CONTRAST

In presenting the quotation, you might feel that certain elements in your piece deserve emphasis. This leads to a very important concept in design—that of contrast. Contrast adds visual interest to the piece and also helps attract and direct the eye of the viewer. There are several ways to add contrast to your work.

Size and weight: Traditionally, initial letters or words, and even first lines of a block of text are often written larger and/or bolder. You may choose to enlarge words within the body of the text. You can also introduce a rhythm to the piece by having a pattern of larger and smaller script sizes.

Color. Emphasized elements can be written in a different color, or gilded. For tips and instruction, see chapter 13, "Color and Gold".

Form. One does not have to limit oneself to a singular style of writing throughout. Through intelligent and very moderate use (for example, an initial word or heading) a different script style can be introduced. The second script should be clearly different and not "almost the same".

Any of the above contrasts can of course be combined—e.g. a larger word that is also in a different color.

MARGINS

Once the layout is completed, the margins need to be considered. Margins should not be thought of as empty space. Margins play an important, active role in the design: they frame the piece, holding it onto the page; they allow for breathing space; and at their best they "energize" the white space.

Classic margins in a vertical layout generally fall in the approximate range of 2:3:4 proportions for top, sides and bottom respectively (1). One can find more elaborate calculations in any book on design. However, although these make for good starting points, in the end it is the eye that needs to be the ultimate judge. In an actual piece of artwork I do this by placing pieces of mat board (which can be obtained from framers who often have cut-offs to offer you) over the edges and adjusting till it looks satisfactory. We do not want to crowd the words by making too tight a margin, nor do we want the quotation to be lost floating in empty space. (In the example below, after looking at the 2:3:4 proportions in (1), I felt the top margin looked a bit tight for this particular text shape, so I adjusted by slightly increasing the top margin and decreasing the bottom margin (2). Note that margins do not have to be equal symmetrically around the text block. Margins can be dramatically increased or reduced (or even eliminated altogether) *if it serves your purpose*. It should never be done as an empty attempt to "be creative".

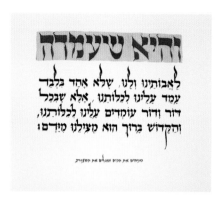

This (cropped) page layout, from the Moriah Haggadah, shows size, color and style contrasts.

When text is placed exactly at the measured vertical center it looks "low" on the page.

One should be aware that the optical center of the page is higher than the measured center. If we were to place the quotation exactly in the vertical center of the page, with equal top and bottom margins, the artwork actually looks low and falling on the page (3). To compensate for this optical illusion, we place the text higher up on the measured page, thus giving us larger bottom margins.

Once a layout has been decided upon and the paste-up completed, it is time to actually write the piece. On good paper (see Tools and Materials), rule up the lines, ticking off lightly with a pencil where we plan each our lines of writing to begin and end. All that is left now is to write the piece as beautifully as we can.

Designing Hillel's Famous Saying

I would now like to illustrate the points discussed above using the well known saying of Hillel: If I am not for myself, who will be?; and if I am only for myself, what am I?; and if not now, when?

The truth is, these days, if I were to begin designing a layout for this project, I would go straight to the computer. Using a program such as CorelDraw or Adobe Illustrator I can quickly test out a few layouts. Since I have digitized many of my scripts (see sidebar) I can also test a variety of scripts on the computer.

Although Hillel's saying is Rabbinic, and therefore might have "religious" associations, its content still has a very modern sensibility and thus could take a variety of scripts. For simplicity's sake though I will only use one script, the Ashkenazic, to illustrate the design possibilities. Since I have already designed a digital font of my Ashkenazic script I obviously used this font in the layout. Within a very short time I was able to view several simple layout options, which you can see on the following pages. What I would most like to share though are the thoughts that go into the design process.

ADVICE WHEN USING THE COMPUTER

There is no doubt that the computer can be a very useful tool to help with layout. Programs such as CorelDraw or Adobe Illustrator can be a tremendous time saver. (Adobe's Mid-east edition works very well with Hebrew. Each Corel version works differently with Hebrew—some better than others.) One can immediately narrow down the options, seeing how different arrangements might look, playing with different sizes, changing colors—all this can be done in minutes and is a great time saver.

However the computer is *a* tool and should not become *an exclusive* tool. There are subtleties that the computer cannot give you. For example, if you are using a computer font to simulate your calligraphy (as I have done in the sample layouts below) you are limited to the weights that come with your font. Often, you will only have one or sometimes two weights at your disposal, regular and bold. When you actually write out your quotation however you have unlimited flexibility with the weight of your letter. For example you can write your letters at a height of anywhere from 2½ to 5 or more pen widths at half intervals. That already gives you 6 weights to choose from. So by all means use the computer, but not at the expense of doing some real-writing trials also. I use the computer to get close to the desired layout, and then do real-writing trials to tweak the layout to give me the best result.

DIGITIZING YOUR CALLIGRAPHY

If you are planning on doing a lot of layout on the computer, consider converting your calligraphic scripts into digital fonts. This will help you, when laying out text, to better visualize the look of your work before you start writing. This will save you a lot of time, especially if you want to decide between several scripts.

Whereas in the past creating a font was a long, tedious process that could take well over a year, with today's technology you can font your script in a matter of hours. All you need is a scanner and a font program. (At the time of this writing the leading font design programs are put out by Fontlab, who offer several different programs, depending on your type-design needs.). You would prepare the best example of your letters and scan them in. You can touch up your work or make any changes within the font program itself.

Spacing is a major issue in type design, just as it is in calligraphy. You will have to work out spacings in your font in order to get the most even texture throughout all letter combinations. The subject of type design is unfortunately beyond the scope of this book. It is highly recommended to read up on the subject if you want to do a good and serious job of it. There are many worthy books on the market.

Scanned letter in a font program

Hillel's saying naturally divides into 3 lines . But as you see below, these give me 3 lines of more or less equal length. In all 3 of the layouts below there is not much movement along the edges and the design is rather static and uninteresting.

אם אין אני לי מי לי
וכשאני לעצמי מה אני
ואם לא עכשיו, אימתי

הלל. פרקי אבות

Flush right

אם אין אני לי מי לי?
וכשאני לעצמי מה אני?
ואם לא עכשיו, אימתי?

הלל. פרקי אבות

Flush left

אם אין אני לי מי לי?
וכשאני לעצמי מה אני?
ואם לא עכשיו, אימתי?

הלל. פרקי אבות

Centered

אם אין אני לי מי לי?
וכשאני לעצמי מה אני?
ואם לא עכשיו, אימתי?

הלל. פרקי אבות

Asymmetrical

Shifting the lines into an asymmetric layout (see design on left) gives more movement. As a balanced design this layout "works", but I am curious to see if I can get more interesting results by breaking up the text differently.

Comparing two asymmetrical layouts

Note the strong spine (grayed area) in the layout on the left compared with the weaker design on the right.

אם אין אני לי מי לי?
וכשאני לעצמי מה אני?
ואם לא עכשיו, אימתי?

הלל. פרקי אבות

אם אין אני לי מי לי?
וכשאני לעצמי מה אני?
ואם לא עכשיו, אימתי?

הלל. פרקי אבות

What if I divide each of the 3 phrases into 2 lines each? This is a natural division as each phrase consists of a hypothesis (If or when) followed by a question. Visually this gives a lot more movement to the piece in all 3 of the layouts below. Adding a second color emphasizes this rhythm even more.

אם אין אני לי
מי לי?
וכשאני לעצמי
מה אני?
ואם לא עכשיו,
אימתי?

הלל. פרקי אבות

Flush left

אם אין אני לי
מי לי?
וכשאני לעצמי
מה אני?
ואם לא עכשיו,
אימתי?

הלל. פרקי אבות

Flush right

אם אין אני לי
מי לי?
וכשאני לעצמי
מה אני?
ואם לא עכשיו,
אימתי?

הלל. פרקי אבות

Centered

If you want to emphasize certain elements in your quotation there should be a rationale to it, either visually or conceptually. You are, after all, asking the reader to look at those elements first.

In Hillel's saying there doesn't seem to be a singular word or phrase asking to be emphasized. However one might choose to emphasize the three "question" parts of the saying. They might suggest a subtext, the questions could be read separately—Who is for me, What am I? When?

Emphasizing an element is also a way to draw the reader into reading your text, acting as a focal point. An enlarged, initial letter might be all that is necessary. These letters can be simple, or as we saw in the Ashkenazic script, they can be a springboard to decorative possibilities, as in the delightful *Aleph* (right) by Mark Podwal.

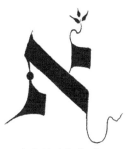

Aleph. Mark Podwal.

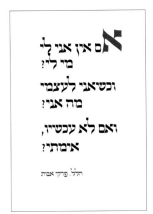

As you can see, the layout possibilities are virtually endless, limited only by your imagination. Below you see two very different versions of actual pieces I did calligraphing the Hillel saying. One is written on parchment and combined with the English translation, which was calligraphed on a home-made mat made from Fabriano Roma paper, and the other utilizing an abstract cursive Hebrew script I developed.

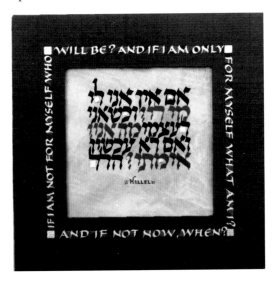

Izzy Pludwinski. *If I am not for myself,* 1990

Izzy Pludwinski. *If I am not for myself* 2010

105

Manually testing out layouts: This was a commission that came as I was writing the book, so I included it here as another illustration of the decision making process, even though it was not a true paste-up. The main text is a verse from Psalms 122: יהי שלום בחילך, שלוה בארמנותיך (Peace be in thy walls and prosperity in your palaces). I had already done the circular border design and the gilding. Now the text had to be arranged. Below is a description of the process.

1. After writing out the texts in a few different scripts and sizes, I cut out the words.

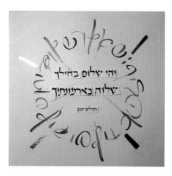

2. The most natural breaking up of the text would be into two lines. This however doesn't fill the circular shape nicely, leaving too much empty space on top and bottom

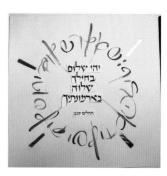

3. Breaking it into 4 lines. This arrangement forms a rigid column shape that doesn't match the circular space nor does it fit with the spirit of the design.

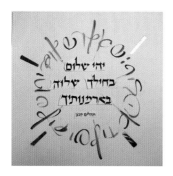

4. By breaking the text into 3 lines I took a bit of artistic licence, as it is not a natural breakup of the text. This arrangement looked the most promising, as it echoes the shape of the circle, though it feels a bit crowded. Perhaps a different script?

5. This Ashkenazic script has such a strong horizontal stress and heaviness that I felt clashes with the border lettering. A calligraphic "dash" was added in the second line to separate the two parts of the verse and to aid the reading.

6. Back to the Yerushalmi script but slightly smaller writing. This looked best to me and was the arrangement chosen for the final piece.

7. All that remained for me to do is rule up the page, mark off in pencil where I intended to begin and end each of my lines, take a deep breath and begin writing.

The final piece

Writing a Text Block

Another way to arrange your calligraphy is in a text block. By text block I mean a fair amount of continuous writing, justified (aligned) on both left and right sides. The block itself can be in the shape of a rectangle, circle, or other defined geometric shape. A ketubah is an example of such a layout. Ketubah design is covered in a later chapter; here we will discuss the factors that go into writing any text block. First we will discuss how to plan out the column in such a way that the left margins are indeed justified. Then we will move onto the important topic of interlinear space.

Justifying Your Work

With a graphics program. If you have a page-layout program (see previous section), lay out your text block and mark off the horizontal halfway point with a vertical line down the center (see below). On your "real" paper also mark off the halfway point in pencil. Begin copying. When you reach the halfway mark on each line, compare with the printout to see if you are "on pace" to finish the line properly. If you are behind you will want to slightly open up your spacing; if ahead you will need to condense in order to end at the same point as your copysheet. (A more detailed illustration of this process is given in the "Designing the Ketubah" section in chapter 16)

תברך את שמך יי אהינו ורוח כל בשר תפאר ותרומם זכרך מלכנו תמיד מן העולם
ועד העולם אתה א ומבלעדיך אין לנו מלך גואל ומושיע פודה ומציל ומפרנס
ומרחם בכל עת צרה וצוקה אין לנו מלך עוזר וסומך אלא אתה: אהי הראשונים
והאחרונים אוה כל בריות אדון כל תולדות המהלל ברוב התשבחות המנהג עולמו
בחסד ובריותיו ברחמים: ויי לא ינום ולא יישן המעורר ישנים והמקיץ נרדמים
והמשיח אלמים והמתיר אסורים והסומך נופלים והזוקף כפופים לך לבדך אנחנו
מודים: אלו פינו מלא שירה כים ולשוננו רנה כהמון גליו ושפתותינו שבח
כמרחבי רקיע ועינינו מאירות כשמש וכירה וידינו פרושות כנשרי שמים ורגלינו
קלות כאילות אין אנחנו מספיקים להודות לך יי אהינו ואהי אבותינו ולברך את

To the left is a computer printout of the planned text block for a section of *The Moriah Haggadah*, with the center line marked in red. Below is the actual written text.

(Note: In *The Moriah Haggadah*, God's name is written with an *aleph-lamed* ligature. In the printout just the *aleph* appears; the *lamed* is omitted.)

Arrangement of text as a block. Page from *The Moriah Haggadah*

The *sofer* way: It is interesting to note the method *Sofrim*, religious scribes, use in order to help them justify their lines. The system works like this. Each letter of the *aleph-bet* is divided into a certain amount of yud-units (yudim), depending on the width of the letter. For example the narrow letters—*gimmel, vav, zayin, yud, nun* and *nun sofit*— all are one yud-unit wide. All other letters are 2 yudim wide except for *shin* which is 3 units wide. A space between words is one yud unit. In a *Megillah* (or even a Torah) copybook (called a *tikkun*), all lines have been counted. An average line has been calculated to be 62 yudim wide. When a scribe looks at a line in his copybook, there is a notation telling him how many yudim are on that line. If there are exactly 62 yudim on the line, it will be designated (see illustration below) with the letters שת , meaning *shitah tamah*, a perfect line. The scribe would write that line with "normal" spacing. If there are less than 62 yudim on that line, say 59 yudim, it will be notated חג—*chaser gimmel* (*gimmel*, being the 3rd letter in the *aleph-bet*, means 3)—meaning 3 yudim are "missing". When the scribe sees he is to write a line that is *chaser*, missing, he knows to begin opening up his spacing. If on the other hand there are more than 62 yudim on a line, say 64, it will be notated with a יב —*yeter bet*, *yeter* meaning extra and *bet* designating two—2 extra. When a scribe sees a *yeter* line in front of him he knows he must begin condensing a bit from the start. This helps keep the spacing even.

A *"shitta tamah"*—perfect line. If you count the "yudim" in the line you will get to 62.

A *"yeter dalet"*—4-extra line. If you count the "yudim" in the line you will get to 66.

A *"chaser dalet"*—4-missing line. If you count the "yudim" in the line you will get to 58.

Sample from a *megillah* copybook

Sometimes though, even with the best of planning, the *sofer* can run into trouble and must stretch a letter to reach the end of the line, as you see the *sofer* did in the second line below. If you must stretch, be sure to read the section "Stretching Letters" below.

אתו ואת בניו על העץ על כן קראו לימים האכלה יב 18
פורים על שם הפור על כן על כל דבר־י חח 19
האגרת הזאת ומה ראו על ככה ומה הגיע אליהם יב 20

If you are not afraid of math, you can use this method to calculate the length of your lines in any layout. Write a sample word or two and count the yudim. Measure the length it takes up. You can then estimate how long any line will take up without having to write out each line. For example if 20 yudim take up 4 centimeters, I will know that 15 yudim will take up 3 centimeters (15/20 x 4 = 3.), and so on. I often use this method when I do not want to go to the computer. Your writing of course needs to be consistent in order to accurately predict the length of line.

On Stretching Letters

Notice how in this Hebrew manuscript several of the letters, such as the *tav* on the 3rd line and the *heh* on the 5th line, have been stretched in order to be flush left. Many Hebrew calligraphers rely on stretching letters in order to solve alignment problems. This is accomplished simply by stretching the horizontal strokes of certain letters past the "classical" proportions of the letter. It should be understood that in classic Hebrew calligraphy, it is best not to resort to the stretching of letters. Obviously, by its very nature, stretching letters disturbs the texture of our block and distorts the "proper" proportions of our letter forms. If our aim is even, optical spacing, it is much better to evenly distribute the density over the whole length of the line—slightly opening the letter and word spacing in order not to attract the eye to any one spot. (Of course in the example to the right, with only one word per line, this is not possible.) Letter stretching is thus used either as a "last resort" or sometimes as an intentional design feature. It should be noted that there is no hyphenation in Hebrew calligraphy, though Hebrew scribes have been creative in devising methods to justify their lines (see following page).

Only a few letters can be properly stretched without a serious distortion of their necessary proportions. The best letters to stretch are: *dalet, heh, chet, lamed, reish* and *tav. Khaf sofit* can theoretically be stretched and looks okay visually but this disturbs an important internal proportion of the letter (i.e. leg longer than roof) and a stretched *final khaf* is effectively just a large *reish*, so save it for emergency use only (in fact a stretched final *khaf* in a Torah is invalid for just this reason—that technically it is a *reish*). Note that only the roofs of the letters are stretched. Also note that the left legs of *heh, chet* and *tav* remain aligned with the left edge of the letter.

GENERAL ADVICE ON STRETCHING

These are my own personal observations on what looks best if there is going to be a bit of stretching in your text:

1. Stretch at the end of a line only. This is for two reasons. First, a person's eye, when initially viewing a page of Hebrew, tends to fall towards the upper right and center of a body of text. You have more of a block of unbroken, even texture when your stretching is limited to the left side. Second, it is more obvious to a reader why you have stretched a letter as you approach your left margin, and thus it doesn't break up the reading as much, whereas a stretched letter at the beginning or middle of the line has the reader wondering: why did he do that?

2. In general, it is better to stretch only one letter rather than a few, even if it means having to stretch it a lot. This is not a hard and fast rule—it would naturally depend on the degree, how many words per line and many other factors, including your ability to make a long, strong, straight horizontal.

3. Stretch a *heh, chet* or *tav* rather than a *reish* or *dalet* if you have the choice as the second stroke of the former closes in the white space, making the stretch less noticeable.

Methods used by medieval scribes for justifying text

Medieval scribes devised various creative methods to end their lines on (roughly) the same left margin. On this page you can see several:

1. Line 4: The scribe knows he will not have enough room to complete the word but begins the word anyway. He wrote the first letter and then inserted a made-up character (not a letter) to end the line. The next line begins again with the same word.

2. Line 7: Stretching the last letter. Here an unusual stretch of only the roof of final *mem.*

3. Line 9: A ligature. The last two letters, *shin* and *tav*, were simply combined into one character to save space.

4. Line 10: Here the assumption must have been that the word would be understood in context. The word should have ended with a *mem* and a *reish*. The *mem* is almost completed and the *reish* is replaced with some calligraphic marks.

5. Line 11. This is similar to the first one. The scribe continued with the first two letters of the next word, but broke up the strokes of the last letter to indicate that it is not to be read. The whole word is written anew on the next page.

Line Spacing

Line spacing, the distance one leaves between lines of writing, is one of the most overlooked topics among beginning calligraphers. And yet the line is probably the most important unit for the calligrapher to consider.

The most basic, practical purpose in choosing correct interlinear spacing is simply to aid the reader, once he or she finishes reading a line, to easily locate and continue reading the next line. An acceptable starting point is to leave space the equivalent of the body height of your letter. If the body height is 5 mm. you leave 5 mm of space. This is just a starting point however and you may need to leave a bit more or less space depending on your purpose and also the rhythm of your letter and word spacing.

The style of letter also influences interlinear spacing. For example, the prominent serifs in a script such as the Yerushalmi script enter into the white space above the line. All other things being equal you would have to leave more space between a line of Yerushalmi than say, a line of Foundational.

Example 1 shows typical line spacing; there is roughly one body height space between lines. After finishing reading one line it is easy to find the next line.

Example 2 has much tighter line spacing. This can give interesting textures graphically, but as far as readability is concerned, after finishing reading line 3 for example, one would likely need to hesitate a bit before finding the correct next line to continue reading— too little space has been left.

However, another factor also comes into play—line length. The shorter the line, the less interlinear space is necessary, as the eye has less distance to travel back to the beginning of the next line, so one can "get away with" a line spacing such as in example 3.

As a general rule, space between lines should never be less than the space between words. If the space between words is too large as compared to the interlinear space, the eye tends to move downwards rather than across. This is because of the gestalt principle of perception that we group similar units together. In the exaggerated example in 4, once one reaches the gap on the first line (after the first two words), the eye moves down to the second line rather than continuing in a horizontal direction.

4 מים רבים לא יוכלו לכבות את האהבה ונהרות לא ישטפוה
אם יתן איש את כל הון ביתו באהבה בוז יבוזו לו : אחות
לנו קטנה ושדים אין לה מה נעשה לאחתנו ביום שידבר

Thus when one looking at your work you should be aware of (beware of?) "rivers of white" (5) running down the page. This too causes a downward pattern which interferes with efficient reading.

5 אם יתן איש את כל הון ביתו
באהבה בוז יבוזו לו : אחות לנו
קטנה ושדים אין לה מה
נעשה לאחתנו ביום שידבר
בה : אם חומה היא נבנה עליה
טירת כסף ואם דלת היא ונצור

It should be remembered that the line is the most important unit in the making up a text block. Refer back to example 1 and notice how there is a clear sense of line. There is a pattern of black line of writing followed by a line of white space. Compare that with example 6 where, due to the overly generous word spacing coupled with too little line spacing the sense of line begins to be lost and the reader's eye, instead of being given a clear direction for reading, is lost in a jungle of words.

6 מים רבים לא יוכלו לכבות את האהבה ונהרות לא ישטפוה
אם יתן איש את כל הון ביתו באהבה בוז יבוזו לו : אחות
לנו קטנה ושדים אין לה מה נעשה לאחתנו ביום שידבר
בה : אם חומה היא נבנה עליה טירת כסף ואם דלת היא

We can sum up the rules of interlinear spacing thus:

The tighter the letter and word spacing, the less interlinear distance is necessary. Conversely, the looser the letter and word spacing, more interlinear space is needed.

The shorter the line, the less line space is needed. The longer the line the more space is needed.

Playing With Line Spacing to Create Graphic Interest

Aside from its practical concerns, interlinear spacing also has a purely graphic purpose. Calligraphers often use very packed line spacing to add tension and to emphasize pattern which increases visual interest to their works. This often comes at the expense of legibility, so only use when easy readability is not the prime aim of your artwork.

One of the wooden panels flanking the central ark at the Yakar synagogue, Jerusalem. Izzy Pludwinski

Josh Baum
Squashed Aleph-bet

Lynn Broide. *Hayom Harat Olam*

TEXTURES. The images on this page have been tightly cropped in order to better appreciate the different patterns in calligraphy. They were all taken from various student works at the Bezalel School.

Works are from the Shechter Collection, in the possession of the Department of Graphic Design at Emunah College. Reproduced with permission

Correcting Mistakes *

It's inevitable. You take as much care as possible, you don't rush, you check and double check, and yet, there it is, a mistake. You have no idea how it got there but the wrong letter, word (or even worse - a wrong line!) is somehow on the page and must be changed. What do you do?

Rule 1: Don't panic. Seriously, there is a tendency to try to do something right away without thinking. Have a good look at the mistake. Is it all lost? Does everything have to be "erased"? Is it only part of the letter or shape that need be redone? (For example if a *tav* was written instead of a *heh*, only the left part of the letter needs to be redone. The roof and right leg can remain).

Traditionally there are three methods for removing the offending trespasser — erasing, scratching, and peeling. Each have (or at least had) their uses .

Erasing. Sometimes, with a lot of elbow grease and patience, one can erase a mistake with a rubber eraser. Your success will depend on what medium you wrote with, and on what surface (e.g. type of paper, parchment,); you might find a combination that works. Erasers come in different grades of abrasiveness so keep trying different ones. An electric eraser, produced by Sovereign, was my savior for many years. One just had to gently caress the surface with the eraser, and on many different types of paper and parchment it would nary leave a mark. One could easily write over the erased portion and no one would know the difference. Alas, those days are over. The white erasing strips that worked so well have been discontinued by the manufacturer and to the best of my knowledge at the time of this writing, no ideal erasing solution exists for taking off ink without damaging the paper. However it is worth keeping an eye out to see if new products appear on the market.

Scratching. In this method one takes a sharp blade and very gently scratches out the unwanted mark. This is usually good for only small corrections as it is difficult not to damage the surface of the paper, which would make writing over it difficult. In this method one gently scratches the ink, changing directions often, trying to disturb the paper surface as little as possible, until the mark is gone. One can only do this if the ink has not penetrated deep into the surface of the paper. When I have resorted to this method, I often combine it with erasing, using a non-abrasive eraser, alternating scratching, erasing, scratching, erasing, etc. until the mark is gone. Once it is all taken out, the paper should be smoothed out, as fibers inevitably will have come loose. See the end of the next section on Peeling for this procedure.

Peeling. This is the method I recommend and most often use. It might look scary in the beginning but with little practice one can attain excellent results. It has the advantage over scratching in that it leaves a much cleaner and smoother

Erasing shield

Erasing

SCRATCHING. Keep the blade as perpendicular to the paper as possible. Aim to scratch only the ink and not the paper. Work in different directions.

*Correcting mistakes and touchups on work for reproduction is discussed at the end of Chapter 10, "Monoline Scripts".

Peeling with a blade. Notice the paper is curved over the edge of the table and a scrap paper is protecting the writing. This is an act where you might find your hands sweating.

surface, thus it is both less noticeable and easier to write on if you have to rewrite over the surface.

Start off with a double-edged blade. While it is still in its paper wrapper carefully break it lengthwise in two halves, making sure you do not cut your fingers in the process. Take out one half. What we want to do is gently peel off the layer of ink, cutting into the paper as little as possible. Gently fold the paper over your table edge (if your table has a sharp corner tape down a heavy paper which is folded over the table edge as you do not want to crease the paper), thus raising the section to be corrected. This will allow for easier entry of the blade. Keeping the blade as flat and as parallel to the paper surface as possible, cut into the paper ever so gently and then flatten the blade completely so that you really have only minimally penetrated the surface of the paper. Try to remove as much of the mistake as possible in one shot, as repeated entries might damage the paper. Continue peeling until you have removed the mistake completely.

If you need to rewrite over the mistake then it is a good idea to re-prepare the surface, as loose fibers might hinder sharp writing. Place a similar sheet of paper over the correction and gently rub over it with either a burnisher or bone folder or even your fingers. This should smooth out the surface. If the peeled area looks shiny and you want to add some tooth to the paper then gently rub in some powdered sandarac*.

The Mistake: In the very last word (!) of a piece, I wrote a *samech* instead of a *peh*.
This occurred because for these last two lines, which were to align flush left, I was writing backwards (from left to right). Spelling mistakes are very common when writing backwards so be especially diligent.

מוקה ובתודה מיוחדת
רכז ללימודי הסםרות

Corrected version after using the peeling method. The correction is virtually unnoticeable.

בהוקרה עמוקה ובתודה מיוחדת
המרכז ללימודי הספרות

*Sandarac is a resin calligraphers can use, in powdered form, to rub into the paper. Sandarac can give a bit of "tooth" to a very slick paper and also can sometimes prevent bleeding of the ink when the writing surface is not ideal.

Letters as Ornament

Many calligrapher/artists choose to combine illustration with their calligraphy. Very often this is done as a border surrounding the text. Border designs are often repeat patterns; they can be floral, they can be geometric. They can also be calligraphic.

You can create interesting designs for "decorating" your layouts by making patterns out of the letters. You can repeat the letters as they are and place them in interesting arrangements, or break them apart and use only parts of the letters. You might even abstract the letters until they are not so easily recognizable and use them to create patterns.

Whether you choose letter-based or illustrative patterns, thought should be given to match the style with the spirit of the text, both visually and content-wise.

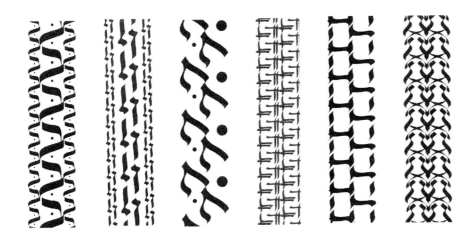

Mikdash Hayim. Book design by Eliyahu Misgav. The letter patterns were created by the designer to illuminate the text for the book — each chapter with a different design. The specific letters chosen and the way they interplay relate symbolically to the ideas present in the chapter.

In this design based on the style of
Pueblo pottery, calligrapher/artist
David Moss plays with figure-ground
relationships, here emphasizing the
negative spaces. He consciously makes
us work to recognize the letters in order
to read this quote from Psalms 105.

For the border design on this ketubah David
Moss abstracts the letter forms into simple
geometric shapes, creating this interesting
pattern. Detail below

Graphic designer Joy Rosenblum often combines the letters in creative ways to produce decorative patterns. The top row shows
different combinations of the letter *shin*. The bottom left row shows the letter *zayin,* and bottom right demonstrates a *lamed* pattern.

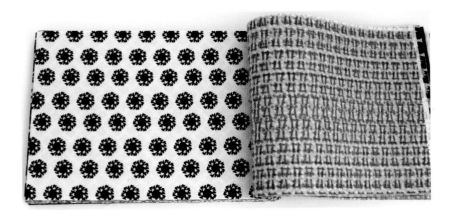

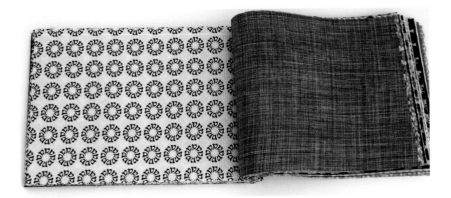

Above: Designer Yaara Baruch here applies her calligraphy to form fabric patterns. This fabric design sample book was produced for her calligraphy studies at the Department of Visual Communication at Shenkar College.

Detail of patterns. From top to bottom: *Tzadi sofit, peh, nun/nun sofit*

Oded Ezer uses the letters of his font, Frankrühliah, to create this spiderweb-like pattern for a notebook cover.

The Drawn Letter

We have been concerned throughout this book until now with *writing* letters—creating letters by writing them directly with a broad-edged pen or other similar tool. Another way to form letters is by drawing their outlines. This is usually done with a pointed instrument, such as pointed pen, pointed brush or ruling pen. The letter can then be either painted in afterwards or left as is.

Drawing letters gives one much more flexibility, as the artist has control over the shape of each outline. The outline is now not being dictated and limited by the broad-edged tool which automatically creates both contours. Some contemporary examples of this are the letters on the Yakar synagogue (p.113) or on the Ben Gurion Memorial book by Fred Pauker (p. 136).

In medieval manuscripts drawn letters were often used for large initial words. After the outlines were drawn they were often then lavishly painted in with figures or other decorative elements.

The tradition was especially revived as Jews began returning to their homeland. There was a need to revive the art of Hebrew lettering, and calligraphy was taught at the Bezalel School in Jerusalem, which was first established in 1906. Below are some examples of drawn lettering from the early 20th century.

Joseph Budko. Initial letters, 1923

Arye Alweil. Title lettering for the *Book of Ruth*.

Drawn letters for a *Haggadah*

From the Shechter Collection, in the possession of the Department of Graphic Design at Emunah College. Reproduced with permission

Above. Two works by graphic artist, illustrator and calligrapher Ismar David.
Top: Design for synagogue sanctuary. Bottom: Rendering for a wall decoration.

Drawing letters, as opposed to writing them directly, is by nature a significantly slower process, and is usually reserved for writing a small amount of text. However, this did not stop artist and calligrapher David Moss (who is often credited with being responsible for the modern revival of the art of ketubah making) from painstakingly drawing every letter on many of his ketubot.

Artist/calligrapher Josh Baum has "drawn" these creative letters with a scissor, carving out the shapes in an improvisational manner. These shapes would not be possible with direct writing.

Artists throughout the ages, such as Rembrandt, Chagall and Ardon have incorporated Hebrew letters into their works. The artist Ben Shahn in particular was fascinated by the mystical attraction of the Hebrew *aleph-bet* and the letters played a prominent role in his graphic works. Here is his painterly composition *Hebrew alphabet* .

Artist/calligrapher Sharon Binder blends her drawn letters in with the background to create this beautiful unified piece, *Or Chadash*.

Modern street artists and designers have in a sense carried on this tradition, adapting Hebrew letters to a graffiti-like style, as in these lively works by artist Dan Groover.

Above: *Achim* (Brothers), street art.

Left: Lychee. Street sign for restaurant.

Below: Expresso. Logo for coffee shop.

The digital revolution has altered the way today's lettering designers and typographers draw. They might start with hand lettering that was then scanned, or start with an existing font and manipulate the letters in a software program such as Adobe Illustrator or CorelDraw.

In font-editing and graphic programs, the outlines are manipulated by moving nodes (shown in red and green) and control vectors (in yellow). Compare their placement on the left legs of these two *tav*s.

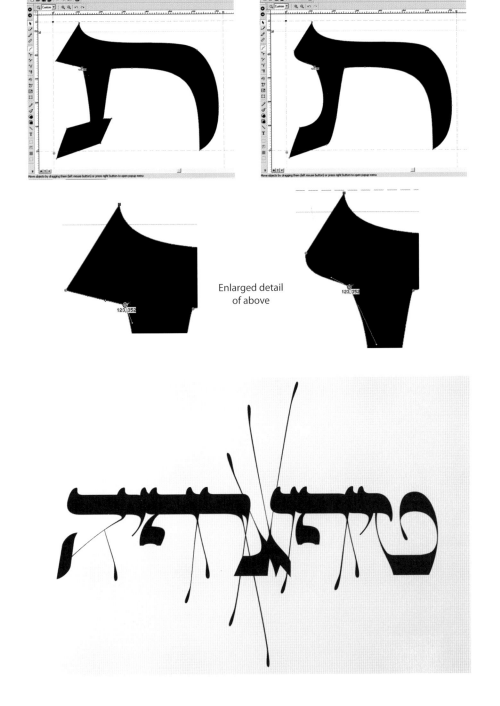

Enlarged detail
of above

Even though designing with type does not give off the same quality of human vibration as calligraphy or hand-drawn letters, there can be quite a bit of creativity in it too.

Oded Ezer is a Hebrew type-designer who incorporates a lot of play in his work. To the left is a poster designed by him based on his Frankrühliah font.

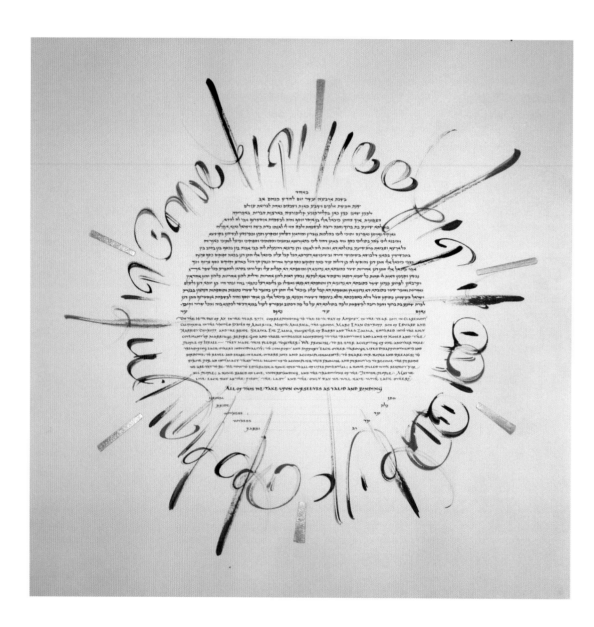

Izzy Pludwinski. *Wildscript Roundel Ketubah*

Chapter 12

Writing Around a Circle

CIRCLES CAN MAKE for strong design elements and writing around a circle is not a particularly difficult task. The one important thing to remember when writing around the circumference of a circle is that each letter is to face the center of the circle and thus all your verticals should point that way. See illustration for what could happen if you do not adjust for this.

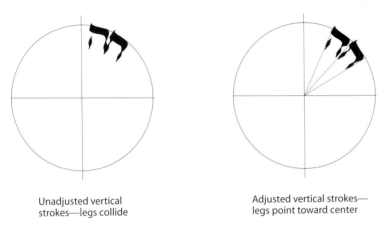

Unadjusted vertical
strokes—legs collide

Adjusted vertical strokes—
legs point toward center

If the circle is relatively large in comparison to the letter size, then you can get away with straight horizontals for the roofs of your letters. If your letters are large relative to the arc, your horizontal roofs would have to curve around the circumference. As far as the planning of the writing, again, one can take advantage of a computer using a page-layout program to easily plan it out, or rely on manual methods.

With a Graphics Software Program

With the click of the mouse you can arrange your text in a circular path. All you need to do is make sure the letter height in your font equals a comfortable height you would use with your pen. Mark off the halfway point around the circle (see following page) and print out your design. Next, on your writing paper, use a compass to rule two concentric circles as guidelines. One circle will be your top guideline. For the bottom guideline, reduce the radius of the

second circle according to your letter height. For example if the radius of your circle is 5 cm and your letter height is 1 cm, you would construct two concentric circles—one with a 5 cm radius for your top guideline, and the second one a 4 cm radius for your bottom guideline.

You can then benefit from the use of a light table to follow (copy over) the printout, or you can pencil in the letters and write over that, or—and this is what I do—just mark off in pencil the halfway point around the circle and write freely, checking against the printout at the halfway point to make sure you are on pace. It is very important in writing around a circle to keep the rhythm even, as it is the consistent texture that gives strength and beauty to the design.

Below is a text from Psalm 125: *Jerusalem is surrounded by hills, and God surrounds His people*. On the left is a computer printout of the text (using a Yerushalmi font which I designed from my own calligraphy) with a line running through the halfway point. My preference is to begin the text between the 2 and 3 o'clock position as the Hebrew reader will naturally go to the upper right side of the text to begin reading. Another reason is this leaves a large portion of the text reading upside-up at the beginning. Once I had the computer printout as a guide, I wrote the text freely (right).

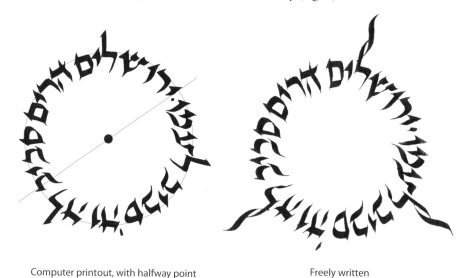

Computer printout, with halfway point
marked by line running through the center

Freely written

The Old Fashioned Way

If you do not have the advantage of using a computer program, then you will have to depend a bit on trial and error in the beginning. I would pencil sketch the letters at a size that you feel will get you all the way round, estimating the width of each letter when written with a pen. Then rule up a circle with two guidelines, changing the radius of the second circle according to your letter height (see above). Write it out and see if you make it evenly around the circle. If not then adjust either your pen size or the diameter of the circle and try again.

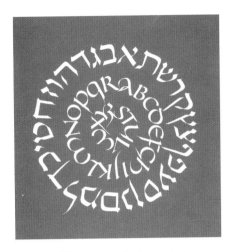

Two very different artworks demonstrating
writing in the round. Above: Lili Wronker,
Hebrew and English alphabet roundel.
Left: Michel D'anastasio. *Composition, from
Psalm 23:4*

The same method would be used to write on any curve. You can even pencil in
lines perpendicular to the line of the arc to help you orientate your letters to face
towards the imaginary center of each different arc.

Blessing over the Shabbat
candles, detail.
Calligraphy: Izzy Pludwinski
Design and parchmentcut:
Luba Bar Menachem

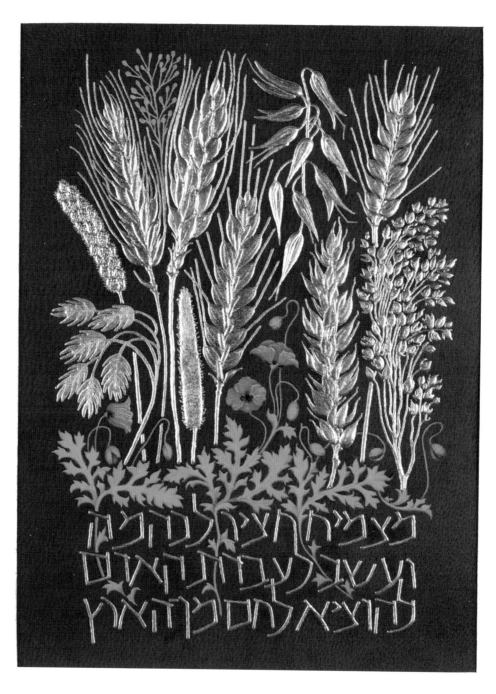

Barbara Wolff. *To Bring Forth Grass,* from Psalm 104

Chapter 13

Color & Gold

Writing with Color

THE PREFERRED MEDIUM to use in your pens in order to write lasting works in color is designer's gouache or watercolors. These usually come in tubes and are mixed with water in a palette to a texture of thick cream and brushed into your nibs just like ink. Gouache will give you rich, opaque color. On each tube should be listed a "permanence" rating for that color which tells you how lightfast it will be. A color with a low permanence grade will fade rather quickly in time and should be avoided for permanent work. Watercolors can also be used when you want a lighter, more transparent look to your letters.

Colored inks that are dye-based should be avoided as these are generally not lightfast. However, there are ever-new pigmented inks being offered on the market that claim more permanence, so by all means, experiment. Remember that if the ink dries waterproof it is essential to be vigilant in the cleaning of your pens.

Nice effects can also be had by filling the reservoir with different hues at the same time. You can keep the colors separate, filling one side of the pen with one color and the other side with a different one to get an interesting two-toned stroke. Or, by diluting the gouache a bit more, the colors can mix inside the pen to give you gradations of color as you write.

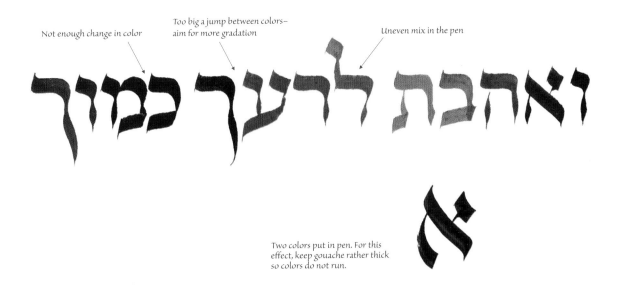

Not enough change in color

Too big a jump between colors– aim for more gradation

Uneven mix in the pen

Two colors put in pen. For this effect, keep gouache rather thick so colors do not run.

Writing with Gold

The easiest option for writing a gold color is using gold gouache. Try out different brands as they each have slightly different hues and qualities. Use the same way as you would any other gouache. Another method is to write with bronze powder (see p.189 for a listing of online outlets where such supplies may be ordered). Add a little bit to your palette plus a drop or two of liquid Gum Arabic (this is necessary in order to adhere the particles to each other and to the paper). Then add water until you get a texture similar to what you use when writing with gouache. One can also write with real 23-karat gold. Gold for writing or painting (called Shell gold) comes in small tablets to which water is added and thus its preparation is similar to gouache. Although it has its uses, this is a very expensive way to use gold. If you want to add real gold to your work, consider instead working with gold leaf.

Gold Leaf

Patent (Transfer) gold leaf

One of the properties of gold is that it can be beaten into ultra thin sheets or "leaves". 23-karat gold leaf is usually sold in booklets of 20 leaves each. The gold needs to adhere to a size—a liquid medium that has dried yet still retains some tackiness. There are traditional sizes, such as gesso, gum ammoniac and glair, and then there are more modern media, which are described below.

I will go through the steps of a very simple method of applying gold leaf. These will give satisfactory results, but those who want to replicate the unmatched medieval methods of applying leaf over gesso should refer to either the comprehensive article on gilding by Donald Jackson in *The Calligrapher's Handbook*, the well illustrated chapter on gesso gilding in *Advanced Calligraphy Techniques* by Diana Hoare, or *The Technique of Raised Gilding* by Jerry Tresser.

Materials for simple gilding:

> 1 sheet of Patent (also called Transfer) gold leaf
> One of the media mentioned below, as a size
> Pointed pen
> Pointed brush
> Relatively smooth, good quality paper or parchment
> Burnisher
> Glassine or wax paper

Burnishers
Above: Dog-toothed agate burnisher.
Below: Lipstick shaped hematite burnisher.

Size

A size is a base that the gold will ultimately adhere to. There are several "modern", ready-made media you can use as size, such as PVA glue, Talens Acrylic Medium (glossy), or Daler-Rowney Decoupage Medium, also known as Craft Seal. (An advantage of using the Daler-Rowney medium as opposed to the other media is that you can also write with it in your pen whereas the other media you must use a brush and paint it onto your drawn letter.) There are also

several media on the market that are made especially for gilding. Follow the instructions that accompany these products, as they might differ from the method described below. If the size is a clear color you might want to add to it a small amount of red or yellow gouache to help you see it better when applying.

Step by Step (Note: Always work on a flat surface when gilding.)

METHOD 1: Gilding on drawn letters

1. Draw your letter with a pencil and outline it with yellow ochre gouache. You can use either a very thin brush or a pointed pen for this (1).

2. When the gouache is dry, fill in your letter generously with the medium with a brush, making sure to cover the outline completely. (2a and b) It is important that the application be done smoothly and evenly, as this will affect the luster of the gold at the end. Clean your brush thoroughly.

3. Allow your letter to completely dry. This might take a few hours.

4. Once the medium has dried thoroughly and is hard, take a sheet of transfer gold (transfer gold is a sheet of gold that is adhered to another sheet of thin paper. It is much easier to handle and work with than loose gold sheets) and position over your letter. Press down with your finger and lightly rub (3), making sure to cover over the edges. Check the letter to make sure it is completely covered with the gold. If necessary breathe slightly onto the letter before reapplying the gold as the moisture in your breath will increase the adhesiveness of the size.

5. To increase the brilliance of the gold you will want to then burnish the letters. Burnishing polishes the letters, making them shine brilliantly. This is traditionally done with a burnisher, which is made from a very hard, very smooth substance such as agate or hematite, which is attached to a wooden handle. Rub the gold with your burnisher, either directly or through a piece of glassine or wax paper, making sure not to scratch the surface (4). Go gently at first, then gradually increase pressure till you achieve the desired brilliance. If you do not have a burnisher you can use a piece of silk to burnish with, or, lacking all of the above, even your finger. If the latter, rub only through a piece of glassine.

For comparison, figure 5 shows a letter that was gilded over a gesso size.

METHOD 2: Writing directly with the size:

As mentioned above, you can write directly by using Decoupage medium in your pen.

1. With a cheap brush, fill your nib with the medium.

2. Write the letters you want to gild (the larger your letters the easier it will be)

3. Clean your nib and brush right away before the remaining liquid dries in them. Continue from step 4 above.

133

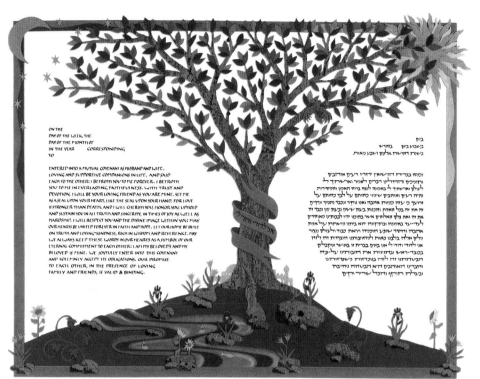

Melissa Dinwiddie. *Tree of Life ketubah*

In this ketubah Melissa Dinwiddie has separated the Hebrew and English texts by placing them on either side of the Tree of Life. Despite the separation, Melissa maintains a unity by giving both scripts a similar "color". If you slightly squint your eyes you will see a similar black/white pattern. To achieve this she has given more space to the wordier English text.

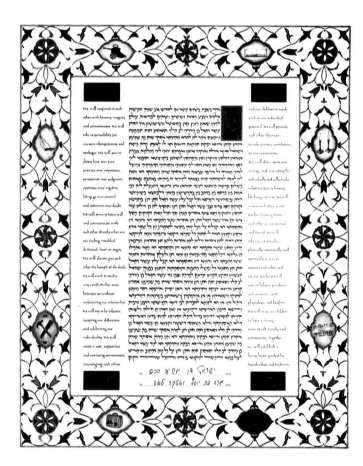

Using contrast. In this ketutbah Gina Jonas successfully contrasts the English text with the Hebrew by both making the English smaller and by changing the texture of the text block by using generous interlinear spacing. This lightens up the English and enlivens the Hebrew.

Chapter 14
Combining Hebrew with English

VERY OFTEN a Hebrew calligrapher will be called upon to write a text in both Hebrew and English. Well, let's get it out in the open. These two languages (in written form) have difficulty living in close proximity to each other, unless one of the two gets clear top billing. Let me explain.

The letter forms of the two scripts have basic differences that make combining them difficult. Traditionally, Hebrew has very strong horizontals and thinner verticals, whereas Latin scripts have strong verticals, and thinner horizontals. Also, Hebrew, in its classical proportions, is a weightier script than English. And to make matters worse, because of the different directions of writing, the two scripts often have natural forward leans that slope in opposite directions.

All this causes a visual dissonance when the two are placed in close proximity to each other. And if that were not enough, English is a wordier language than Hebrew. An English translation of a Hebrew text usually requires anywhere between 25% and 100% more words. So combining the two is often a nightmarish job for the calligrapher. But all is not lost and we will try to go through some approaches to help make it work.

The first factor you can play with is that of distance. This rule is simple enough. Just like two boys who are fighting, the farther the two texts are kept from each other the less problem of visual dissonance.

At some point though you might find yourself needing to place the Hebrew and English texts in closer proximity. You can do this one of two ways—either by contrasting the two or by unifying them. Using contrast is certainly the simpler solution and gives you some flexibility of options. There are several ways to introduce contrast:

It is the spirit of the scripts, more than anything else, that unifies the two languages in this logo for a Jerusalem restaurant. The Hebrew is set in the font Shir, developed by Izzy Pludwinski. Unfortunately the owner of the restaurant was not able to recall the name of the logo designer.

If the area taken by the two scripts needs to be equal yet there are significantly more words in the English, as in this ketubah design by Izzy Pludwinski, then something has to give. Here the Hebrew side, with its slightly larger letters, looks a bit heavier.

Izzy Pludwinski. *Quote from Orot Hakodesh* by Harav Kook. Lines were alternated, with English in a smaller size. Two hues of bronze powder were used for the two languages.

Fred Pauker. Book Jacket

1. **Size.** Choose one language as your main text—your main point of visual interest—and set the other one in a smaller size. The greater the difference in size, the less one has to worry about the disparate letter shapes of the two scripts, and the closer the two can be placed to each other.

2. **Texture**. One can utilize the difference in letter forms and weights of the two scripts to make for an interesting juxtaposition. For example, contrasting a square, weighty Hebrew with a light, flowing italic, as in Malla Carl's *Shaar Shechem* piece below.

Malla Carl. *Sha'ar Shechem* (detail). Full picture below right

3. **Color.** In the book jacket by Fred Pauker (below, left) the two languages are quite close to each other in size but by setting the Hebrew in a different color, which mutes into the background, the dangers of dissonance has been greatly reduced.

Malla Carl. *Sha'ar Shechem*

Sometimes it is not possible to use contrast, as the commission might require that the two languages be treated equally in both size and color. Trying to unify the two, giving them equal importance, is difficult and requires much thought in planning and letter design. Fred Pauker's sponsor book for Ben Gurion University (below, right) shows how well a monoline treatment of the letters can work, although the letters were drawn rather than written directly.

If serifs are to be used for either script, one ought to retain the dignity of each language's written tradition. Odd features might crop up if this is not respected. In the Hebrew typeface designed by the

Fred Pauker. *Memorial Book,* Ben Gurion University

renowned English sculptor, artist and letter designer Eric Gill, Hebrew forms are dressed up with Roman serifs. This gives the letters a peculiar look, as the added elements are foreign to the organic structure and to the tradition of the Hebrew letter.

Selected letters from *Gill Hebrew*

Here are two more designs by Fred Pauker, successfully combining Hebrew and English:

Fred Pauker. Logo for the Israel Bibliophiles

Fred Pauker. Storefront sign, Jerusalem

Malla Carl, mentioned on the previous page, is a Jerusalem artist and calligrapher who often combines Hebrew and English in her artworks. In the piece below Malla retains a similar weight and texture in the two scripts, but she has avoided any possible dissonance in a few ways. First, she did not begin the two blocks on the same horizontal line. Secondly, she made the English smaller. Thirdly, she placed the Hebrew to the left of the English, thus the reading directions in the two languages go away from, rather than towards each other.

Malla Carl. *David's Citadel*. Detail

Malla Carl. *David's Citadel*

הַתִּקְוָה

כָּל עוֹד בַּלֵּבָב פְּנִימָה
נֶפֶשׁ יְהוּדִי הוֹמִיָּה
וּלְפַאֲתֵי מִזְרָח קָדִימָה
עַיִן לְצִיּוֹן צוֹפִיָּה ·

עוֹד לֹא אָבְדָה תִּקְוָתֵנוּ
הַתִּקְוָה בַּת שְׁנוֹת אַלְפַּיִם
לִהְיוֹת עַם חָפְשִׁי בְּאַרְצֵנוּ
אֶרֶץ צִיּוֹן וִירוּשָׁלַיִם ·

Matthew L. Berkowitz. *Hatikvah Anthem* from *The Lovell Haggadah*. Calligraphy: Izzy Pludwinski

Chapter 15
Marks & Numerals

Vowels

THE LETTERS IN THE HEBREW SCRIPT are all consonants—no vowels(!) A person proficient in the Hebrew language can read a text written with only these consonants; pronunciation is inferred from the context. In Israel, newspapers and novels, for example, are written without any vowels. However, there are texts where vowels are added in order to aid in pronunciation or to avoid ambiguity, for example the Bible, prayer books, poetry and children's books. These vowels are not letters as in the Latin alphabet, but rather marks—dots and dashes—that are added to the consonants. Depending on which vowel sound it is, the vowel mark is placed either underneath* or above the letter (see below). In two instances a *vav* with a mark is added as a vowel in the body of the word.

The marks are placed centered to the letter, except in letters when there is only one leg, such as *dalet* or *reish*. In such a case the vowel would be placed centered under the leg. This is demonstrated below using *mem* and *reish* as examples.

Accents

The accent mark, or in Hebrew, the *dagesh*, can change the way a letter is pronounced. Thus the shape we learnt for *bet* will be pronounced either as a b or a v (the letter would then be called *vet*), depending on whether the letter is accented. *Peh* will be either a P sound or an F sound (and called *feih*). The accented mark is usually a dot placed inside the letter. There are complex grammatical rules dictating which letters receive a *dagesh* and when.

feih peih vet bet

*The system described here is the one in use in modern Hebrew, which is based on the Tiberian system of vocalization. Historically, there existed several other systems, such as the Eretz Yisraeli system where the vowels were placed above the letter. See illustration on following page.

Pen-made vowels marks

Vowels raised for *yud*

Penning the marks

Although in typography the dots are usually round, in calligraphy it makes more sense to use the natural shapes formed by our broad-edged pens, such as the diamond.

The marks should be readable but not overly conspicuous, so use a smaller pen for the marks, perhaps even flattening the pen angle for horizontal stokes to 45 degrees or less. Placement of the vowels should be close enough to the letter to be easily read, but not too close to "crowd' the letter. When one looks at various Hebrew manuscripts one sees variance in the "philosophy" of the placement of the *nikkud*—i.e. whether they all line up on one horizontal axis or whether they vary depending on the letter—for example raising the vowel when it appears under the short letter *yud* (see image at left).

When writing text with vowel marks, be sure to leave enough interlinear space to avoid crowding, or worse, a collision with an ascending *lamed*.

Calligraphers can choose to use the marks to enhance the look of their work. Although usually added in the same color as the letters, there is no reason not to try a different color for these marks. For artistic reasons you might want to make the marks prominent rather than inconspicuous. I suggest playing with different sizes, colors and shapes, seeing what combination best fits your purpose.

Shown below is first a sentence from a modern prayer book set in type (1). Below left is a 10th century manuscript (2) showing the Eretz Yisraeli system of vocalization which placed the vowels on top of the letters. To the right of that is a text from a 15th century Ashkenazic Haggadah (3). Notice the scribe has decided to use only very thin lines for marks, rather than dots. On the *Hatikva* anthem from the Lovell Haggadah shown on the opening page to this chapter a different color was used for the marks in order to better relate the text to the border design.

בָּרוּךְ אַתָּה יי אֱלֹהֵינוּ מֶלֶךְ הָעוֹלָם בּוֹרֵא פְּרִי הַגָּפֶן:

1 Text set in type

2 10th century manuscript—vowels are placed on top of letters

3 15th century manuscript

Numerals and Punctuation

Hebrew has its own numbering system (the "gematria" system), in which each letter has an equivalent numeric value. Thus *aleph* is 1, *bet* is 2, *gimmel*, 3, etc. until *yud* which is 10. Eleven is denoted by combining the *yud* (10) and *aleph* (1) and would be written: י״א , 12 would be י״ב, and so on.

ת	ש	ר	ק		צ	פ	ע	ס	נ	מ	ל	כ	י		ט	ח	ז	ו	ה	ד	ג	ב	א
400	300	200	100		90	80	70	60	50	40	30	20	10		9	8	7	6	5	4	3	2	1

Hebrew dates (i.e. the date according to the Hebrew calendar) are written in all-Hebrew characters. For example, the Hebrew date, the 22nd of Tishrei 5771 would be written:

כ״ב תשרי, תשע״א

1	70	300	400		2	20

(The 5000 is often omitted in the date. When it is written in full it would be written as below, with the first *heh*-plus-apostrophe standing for the 5000.)

ה׳ תשע״א

5000

There might be times, though when you will need to combine "regular" (Arabic) numerals with Hebrew characters. It is not simple to have these match but we must try as best we can. Try keeping the pen angle as close as possible to that of your Hebrew script.

1 2 3 4 5 6 7 8 9 0

Punctuation, such as periods and commas, can be made with the same size pen. Use a diamond shape for a full stop. You can place the period in the middle of the body height rather than on the baseline. Other possibilities are two diamond shapes, one on top of the other or even a triangle of diamond shapes. Commas and apostrophes can be a simple shape made by sliding the pen across its edge. There are no hard and fast rules—it all depends on what fits your purpose.

היה באוגוסט, 1954•

היה באוגוסט, 1954:

היה באוגוסט, 1954

Nava Shoham. *Halleluya Ketubah*

Laya Crust. *Abstractions 2 Ketubah*

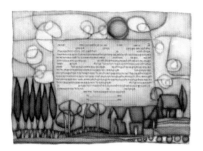

Stephanie Adler. *Telemachus ketubah*

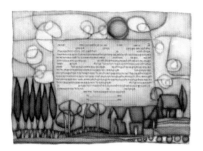

Rachel Deitsch. *Idyll Ketubah*

Chapter 16

The Ketubah

ONE OF THE MOST POPULAR commissions for a Hebrew calligrapher is writing a ketubah. A ketubah (ketubot in plural, k'suva in Ashkenazic pronunciation) is a wedding contract. It was instituted by the rabbis as a means for protecting the wife at a time when husbands were taking things too lightly and divorcing their wives with too much ease. The traditional ketubah protects the woman's rights by imposing a serious sum of money to be paid by the husband in the event of divorce or by his inheritors in the event of his passing away.

Ketubah texts fall into three major categories—Orthodox, Conservative, and Egalitarian/Reform. (In Israel, the longer *Rabbanut* text is used, which has both Ashkenazic and Sephardic versions.) The Orthodox text has basically remained unchanged since Talmudic times. Its language is mostly legal, and it is one-sided in that it lists the obligations of the husband toward the wife. In length it is around 270 words. Its language is a combination of Hebrew and Aramaic.

The Conservative text is very similar to the Orthodox. It is slightly more egalitarian in content (the groom "acquires" the bride and the bride "acquires" the groom). The biggest difference though is that the Conservative text includes the Lieberman Clause, which expresses the right of either party to demand the other to appear before a rabbinic court in the event that civil divorce proceedings occur. This is an attempt to prevent the horrible situation of the *agunah*, a woman who has not received a *get* (religious divorce), without which, according to Jewish law, she cannot remarry. The length of the Conservative text is approximately 360 words.

Egalitarian ketubot come in all shapes and sizes. There is no one authorized text. One can find many examples of texts on the internet (if you plan on copying a text, please be careful to respect copyright laws when applicable). Often couples compose their own texts. These usually emphasize the emotional commitment the couple vows to each other. These texts are usually written in both Hebrew and English.

In Orthodox and Conservative ketubot, strict laws apply regarding the wording of the texts. It must be said that one of the biggest nightmares for the Hebrew calligrapher is dealing with rabbis who make ever-increasing demands on the requirements for these texts. This is not the proper venue for me to vent my opinions on some of these demands. Let it suffice to say that each rabbi has his (and her) quirks and the best way to avoid awkward situations is to have the rabbis give you the exact text they want. There is no one standard accepted-across-the-board text. Even within the Orthodox text there are many, many

words which one rabbi will want spelled one way and another rabbi will demand be spelled another way. I have written hundreds of ketubot, and rabbis still manage to surprise me with new and unusual demands. So my suggestion is to either request from the rabbi a copy of the exact text he wants, or you provide a filled out text for him to either approve or suggest changes if not to his approval. Nobody wants to reach the awkward situation where, at the wedding ceremony itself, the rabbi declares the ketubah invalid.

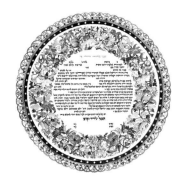

Amalya Nini. *Shibolim Ketubah*

Orthodox and Conservative Texts—Getting the Information

Below is the questionnaire I ask couples to fill out. This information will be "plugged" into the appropriate places in the texts. If you can get the rabbi to give you an authorized text with the personal information already filled out by him that is the best situation. If not you will have to fill in the information. Following the questionnaire is a detailed guide how to place this information in the ketubah text.

Ray Michaels. *My love My Friend Ketubah*

KETUBAH INFORMATION QUESTIONNAIRE

1. Date of wedding, and will ceremony be before or after sunset?

2. City and State or District (and sometimes County or Continent) where wedding will take place (ask if the rabbi wants the country or continent to be added or not)

3. Groom's Hebrew first name and middle (if any) names

4. Groom's father's Hebrew first name and middle (if any) names

5. Bride's Hebrew first name and middle (if any) names

6. Bride's father's Hebrew first name and middle (if any) names

7. Will the mothers' names be included in the ketubah? (Usually only the bride and groom's father's names are mentioned and not the mother's. However, sometimes, if the couple wants the mother's name mentioned the rabbi will allow it, so if yes, please check with the rabbi first if this is acceptable to him).

 If yes: Groom's mother's name(s):
 Bride's mother's name(s):

Sivia Katz. *Marbled Dodi Li Ketubah*

8. Will family names be included in the ketubah? (Traditionally, family names are not mentioned in the ketubah but lately this is changing. Please check with the rabbi whether he wants/permits it). Include spellings if possible)

 If yes: Groom's family name
 Bride's family name

9. Is this the bride's first marriage? (if not, divorced? widowed?)

10. Is the bride a convert?

11. Are the parents alive?

12. Are any of the fathers *kohanim* or *levi'im*?

13. If the text is Orthodox or Conservative then please ask the Rabbi whether the leg of the letter *kuf* in the word *u'knina* should be written in or omitted.

14. If any names are not common, especially Yiddish names, then please include a spelling in English characters for the name (e.g. Shayna—*shin, yud, yud, nun, ayin*).

Nishima Kaplan. *Love Song Ketubah*

Filling-in the Information—Orthodox and Conservative Texts

The information you just gathered via the questionnaire is now plugged into the appropriate areas in the ketubah. Below are the Orthodox and Conservative texts. The numbers in the blanks correspond, point by point, to the numbers in the descriptive notes which follow on the next pages. Referring to that will help you know what to write and what to look out for. But remember, no matter how authorized the version, some rabbis will want certain words spelled differently so double and triple check, and get a confirmation for the text and the personal information before you start writing.

*Sample Orthodox text**

ב __1__ בשבת __2__ לחדש __3__ שנת חמשת אלפים ושבע
מאות __4__ לבריאת עולם למנין שאנו מנין כאן __5__ איך
החתן __6__ בן __7__ אמר להדא __8__ , __9__ בת
__10__ הוי לי לאנתו כדת משה וישראל ואנא אפלח ואוקיר ואיזון
ואפרנס יתיכי ליכי כהלכות גוברין יהודאין דפלחין ומוקרין וזנין ומפרנסין
לנשיהון בקושטא ויהיבנא ליכי __11__ דחזי ליכי
__12__ ומזוניכי וכסותיכי וספוקיכי ומיעל לותיכי כאורח כל ארעא
וצביאת מרת __9__ , __8__ דא והות ליה לאנתו ודן נדוניא דהנעלת ליה
__13__ בין בכסף בין בזהב בין בתכשיטין במאני דלבושא בשימושי
דירה ובשימושא דערסא הכל קבל עליו __6__ חתן דנן
ב __14__ זקוקים כסף צרוף וצבי __6__ חתן דנן והוסיף לה מן דיליה
עוד __14__ זקוקים כסף צרוף אחרים כנגדן סך הכל __15__ זקוקים כסף
צרוף וכך אמר __6__ חתן דנן אחריות שטר כתובתא דא נדוניא דן
ותוספתא דא קבלית עלי ועל ירתי בתראי להתפרע מכל שפר ארג נכסין
וקנינין דאית לי תחות כל שמיא דקנאי ודעתיד אנא למקנא נכסין דאית
להון אחריות ודלית להון אחריות כלהון יהון אחראין וערבאין לפרוע
מנהון שטר כתובתא דא נדוניא דן ותוספתא דא מנאי ואפילו מן גלימא
דעל כתפאי בחיי ובתר חיי מן יומא דנן ולעלם ואחריות וחומר שטר
כתובתא דא נדוניא דן ותוספתא דא קבל עליו __6__ חתן דנן
כחומר כל שטרי כתובות ותוספתות דנהגין בבנת ישראל העשויין כתקון
חז"ל דלא כאסמכתא ודלא כטופסי דשטרי (וקנינא) מן __6__ בן
__7__ חתן דנן למרת __9__ בת __10__ ,
__8__ דא על כל מה דכתוב ומפורש לעיל במנא דכשר למקניא ביה

The word "u'knina" ←
(see page 147)

והכל שריר וקים

נאום עד
נאום עד

* Official text of the Rabbinical Council of America

Sample Conservative text—*
with the Lieberman clause highlighted in yellow.

ב __1__ בשבת ב __2__ לחדש __3__ שנת חמשת אלפים ושבע מאות __4__
לבריאת עולם למנין שאנו מונין כאן __5__ איך החתן __6__ בן __7__ אמר
לה להדא __8__ __9__ בת __10__ הוי לי לאנתו כדת משה
וישראל ואנא אפלח ואוקיר ואיזון ואפרנס יתיכי ליכי כהלכות גוברין
יהודאין דפלחין ומוקרין וזנין ומפרנסין לנשיהון בקושטא, ויהיבנא
ליכי __11__ דחזי ליכי __12__ ומזוניכי וכסותיכי וספוקיכי ומיעל
לותיכי כאורח כל ארעא וצביאת מרת __9__ __8__ דא והות ליה לאנתו
לאשתתופי עמיה בצוותא לקיימא ית ביתייהו באהבה ובאחוה בשלום
וברעות כמנהגא דנשי יהודאן ודין נדוניא דהנעלת ליה __13__ בין בכסף
בין בזהב בין בתכשיטין במאני דלבושא בשימושי דירה ובשימושא
דערסא הכל קבל עליו __6__ חתן דנן ב __14__ זקוקים כסף צרוף וצבי
__6__ חתן דנן והוסיף לה מן דיליה עוד __14__ זקוקים כסף צרוף אחרים
כנגדן סך הכל __15__ זקוקים כסף צרוף. וכך אמר __6__ חתן דנן אחריות
שטר כתובתא דא נדוניא דין ותוספתא דא קבלית עלי ועל ירתאי
בתראי להתפרע מכל שפר ארג נכסין וקנינין דאית לי תחות כל שמיא
דקנאי ודעתיד אנא למקנא, נכסין דאית להון אחריות ודלית להון
אחריות כלהון יהון אחראין וערבאין לפרוע מנהון שטר כתובתא דא
נדוניא דין ותוספתא דא מנאי ואפילו מן גלימא דעל כתפאי, בחיי ובתר
חיי מן יומא דנן ולעלם ואחריות וחומר שטר כתובתא דא נדוניא דין
ותוספתא דא קבל עליו __6__ חתן דנן כחומר כל שטרי כתובות
ותוספתות דנהגין בבנות ישראל העשוין כתקון חז"ל וצביאו מר __6__
חתן דנן ומרת __9__ __8__ דא דאן יסיק אדעתא דחד מינהון לנתוקי
נישואיהון או אן איתנתוק נישואיהון בערכאות דמדינתא דיכול דין או
דא לזמנא לחבריה לבי דינא דכנישתא דרבנן ודבית מדרשא דרבנן
דארעתא דקיימא או מאן דאתי מן חילה וליצותו תרוייהו לפסקא
דדיניה בדיל דיכלו תרוייהו למיחי בדיני דאורייתא דלא כאסמכתא
ודלא כטופסי דשטרי (וקנינא)מן מר __6__ בן __7__ חתן דנן למרת __9__
בת __10__, __8__ דא ומן מרת __9__ בת __10__ דא למר __6__ בן __7__
חתן דנן על כל מה דכתוב ומפורש לעיל במנא דכשר למקניא ביה

The word "u'knina"
(see page 147)

והכל שריר וקים

נאום _____ עד

נאום _____ עד

*Official text of the Rabbinical Assembly

The numbers beginning each section here refer to the numbers set in the blanks in the ketubah texts on the preceding pages.

1. The Hebrew day of week. Note that the Hebrew day of week changes after sunset. So a Saturday night wedding is considered "Sunday" and one writes באחד, literally the first day.

Saturday night or Sunday: באחד
Sunday night or Monday: בשני
Monday night or Tuesday: בשלישי
Tuesday night or Wednesday: ברביעי
Wednesday night or Thursday: בחמישי
Thursday night or Friday: בששי

2. Day of the month. The important thing to remember is that the Hebrew date changes at sunset. For example the 12th day of the month of *Kislev* changes to the 13th of *Kislev* at sunset. It is therefore crucial that you find out if the wedding ceremony will take place before or after sunset. (If it is close, you should consult their rabbi). As far as writing in the date, for days one to nine of the month, you write ימים after the number. (For example, the ninth day of *Kislev* would be written תשעה ימים לחודש כסלו. For days 10–30 of the month, use the word יום —for example בארבעה עשר יום. If the date comes out on the first of the month, on *Rosh Chodesh* (the New Moon), for example the first of Shevat, one would write באחד לחודש שבט. Sometimes there are two days to the Hebrew New Moon, the 30th of the previous month and the first of the new month. If, for example, the wedding falls on the 30th of Nisan (which is also the first day of the New Moon of Iyar) then the text would read:
בשלושים יום לחודש ניסן שהוא א׳ דראש חודש אייר

3. Hebrew month. For חשון sometimes the rabbi will want מרחשון, and for אב sometimes the rabbi will want מנחם אב, so be sure to ask.

4. Year. The formula for the year is חמשת אלפים ושבע מאות ו ____ and the exact year is filled in. It is in the female form so for example, for the year 5771 you would write ושבעים ואחת .

5. Where wedding will take place: City (and State if in the U.S.). Rabbis sometimes have their own ways to spell the city and state so please make sure you have correct spellings. Some rabbis will ask to add the name of the country, and some rabbis will want the continent added (for U.S. and Canada אמריקה הצפונית). To complicate matters some rabbis demand an Aramaic or Yiddish spelling for America, e.g. אמריקא.

6. Groom's first (and middle) names. Be sure to have the exact Hebrew spelling.

7. Groom's father's first (and middle) names. Be sure you have the exact Hebrew spelling. If the father is a *kohen* or *levi*, it is added after the name: e.g. אהרן הכהן. Regarding mother's names and family names see below.

8. For bride's first marriage: בתולתא
 If divorced: מתרכתא
 If widowed: ארמלתא
 If convert: גיורתא

Sometimes a general word is used instead of גיורתא such as כלתא (bride) or איתתא (woman).

9. Bride's first (and middle) names. Be sure you have the exact Hebrew spelling.

Archie Granot. *Shalev ketubah*

10. Bride's father's first (and middle) names. Be sure you have the exact Hebrew spelling. If the father is a *kohen* or *levi* it is added after the name: e.g. אהרן הכהן.

11. For bride's first marriage: מהר בתוליכי כסף זוזי מאתן
 If divorced: כסף מתרכתיכי זוזי מאה
 If widowed: כסף ארמלתיכי זוזי מאה
 If convert: כסף זוזי מאה

12. For bride's first marriage: מדאורייתא. All others: מדרבנן

13. If bride's father is alive: מבי אבוה
 For convert: skip
 If bride's father is deceased: מבי נשא

14. For bride's first marriage: מאה. All others: חמישים

15. For bride's first marriage: מאתים. All others: מאה

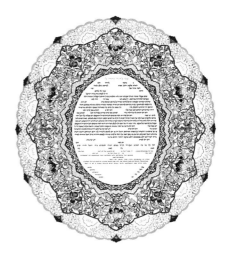

Amalya Nini. *Wild Irises ketubah*

Additional Notes

On the word וקנינא: There is a word toward the end of the ketubah, וקנינא (pronounced *u'knina*—circled in red on the sample Orthodox and Conservative texts shown above) that some rabbis (usually only in the U.S.) want either the whole word or part of the word left out, to be filled in by the rabbi at the time of the signing of the ketubah by the witnesses. Most rabbis will ask that you to omit only the leg of the letter *kuf* in that word.

kuf with leg taken out

On the inclusion of family names: There is no definite rule on this. Some rabbis will require family names; some will (for some strange reason) forbid it. If it is included, it comes after the father's (or mother's) name in the form of : למשפחת—for example: רון בן דוד למשפחת גולדברג

In Israel (where family names are required) often the word לבית is used before mentioning the bride's family name instead of the word למשפחת. For example, רחל בת משה לבית דגני

On the inclusion of the mother's names: Traditionally, only the bride and groom's fathers' names were written in the ketubah, not the mothers'. However, couples are more and more frequently asking to have the mothers' names included too. Again, each rabbi will have his opinion on this and should be consulted.

The Ending of the Ketubah:

The ketubah in Orthodox and Conservative texts ends with the words והכל שריר וקים—(and all is well and valid) though some rabbis request it to read הכל שריר וקים (without the initial *vav*). These words are often written larger and centered on the page. Some strict rabbis do not want there to be any open space between these larger words and the edges of the text, in order that no words can

be dubiously added after the signing of the ketubah, thus changing the meaning of the contract. They might then demand that the empty space be filled in with decoration, or the words stretched to fill the line.

After these words come the signature lines. In Orthodox and Conservative

אחריות שׁטר כתובתא דא נדוניא דן ותוספתא דא קבלית עלי ועל ירתי בתראי להתפרע מכל שׁפר ארג נכסין וקנינין דאית לי תחות כל שׁמיא דקנאי ודעתיד אנא למקנא, נכסין דאית להון אחריות ודלית להון אחריות כלהון יהון אחראין וערבאין לפרוע מנהון שׁטר כתובתא דא נדוניא דן ותוספתא דא מנאי ואפילו מן גלימא דעל כתפאי, בחיי ובתר חיי מן יומא דנן ולעלם ואחריות שׁטר כתובתא דא נדוניא דן ותוספתא דא קבל עליו רפאל יוסף חתן דנן כחומר כל שׁטרי כתובות ותוספתות דנהגין בבנות ישׂראל העשׂויין כתקון חכמינו זכרונם לברכה דלא כאסמכתא ודלא כטופסי דשׁטרי ולדוּנא מן רפאל יוסף בן אליהו צבי חתן דנן למרת פנינה שׂרה חיה בת ברוך שׁמואל הלוי בתולתא דא על כל מה דכתוב ומפורש לעיל במנא דכשׁר למקניא ביה,

Flourishes added to fill the line ⟶ הַכּל שָׁרִיר וקַיָּם

נאוּם _____ עֵד

נאוּם _____ עֵד

ketubot only the two witnesses sign the Hebrew ketubah. (In Israel the groom also adds his signature.) In Orthodox and most Conservative ketubot the bride does not sign, since the ketubah text lists the obligations of the groom to the bride. Again, make sure you do not leave excessive space between the signature lines, nor between the signature lines and the words above it or you might hear from the rabbi. The signature lines are usually written with the word נאם (or נאום) written on the right side, then space for the signature (you can lightly pencil in space for the signature) and then the word עד written in, so the two witness lines will look like this:

נאום _____עד

נאום _____עד

In British ketubot sometimes the word *ne'um* is omitted. Consult with the rabbi.

Sometimes the couple will want to add an English text. See below for a discussion how to incorporate this into the ketubah.

Egalitarian Text

As mentioned above, there is no official Egalitarian/Reform text and dozens of different examples exist, with couples often composing their own text. Often the ketubah text is in two languages with the Hebrew text appearing first followed by a translation, or they are arranged side by side. In the Hebrew part, the couples' Hebrew names are used and in the English the English names are used. Since there are no strict laws here, couples can choose what information they want to include. However it is recommended that this too should be decided in conjunction with their rabbi or officiant. In egalitarian texts the bride, groom and rabbi (or officiant) sign in addition to the two witnesses, so you have five signature lines. The signature lines often appear only once, after all the texts have been written.

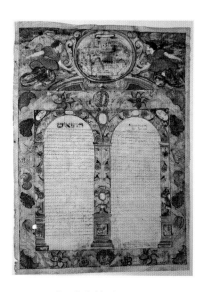

Ketubah, Venice, 1693
Image courtesy of The Library of
The Jewish Theological Seminary

One possible arrangement for signature lines of an egalitarian text:

BRIDE	_____	כלה
GROOM	_____	חתן
WITNESS	_____	עד
WITNESS	_____	עד
RABBI	_____	רב

English

A couple might request that an English text be added to the ketubah. In Orthodox and Conservative texts this is usually not a translation of the Hebrew/Aramaic text, which is quite legal in its formulation; rather it is one that stresses the emotional commitment the couple pledges to each other. If it is an Orthodox ceremony ask the rabbi if he has any objections or requirements for incorporating English text and signature lines into the ketubah document. In any case, for both Orthodox and Conservative ketubot, the English text should appear after the witnesses sign the Hebrew and may include separate signature lines of its own. In Conservative ketubot, the bride, groom and rabbi (or officiant) might sign this English part, in addition to the two witnesses, so you have five signature lines for the English text, in addition to the two for the Hebrew/Aramaic text. For Egalitarian texts you often find only one set of signature lines (bride, groom, two witnesses, and rabbi or officiant) which appear after both languages have been written. You might have the titles of the signees in English on the left, and in Hebrew to the right of the signature lines, giving the option for the signees to sign in whatever (or both) languages they decide.

Designing the Ketubah

Now that you have all the information it is time to plan out the actual writing of the ketubah. This chapter will help you plan out the text block. You can of course choose afterwards to decorate the ketubah with some artwork, perhaps a border design around the text block. But whether you begin with your artwork or with the text block it will help to know what area the text block will take up.

In general there are no regulations regarding the size of a ketubah. Regarding the shape of the ketubah however, Orthodox and some Conservative rabbis will require that the text area fit into a clearly defined geometric shape, such as a rectangle, square, circle, or oval. Rabbis are concerned that if the shape is too free and undefined, extra words could be dubiously added after the signing which would alter the content, and the ketubah is, after all, a contract.

I suggest starting with a simple rectangular shape for your first ketubah, as planning out a shape such as a circle or oval is significantly more difficult, unless you are computer savvy and have a good graphics program that works well in Hebrew. Here I will discuss the designing of an Orthodox ketubah in simple rectangular shape. I will discuss two methods—for those with a computer graphics program and those without.

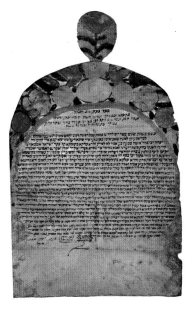

Ketubah, Algiers, 1832
Image courtesy of The Library of
The Jewish Theological Seminary

(Note: If your ketubah text will be in the form of a simple rectangular shape, you might be able to plan your page in a word processing program such as Microsoft Word, but you will have fewer options to vary spacing and font sizes)

Using a Graphics Program
(such as CorelDraw or Adobe Illustrator, ME version):

With the advent of the computer age, the planning out of a ketubah text, which in the past took at least several hours and consisted of counting words and letters and producing piles and piles of trials, can now be designed in a matter of minutes.

First, write about three lines of the ketubah text in the script and size you plan to use, choosing an interlinear spacing that looks right. You should feel comfortable lettering at this size and be able to write it fairly consistently. A good starting point might be using a 1½ mm nib. Take one line of your writing and measure the horizontal distance your line of writing takes up. Measure your interlinear spacing. You now have enough information to feed into your program. Type in the sentence (using any font) you just practiced. Adjust the font size and font spacing till it matches the horizontal distance your actual writing took up. In your software program adjust the leading (interlinear spacing) to match that of your writing trial. Now apply those parameters to the entire ketubah text. (The first time you do this you will have to type in the entire text. Once it is in the computer you will be able to lay out your text in minutes.) The program now gives you the width and length of the text block. You can easily vary these to give you the proportions you want for your text block. You want to "force justify" your lines, meaning all your lines, including the last one, should be aligned to both the left and right edges. Check to make sure you do not have too few words left over on your last line. You want your last line to be just as filled out as your other lines. Adjust accordingly.

Sometimes you are given a predefined space and must fit your text into that space. In such a case you need to work backwards. You would plug the ketubah text into your program and adjust the size of font, the letter and word spacing, and interlinear spacing, until the text fills your given area. You then write at a size and rhythm that matches the font. Of course you must still follow all the rules for the proper composition of a text block. You cannot have poor spacing just to match the computer layout. One often has to try a few combinations of size and spacing until it works. The computer is a big help but it is not a replacement for intelligent decision making.

Once you have the text fully and properly arranged, print it out and draw a vertical line down the exact center of the text block in pencil (or do this in your program before you print out). This will serve as a guide when writing so you can check at the halfway point of each line if you are "on pace" to finish the line properly. If you find you are too much ahead of pace or too much behind you can slightly adjust your spacing so you can finish the line properly. If you are too off and see that you cannot easily end the line where you are supposed to, you might need to send a word to the next line. If this happens go back to your computer, redesign the text block, print out the new text layout and continue.

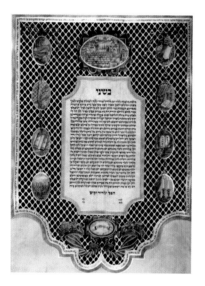

Parchment-cut ketubah. Artist: Luba Bar-Menachem. Calligraphy: Izzy Pludwinski

מרת בתיה כלתא דא והות ליה לאנתו ודן נדוניא דהנעלת ליה בבי נשא בין בכסף
בין בזהב בין בתכשיטין במאני דלבושא בשימושי דירה ובשימושא דערסא הכל
קבל עלוי אליהו חתן דן בחמישים זקוקים כסף צרוף וצבי אליהו חתן דן והוסיף
לה מן דיליה עוד חמישים זקוקים כסף צרוף אחרים כנגדן סך הכל מאה זקוקים
כסף צרוף וכך אמר אליהו חתן דן אחריות שטר כתובתא דא נדוניא דן ותוספתא

◄ Detail of a copy sheet, laid out in CorelDraw with a font I created based on my calligraphy, and printed out with centered line marked in red. Note: For layout purposes it does not really matter what font you use.

מרת בתיה כלתא דא והות ליה לאנתו ודן נדוניא דהנעלת ליה בבי נשא בין בכסף
בין בזהב בין בתכשיטין במאני דלבושא בשימושי דירה ובשימושא דערסא הכל
קבל עלוי אליהו חתן דן בחמישים זקוקים כסף צרוף וצבי אליהו חתן דן והוסירה
לה מן דיליה עוד חמישים זקוקים כסף צרוף אחרים כנגדן סך הכל מאה זקוקים
כסף צרוף וכך אמר אליהו חתן דן אחריות שטר כתובתא דא נדוניא דן ותוספתא
דא קבלית עלי ועל ירתי בתראי להתפרע מכל שפר ארג נכסין וקנינין דאית לי
תחות כל שמיא דקנאי ודעתיד אנא למקנא נכסין דאית להון אחריות ודלית להון
אחריות כלהון יהון אחראין וערבאין לפרוע מנהון שטר כתובתא דא נדוניא דן
ותוספתא דא מנאי ואפילו מן גלימא דעל כתפאי בחיי ובתר חיי מן יומא דנן ולעלם

Planning a Ketubah Text Manually

There is a reason a scribe is called in Hebrew a *sofer*—literally, a counter. Begin by writing a practice sentence of 10 words at the size you plan on writing. An average word in a ketubah is approximately 4½ letters, so your practice words should be close to that average. You can use this text if you want:

בשלישי בשבת בתשעה ועשרים יום לחדש סיון שנת חמשת אלפים

Measure the length of the line that the above sentence takes up with your writing. Let's say those 10 practice words measures a length of 14 cm. If you decide to have your line length on the actual ketubah 14 cm, then you would average 10 words per line. Considering there are approximately 270 words in an Orthodox ketubah (but do count your exact total as each ketubah text will vary slightly depending on the personal information) your ketubah would then take up 27 lines of text. (Note that in the Conservative text there are about 360 words.) Decide on your interlinear space by writing a few practice lines and seeing what looks right. You should leave at least the space of the body height of your letters between lines, often more. Once you know that, you can easily calculate the height of your text block. For example if your letter height is 3 mm and the interlinear space is 5 mm then each line will take up 8 mm. The height of your text block will be 27x 8 mm = 216 mm or 21.6 cm (actually it will be 21.1 since the last line is only 3 mm, as there is no 5 mm of interlinear space after it). Your text block would then come out to 14 cm wide and 21.1 cm tall.

All this is of course an approximation and I would do several checks (counting words) along the way to make sure I am keeping pace with my calculations. The more experience you have the more accurate your estimates will be. In the beginning allow yourself a lot of room for error in your planning.

◄ Detail of the actual ketubah, with centered line marked in pencil. When I reach the center line in the original, I compare with the copy sheet (top image) to see if I am on pace or if there is a need to condense or open up the spacing.

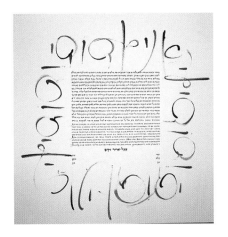

Izzy Pludwinski. *Wildscript square ketubah*

Of course before you start, if you are not happy with the expected rectangle shape you can always change the proportions. You may decide to make your rectangle narrower and taller—say only 9 words per line. You would then measure the length of 9 words and figure on 30 lines (270 words divided by 9 words per line = 30). Or you might decide to have a very wide text block, with 15 words per line for example. You would then have only 18 lines of writing, and so on.

These calculations help you prepare the text block till the last 3 words of your ketubah, *V'haKol Sharir V'Kayam*—והכל שריר וקים. For the treatment of this ending and how it may be designed, including the signature lines, see the "Ending of the Ketubah" section above. But for our purposes, if you want to estimate the extra space needed for the ending (והכל שריר וקים plus two witness lines), you can count on approximately the equivalent five extra lines of writing (if there are only two signatures); but this will vary depending on how large you make the words והכל שריר וקים and how many signature lines there will be (see image below).

Of course if you are going to add English you must plan for this too. I would work in the same manner. Count the number of words in the text, write at least 10 practice words (of average length) and measure its linear distance, decide on the interlinear distance and do the calculations.

Fully written out ketubah, Orthodox text, in rectangular shape, with space left for an enlarged initial letter to be gilded. Calligraphy: Izzy Pludwinski

Space left for an enlarged, initial letter, to be gilded

The "ending" adds about the equivalent of 5 extra lines of writing.

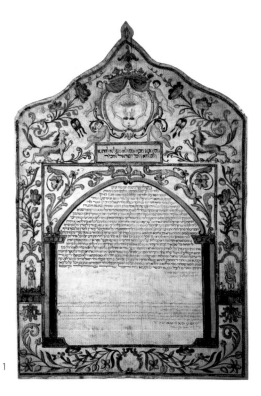

1

2

3

4

Images courtesy of The Library of The Jewish Theological Seminary

Above is a selection of ketubot from previous centuries. Italian ketubot have the reputation of being the most ornate, and in (1) you see an example from Ancona, Italy, dated 1811. Ketubot though can also be "decorated" utilizing only the letters, as in this Mantuan ketubah (2) from 1802. I love the informality of the writing in this 1804 Kurdish ketubah from Amadiyah (3). In (4), from Venice, notice the manuscript contains not only the ketubah text which is on the right column, but also the *tna'im*—the engagement agreement, on the left.

Detail from the first column of a *Megillat Shir HaShirim* (Song of Songs).
Illumination and parchment-cut: Luba Bar Menachem. Calligraphy: Izzy Pludwinski

154

Chapter 17

The Art of the Sofer

'SAID RABBI MEIR: When I visited Rabbi Yishmael he asked me : "My son, what is your profession?" A scribe, I answered. He said to me: "Be careful in your work for your work is the work of heaven and should you leave out one letter or add one letter you can destroy the whole world". From here it should be seen that a scribe should be God fearing, for if he errs, it is as if he is stealing from the public, blessings are said in vain and commandments will not be fulfilled…but he who writes a good and valid *Torah, t'fillin* and *mezuzah*, his reward is multiplied and multiplied.' (Quoted from the Talmud in the opening paragraph of the *Keset HaSofer*, one of the standard books teaching the laws of becoming a scribe.)

One can see from the above quote how serious the profession of the scribe is, for the community will be dependant on the scribe's honesty and talent to provide it with kosher (literally "fitting") religious articles. The Hebrew scribe is called a *Sofer STaM*. *Sofer* meaning a scribe (literally one who counts), and *STaM* being an acronym for *Sefer Torah, Tfillin* and *Mezuzot*—the three most important articles written by the scribe. There are hundreds of laws prescribing everything regarding the writing of these objects—including what material they are to be written on, the ink used, who may write, the scribe's intention, writing God's name, and dozens and dozens of laws explaining how to write each letter correctly. It is beyond the scope of this book to go into the details of each letter, but more than that, the art of the scribe is a serious matter and anyone who is interested in learning this skill should seek out a qualified teacher to personally learn from. I will only describe here the parts of this craft/art/profession that have relevance to the calligrapher in general.

Detail from a *Megillat Esther* in Ashkenazic STaM script

Sample of Sephardic STaM script taken from a Torah scroll from Baghdad

The Script

אבגדהוזחטיכלמנסעפצקרשת רמ ן ף ץ

As mentioned above, there are dozens of laws prescribing how to write each letter. One detail missing on one letter and an entire Torah scroll can be invalidated. There are two major traditions of STaM script (also known as Ashurit), the Ashkenazic and the Sephardic. They are similar to, but not identical to, the corresponding medieval scripts discussed in previous chapters. In order to write them properly one ought to use the traditional writing tools—quills for the Ashkenazic, and reed pens for the Sephardic, as it is only with these tools that one can bring out the subtleties and beauty in each of these scripts. Metal nibs just won't do (though it is "kosher" to write with one). Following is a description of how to cut a quill.

membrane

tightly packed part

Making a Quill

TOOLS NEEDED: Turkey quills, utility knife, scalpel with size 11 blades, double-sided razor blades, awl.

We want our quills to be sturdy and turkey quills seem to be hard enough as is, whereas quills of smaller birds might need curing—a process where the quills are immersed in hot sand for a few hours while rotating them every so often.

CHOOSING YOUR QUILL: First, look for shafts that are reasonably rounded and not "squashed flat". Place the feather in your hand to see that it feels comfortable. There is a natural curve to the feather; the direction of the curve depends on which side of the bird it was taken from. Although it is generally thought that feathers from the left wing of the bird are best for right handed calligraphers, it is really a matter of personal taste and I have often used quills from the "wrong" side if it felt comfortable enough in my hand.

PREPARING THE QUILL BEFORE CUTTING: Long feathers (1) look impressive in movies but would just get in the way (tickling your nose, poking your eye) if not trimmed. Using your utility knife, cut the quill until it is around 15–20 cm long (2). Then strip off the barbs of at least one side of the quill; for esthetic purposes you can leave a few feathers on the other side.

Inside the barrel you will notice strips of the inner membrane (3) that is wound in an almost spiral fashion; towards the tip it is very tightly packed. Using your utility knife (4), cut off that area at the tip (approximately 5 mm) in a straight cut (5). Soak the quill in approximately 3 cm of water(6) for a few hours in order to soften it.

After it has been soaked a while, take the quill out and shake out excess water. There is a thin membrane on the outer surface of the barrel which we want to remove. Using the back side (the dull side) of the scalpel blade, scrape off the thin membrane all around the barrel (7). You should now have a clear and smooth barrel.

CUTTING THE QUILL: We are now ready for our first cut of the quill. Starting 2–3 cm from the tip of the quill and still using the utility knife, cut in a scooping motion down and across towards the tip till you have removed a little more than half the diameter of the quill (8). If you are cutting with your right hand the quill should be in your left palm and rest on your index finger by your first knuckle and held in place by your thumb. The underside of the quill faces up. The knife is held in your right hand, also between thumb and index finger, and is pushed by both thumbs (see positioning in 4). The first finger of your left hand (underneath the quill) provides a counter to this so you have complete control and can make slow and delicate cuts.

After you have scooped out half the diameter you want to remove any inner membrane remaining. Sticking the awl (or any long thin object such as the end of a brush or a knitting needle) up the length of the shaft, push out all of the

inner membrane trying not to scratch the inner surface of the quill. Now we are ready to make a slit in the quill. This is what will allow the ink to be drawn into the pen. This slit can be made with the double-edged razor blade. To do this safely we only use half the blade so, while the blade is still in its paper covering, fold the blade in half lengthwise until it snaps. Take out one of the halves. Place the quill face up off the edge of the table. Holding the blade perpendicular to the quill's edge, insert the blade cleanly down the center of the quill (9). I make the slit about 5 mm long although this can be varied. In fact, all the lengths described can be adjusted according to how flexible you want the quill. Often the viscosity of the ink plays a factor too. With time you will be attuned to the right proportions to give you the quill that works best for you.

8

9

Now it is time for the second cut. Beginning around 15 mm from the tip we are going to pare down the quill from the sides. Starting at one side, this time using your scalpel, while holding it rather perpendicular to the quill, insert the blade and cut in and across the length towards the tip (10). The motion is first a slight curve inwards and then straightening out to run parallel to the slit. Move in slow steps, paring a little at a time. When you reach close to the desired width on one side of the slit turn the quill over and begin paring the other side. Beginning the same distance away as your first side, begin paring, aiming to form a nice symmetrical shape to your quill point. Go back and forth between the sides until you have a nicely formed edge that is slightly *smaller* than the final size you would like.

10

THE FINAL CUT: Turn the quill underside down and rest it on a hard surface such as a piece of thick glass. Scribes often use their fingernails (11) for a surface! Take the (half a) double-edged blade and place it a little bit back (a millimeter or so) of the tip. There are two angles to think about. One is the angle your nib will have. Hebrew right-handers will want the right side of the nib to be higher than the left so position your blade accordingly. Second is the angle your blade makes when cutting. You want to cut almost straight down but in a very slight angle going down and away from you (towards the tip) (12). The tip should fly off cleanly, leaving a slight chisel edge. If you have to saw back and forth to cut the edge you will not have a sharp edge to write with. Make sure the part of the blade that you are using is new. Sometimes the quill's membrane is too thick and needs to be thinned. Use the scalpel to pare off from its upper surface.

11

FINE TUNING: In the above directions we did not put pressure on the nib when making the final cut, and so the edge is a clean, straight line. In this variation we do put slight pressure on the nib, opening up the slit a bit as we make the final cut. After the cut, the quill will now have a "step" to its edge (13a, following page). Using the blade we now smooth out the step in a curved motion (13b) to give the final shape (13c and 14). The theory is that since we all write with a certain amount of pressure, which naturally opens up the slit, this raises one end of the quill tip off the parchment. By first forming a step and then smoothing it out, the new shape compensates for that, ensuring smooth contact throughout.

12

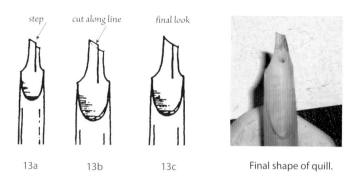

step cut along line final look

13a 13b 13c Final shape of quill.

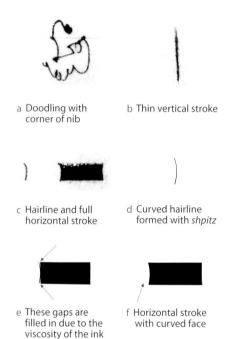

a Doodling with
corner of nib

b Thin vertical stroke

c Hairline and full
horizontal stroke

d Curved hairline
formed with *shpitz*

e These gaps are
filled in due to the
viscosity of the ink

f Horizontal stroke
with curved face

Writing with the Quill

The letters of the STaM *aleph-bet* are written with a 90 degree pen angle. There are three major strokes used in the STaM script. One is a hairline (a) which you get by using only the top corner of the quill's edge, called the *shpitz*. To write with the *shpitz*, simply rotate the quill slightly outwards till only the corner rests on the page. The second stroke is a thin vertical stroke (b) formed by holding the pen at a 90 degree angle, with the entire edge of the nib on the parchment and stroking downwards. Because of the curvature of the quill's edge this stroke will not be as thin as the hairline. The third stroke is the full thick horizontal stroke using the entire width of the nib (c). To get the horizontal roof shape one would first begin with a thin hairline using the *shpitz*. With speed this hairline often slightly curves(d). Then place the quill just abutting the hairline (e). Due to the viscosity of the ink the horizontal draws out the ink of the hairline to produce a smooth horizontal with a curved face (f). Continue with the horizontal.

MAKING CROWNS

One feature of the letters that is much easier to make with a quill, as opposed to a metal nib, is the *tag*, or *taggim* in plural. *Taggim* look like crowns adorning some of the letters. *Shin, ayin, tet, nun, zayin, gimmel* and *tzadi* (and final *nun* and *tzadi*) each have 3 *taggim* on their heads. These are made with the *shpitz* by first "drawing" a dot and then coming down with the *shpitz*. The middle tag is taller than the rest. Below are the letters with three tagim. There are other letters that receive one *tag*, and others none.

Storing the Quills

If the quills are left to dry up, the slit will begin to widen and the quill will be very difficult, if not impossible, to write with. To prevent this, store your quills suspended *over* water. I do this by covering a glass with a piece of plastic into which I have pierced holes and insert the quills so the tips remain a few millimeters above the water surface.

Stored quills hovering above water

Parchment

The *sofer* writes on parchment. The skin must come from the species of a kosher animal. Vellum is the term used specifically for calfskin. The most prized skins come from an unborn calf, called *shlil* in Hebrew. (It should be noted that the animals are never killed just for their skins.) The *sofer* today writes only on the "flesh" side. In Israel there are many parchment outlets for *soferim*. The skins sold are already beautifully prepared on the flesh side, ready for writing. Calligraphers not writing the sacred texts however, often choose to write on the hair side as this side usually has more character, showing the hues and patterns of the animal's hide. The surface of the hair side is often slick and works best when rubbed with various grades of sandpaper, depending on the degree of slickness. Sandarac powder may also be rubbed in to add extra "tooth". Pumice is rubbed when it is too greasy.

Although parchment is expensive, one advantage is that it is relatively easy to correct mistakes on it. See section on *Correcting Mistakes* in Chapter 11.

Artist Malla Carl often uses the natural coloring of the "hair" side of the parchment to great effect in her works.

Scoring Lines

Since no extraneous marks are allowed, lines are not penciled in but rather scored into the parchment using an awl. Only top guidelines are scored as the letters hang from this top line.

Pre-scored *T'fillin* parchment, waiting to be written on. The lines are 4 mm apart, meaning the letters will have to be less than 2 mm tall!

Awl used for scoring lines

Ink

The ink must be black. Originally a carbon based ink, made from the soot of burnt oils was used. Today's inks are usually made from ground gallnuts with iron (or copper?) sulfate and gum arabic added. In certain recipes, vinegar and honey might be added. *Sofer* ink is a much more viscous (and better smelling!) ink than traditionally used by calligraphers. It does not flow well in metal pens, but works beautifully with a quill. It dries quite shiny and often sits raised on the parchment, giving an interesting tactile texture to the page. (The shiny black ink on the stark white parchment also reflects the *midrashic* idea of the Torah being given as black fire on white fire.)

The raised texture of the ink
Photography and script by Avraham Borshevsky

Chapter 18

Analyzing Historical Manuscripts

THERE ARE TWO APPROACHES to teaching scripts. One is to provide an exemplar for the student to copy exactly. The positive side of this approach is that it provides clarity, giving students a clear model to compare their work to. The downside is the student becomes dependent on, and eventually limited by, the exemplar. In the absence of an accompanying explanation, the false impression might be had that there is, for example, one "correct" Sephardic script or one "correct" Ashkenazic script. However, despite its limitations, for beginning students this approach might be the more practical one.

A second approach begins by encouraging students to directly confront the historical sources for the scripts. This gives students a wider perspective as the scripts are seen within a certain historical and developmental context. Students easily understand that exemplars do not just appear out of nowhere; they are the result of someone, at some point, making choices. This method asks the students to analyze the scripts themselves, thereby placing them in the decision-making process. It is the hope that this "more independent" student will write better because of this deeper understanding, will make more intelligent choices when introducing variations, and will have the confidence to experiment with newer forms.

When looking at a historical example, it should be remembered that every letter is composed of several elements, each one of which might vary from manuscript to manuscript. Even within a given manuscript, the same letter might appear in different variations. For a detailed paleographic analysis of the Hebrew letter and its historical development, I highly recommend Ada Yardeni's excellent book, *A Book of Hebrew Scripts*. What I want to give here is a general, beginning approach to looking at manuscripts and how to gather certain information to aid in understanding where our modern calligraphic exemplars come from.

Of the many features that determine the character of the broad-edged script*, we will focus on:

1. The pen angle of the script
2. The weight of the letters (how many nib widths tall the letter is)

*Many of the features discussed here are taken from Edward Johnston's 7 steps for analyzing a manuscript in his *Lessons in Formal Writing*.

3. Proportions of the letters (the proportions of the "square" letters such as *reish* and *chet*. Do they fit into an imaginary square or a rectangle? What shape rectangle?)
4. Basic form of the letters. (What is their skeletal shape?)
5. Beginnings and finishes. (What, if any, type of serif and finishes are there at the beginning of the horizontal and the end of the vertical strokes?)
6. Slant of the letter. (Does the letter stand upright? Does it slant either forward or backward?)

Other factors that might also be analyzed are the number of strokes necessary to form each letter, the order of the strokes and the direction of the strokes. A guess might even be ventured regarding the speed at which the script was written.

We will now go through each of these steps, analyzing the lettering on the Haggadah manuscript that we looked at in the chapter on the Sephardi script, the *Brother to the Rylands Haggadah*.

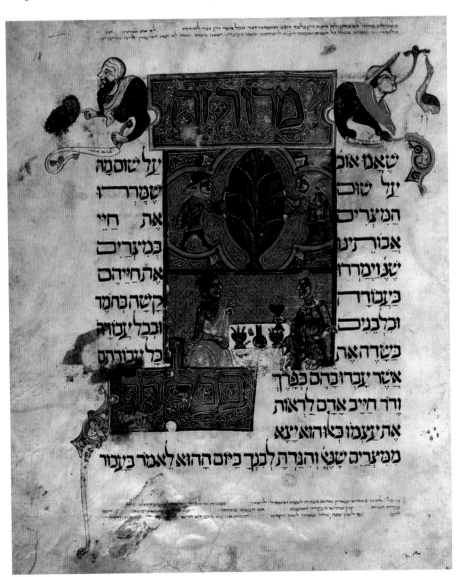

Haggadah, Spain, 14th century
OR. MS 1404 folio 18
© The British Library Board

Note: To aid in my measurements I first enlarged the image below until the body height of the letters was 14 mm tall. Having said that, it is also important to know at what size the manuscript was written. In the plates section at the end of this chapter, a section of each manuscripts is reproduced at actual size.

Measuring pen angles from an enlarged detail of the manuscript:

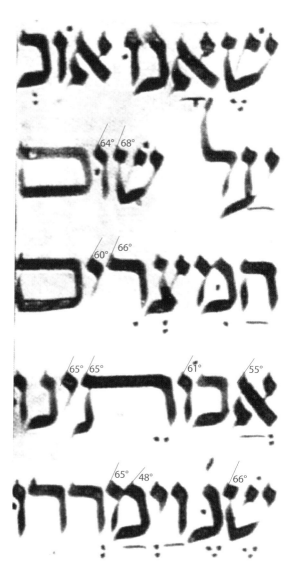

1. The pen angle of the script: In the chapter on the Sephardic script I suggested a pen angle of 60 degrees. Where did that number come from? Looking at our historical manuscript, one can estimate the pen angle by looking at the relative thicknesses of the horizontal vs. vertical strokes. Which is thicker? How much thicker? This gives us a quick estimation of the pen angle.

To get a more exact answer I looked for a few clear, sharp edges on a few letters and accurately drew a line along those edges. I drew a second line along the top horizontal guideline. The pen angle can then be measured either with a protractor or digitally on the computer. I chose a few different letters to give me an average pen angle. It might pay to repeat the exercise with another appearance of the same letter in order to see if the scribe himself was consistent. Checking with different letters will also give you a clue whether pen angle was kept the same throughout the *aleph-bet* or was changed depending on the letter. As one can see from the results the scribe was fairly consistent in his pen angle, ranging mostly between 60 and 65 degrees. Only the right stroke of *mem* and the diagonal of *aleph* showed flattening to 48 and 55 degrees respectively.

One should keep in mind that often the pen angle changes for diagonal or sloped strokes, such as the middle stroke for *aleph*. If the pen angle is not changed then the stroke would appear much heavier than the horizontal (you

often see this with the downstroke of the letter *tzadi*) so, often the pen angle is steepened on these strokes. In our example however the angle remained close to 60 degrees for *aleph* (and notice how the diagonal stroke is indeed heavier than the horizontal strokes).

2. The weight of the letters: Next I want to analyze the weight of the letter—how many pen widths tall is it? Again I look for a nice sharp edge at the end of one of the strokes of the letters, and measure the width of the pen nib. I then measure the height of an average letter. (Again I take a few measurements as the scribe might not have been consistent with the height of his letters. Remember, these letters "hang" from a top guideline with no bottom guideline so the height of the letters may differ.). To get exact measurements I used the aid of a computer but in even using a ruler I saw the pen width fell between 3½ and 4 mm. Dividing the height (14 mm) by the pen width (3.7 mm on average) gives me a pen weight of 3.75 nib units.

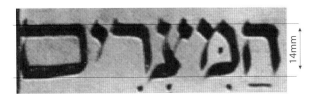 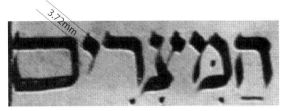

Measuring body height Measuring stroke width (computer calculated)

Calculating letter height in number of pen widths to give the weight of the letter (height divided by nib width). The average height of the letters in the enlarged image above was 14 mm. The average measurement of the nib width was 3.7 mm. Dividing the body height (14 mm) by the pen width (3.7) gives a letter that is approximately 3¾ pen widths tall.

3. Proportions of the letters: Next I measured the widths and heights of both *reish* and *heh* as that would give me an idea of the proportions of most of the letters. I mostly chose the letters on the bottom row as they would be less distorted by stretching or condensing than the ones that appear on the short lines. I would expect the *reish* to be a tad narrower than *heh* in order to decrease the open counter within *reish* (see "Skeletal *aleph-bet*" chapter), and indeed that is what we find. The *reish* fits into a rectangle with proportions almost 1.5:1 whereas the *heh* is wider, more square in form, fitting inside a rectangle 1.25:1. *Shin*, as expected, is the widest letter, fitting into a rectangle slightly wider than taller. Of course the narrow letters can be similarly analyzed.

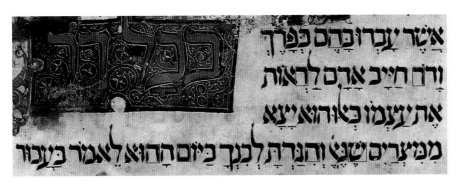

heh reish

Comparing the rectangular proportions of *heh* and *reish*

4. Basic forms of the letters: Basic skeletal forms do not differ too much within a given style, but what makes a particular script unique? Often it is in the small details. A *chet* for example, consists generally of a top horizontal stroke with two verticals coming down each edge. But is the horizontal stroke perfectly straight? Does it slope either upwards or downwards? Does it change direction in the middle? In our manuscript the horizontals are fairly straight; but in other manuscripts this is not necessarily so.

How do the horizontal strokes connect with the vertical? Does the horizontal begin with a serif? If so, what shape is the serif? (The serifs and joins for this manuscript have been discussed in the introduction to the Sephardic script.)

1 Shape of *reish*

Notice the *reish* (1). A *reish* is a simple horizontal stroke which curves into a vertical stroke. But what kind of curve is it—a soft rounded one, an almost angular curve? Look for unique elements in each of the letters, for example the subtle curve in the ascender stroke of our *lamed* (2), the curvature of the diagonal in *aleph* (3) and so on.

2 Curved ascender stroke

Notice the *aleph-lamed* ligature (4). The *aleph-lamed* combination is the only ligature in formal Hebrew writing. This developed most likely because the two letters spell *El*—one of God's names. There has always been a reticence in Jewish tradition to directly spelling out God's name and so these two letters were abbreviated into a ligature and can appear whenever the two letters are together, even when there is no reference to God's name, as in this word in our manuscript.

3 Curvature in diagonal

5. Beginnings and endings: Notice that there is a short, rounded lead-in stroke to most of the tops of letters. We discussed these serifs in detail in the Sephardic Script section. Regarding endings, the vertical legs of the letters (e.g. *dalet, heh, vav, chet, reish, tav*) for the most part come straight down (5) with no curvature, nor additional trimmings at all.

4 *Aleph-lamed* ligature
in middle of word כאלו.

6. Slant: In our manuscript, though there are some letters that slightly lean forward and some that slightly lean backwards, the overall the impression is one of a stable upright script.

Once the analysis is completed, try copying or tracing the letters over a photocopied sheet. One can also do this with a dry pen. Enlarge the photocopy until the pen width of the manuscript equals the size of your pen. Keep in mind that the tools used then are most likely different than what you might be using so an exact copy might not be possible. The scribe might have varied the pressure when writing with his reed on parchment, which would give a more varied line than what might be possible to achieve with a metal pen writing on paper.

5 Straight leg

Translation

Once the letters of a given script and their construction are thoroughly understood one can begin to think of translating these forms for contemporary use (unless one specifically wants to present a medieval flavor). When doing this one must be aware of how a modern reader recognizes and distinguishes between the letters. What worked in the Middle Ages might not work so well

today. In our Sephardic manuscript, some of the *dalet*s, particularly the *dalet* in the word *avodah* which appears on the sixth line in the manuscript on page 54, have a rounded looking corner (6) to them, which a modern reader could easily mistake for a *reish*. To find a better *dalet* for contemporary use I would still first look to the same manuscript for alternative forms. In line 10 of the manuscript there is a *dalet* (7) that has elements that could definitely be incorporated. The join is a bit more angular and the vertical stroke juts out a bit on top which distinguishes it from *reish*. I would say this would have to be a bit more emphasized (8) in a modern exemplar in order to completely avoid confusion.

The *gimmel* on the bottom line of the manuscript (9) can be too easily confused with *nun* to the modern reader, who is more used to a gap within the base or at least a clearer differentiation (10) between the base stroke and the right leg.

Another letter that often needs modification is *heh*. In our manuscript the *heh*s are very clear, but in many others the left leg of *heh* was not written separated from the roof (11) and so to the modern reader can be easily confused with *chet*. This would have to be modified for contemporary use (12).

The Plates

On the following pages are ten plates of manuscripts in different styles that can be analyzed in the manner described above. They are presented as full pages (some with cropped margins) and also a detail at a scale of 1:1 so you can appreciate them at their actual size. These are just a handful out of hundreds, so it is my hope they will inspire you to seek out other historical Hebrew manuscripts on your own—whether for analytic study or just to be enjoyed for their beauty.

Choosing and Finding Historical Sources

When one searches for historical sources one is faced with literally hundreds of manuscripts. How does one choose a script to study? The initial choice might be an esthetic one—which one attracts me to want to learn it? A second factor is which manuscript can, in the words of Edward Johnston, "breed varieties"? In other words a less polished script might not be that beautiful but might contain essential features that would provide a solid foundation for building upon, or alternatively, contain interesting features that stimulate the imagination and the desire for experimentation.

Where does one look to find historical examples? Libraries (real and virtual), museums, books, even published calendars. In Israel there is probably no better source then the manuscript department of the National Library. If one cannot get there, the excellent specimen books produced by the Israel Academy of Science and Humanities, offering hundreds of examples of each style of script, including both square and cursive forms, are available for purchase. (At the time of this writing, two volumes have been published—one on Mizrachi and Yemenite scripts and one on Sephardic scripts; a volume on Ashkenazic scripts is due out shortly. See "For Further Reading", p. 188).

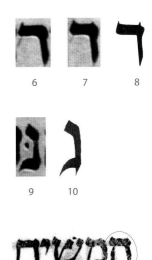

Heh with leg connected to roof

Full page, with
margins cropped ▶

Actual size ▶

Plate 1: Mizrachi (Oriental) Script. Bible, Prophets (JTS L232, fol. 83r), 10th or 11th century, Mid-East
Page size 34 x 31 cm. Courtesy of The Library of The Jewish Theological Seminary

◀ Full page, with
margins cropped

◀ Actual size

Plate 2: Mizrachi (Oriental) Script. Karaite manuscript (AIU 234 H, fol. 15v) Egypt, 1198. Page size 21 x 14 cm
Reprinted with permission courtesy of the Alliance Israélite Universelle, Paris

Actual size, with
Margins cropped ▶

ליהדי בנו ואחיו שנים עשר׳ החמשי מתכיהו בנו ואחיו שנם

עשר׳ הששי בקיהו בנו ואחיו שנים עשר׳ השבעי

ישראלה בנו ואחיו שנים עשר׳ השמיני ישעיהו בנו ואחיו

שנים עשר׳ התשיעי מתניהו בנו ואחיו שנים עשרי

העשירי שמעי בנו ואחיו שנים עשר׳ עשתי עשר עזראל

בניו ואחיו שנים עשר׳ השנים עשר להשביה בניו ואחיו

שנים עשר׳ לשלש עזל שובאל בניו ואחיו שנים עשר׳

לארבעה עזל מתתיהו בניו ואחיו שנים עשר׳ לחמשה עזל

לירמות בניו ואחיו שמם עשר׳ לששה עזל לחנניהו בניו

ואחיו שנים עשר׳ לשבעה עזל לישבקשה בניו ואחיו שנים

עשר׳ לשמנה עזל לחננ בניו ואחיו שנים עשר׳

לתשעה עשר למלותי בנו ואחיו שנים עשר׳ לעשרים

לאליתה בנו ואחיו שנים עשר׳ לאחד ועשרים להותיר בנו

ואחיו שנים עשר׳ לשנים ועשרים לגדלתי בניו ואחיו שנם

עשר׳ לשלשה ועשרים למחזיאות בניו ואחיו שנים עשר׳

לארבעה ועשרים לרוממתיעזר בנו ואחיו שנים עשר׳

למחלקות לשערים לקרחים משלמיהו ובזקלא מזבני אסף׳

ולמשלמיהו בנים זכריהו הבבול ידיעאל השני זבדיהו

השלישי

Plate 3: Yemenite Script. Bible, 1504 (JTS L 427, fol. 201v) Page size: 24.5 x 19.5 cm
Courtesy of The Library of The Jewish Theological Seminary

168

Plate 4: Sephardic semi-cursive writing from *Sefer ha-Midot* / Aristotle (JTS MS 2315, fol 24r), Spain, early 15th century
Page size 19 x 13.8 cm. Courtesy of The Library of The Jewish Theological Seminary

169

Full page, with margins cropped ▶

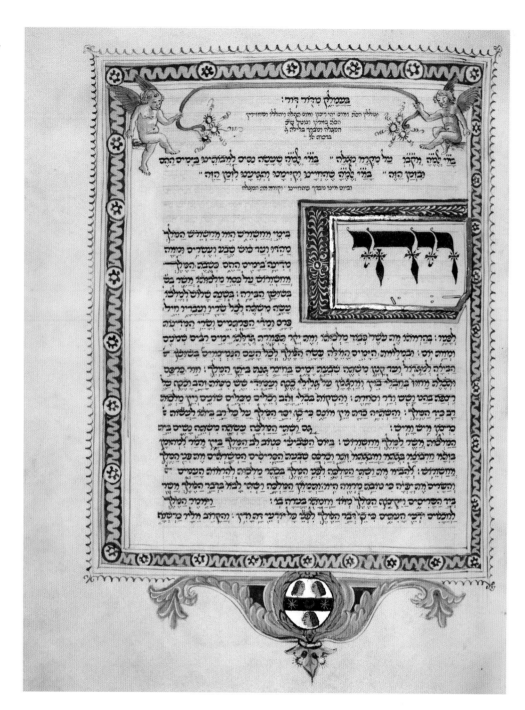

Actual size ▶

Plate 5: Semi-cursive writing from the Rothschild Mahzor (JTS MS 8892, fol. 75r). Florence, 1490
Page size 29 x 22 cm. Courtesy of The Library of The Jewish Theological Seminary

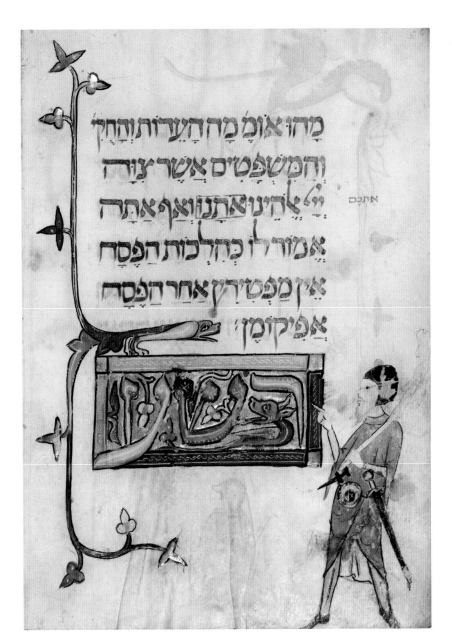

◀ Full page

◀ Actual size

Plate 6: Sephardic script from the Prato Haggadah (JTS MS 9478, folio 5v), Spain, circa 1300
Page size 21.0 x 14.9 cm, Courtesy of The Library of The Jewish Theological Seminary

Hebrew manuscript page, mostly an image.

Full page, with
margins cropped ▶

This page, from the Codex
Maimuni—Moses Maimonedes'
Mishneh Torah— is written in
Ashkenazic semi-cursive script
(note the gothic influence), with
square Ashkenazic script used
for headings and other important
words. The pages are also
enlivened with micrography in
the margins.

Actual size ▶

Plate 7: Ashkenazic semi-cursive writing from the Codex Maimuni, volume IV, fol 104. Text completed in 1296,
commentaries completed in 1413 .Page size 51 x 35.5 cm. Reprinted with permission, courtesy of Corvina Publishers

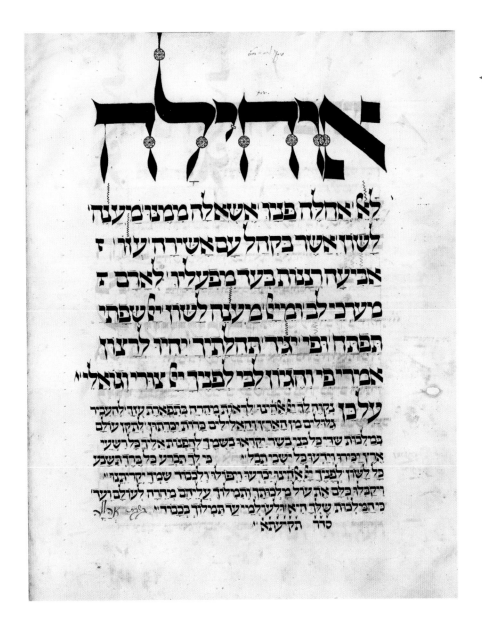

Full page, with margins cropped. Heading is clipped in the original

◀ Actual size

Plate 8: Square Ashkenazic writing from the Esslingen Machzor (JTS MS 9344, fol. 22v), Germany, 1290
Page size 46.5 x 35.5 cm. Courtesy of The Library of The Jewish Theological Seminary

Full page, with
margins cropped ▶

The letter forms on this cursive
script might be difficult to decipher. It is
included here more to suggest a
different texture and rhythm
possibility, rather than for a letter by
letter analyses.

Actual size ▶

Plate 9: Spanish "cursive" script, from Maimonides' *Guide to the Perplexed*, 1479. Page size 26 x 17.5 cm
BN hebr. 758, fol 75v, Bibliothèque Nationale de France

Full page, with margins cropped

Actual size

Plate 10. Letter, written in Yiddish in a Hebrew "cursive", 1840
From the collection of Lili Wronker, reproduced with permission

Izzy Pludwinski. *Man Must Renew Himself Constantly*. Abstract Hebrew calligraphy

Chapter 19

Going Wild

UNTIL NOW WE HAVE presented calligraphy as an exacting discipline; we measured things exactly; we tried to copy things exactly. This was necessary in order to develop good habits, gain control of the pen, and facilitate one of the most important aims of good writing, namely legibility. However all this measuring and concern for legibility can often lead to a certain type of creative paralysis. Calligraphy, especially modern calligraphy, also has an expressive function; whereas in the past the role of the calligrapher was to be a servant to the text, today's calligrapher might be asking questions such as: How does the text move me emotionally and/or intellectually? How can I express these feelings or ideas visually? In such cases, the quality of the calligraphy is not necessarily measured by how easily readable the text is, nor by how beautiful are the letter forms, but how effective is the artwork in expressing those feelings and ideas, to what extent is the viewer challenged and brought into the piece, how strong is the work graphically, and so on. This does not in any way mean that all that we have learnt until now is to be discarded. The same design principles that applied to traditional calligraphy will also apply here—but there is a certain freedom of form that we will now invite into the picture. To allow that to happen it is helpful to approach this chapter with a healthy sense of play.

On Play

The role that "play" can play in our "work" should never be underestimated. Besides being a joyful act in its own right, play allows the parts of us that have been buried to come out and find expression—the parts of us that our judging eye ("It's not beautiful, it's illegible, it's messy, it's childish") and our internal censor ("You can't do that - there are rules!") often try to repress.

Just as different music evokes different feelings so does our calligraphy. The more subtle, the more complex the emotion, the more effort must be invested to find the right vessel of expression. Through play, we can widen our calligraphic repertoire, thus enabling us to express in a clearer manner what it is we are trying to communicate. In so doing, we might even discover a little bit more about ourselves.

Ultimately, play helps us achieve the important goal of uniting content with form. This holds true whether we are writing a formal text, a single word, or an abstract mark; whether we are expressing a cerebral idea or a complex, as-of-yet undefined emotion.

So in this section we will try to let go a bit. No ruling lines; no copying from exemplars. We will be experimenting with creating new forms and using

Aleph-bet with
emphasis on round forms

Letters written without lifting pen

Exaggerating heights

different tools. No less an important source for vibrant letters are our natural hand motions and rhythms and these must also be brought into the picture. This section will not contain material to be learnt but rather suggestions of exercises meant to stimulate those creative juices and to try and get you to think "outside the box" in regards to letter forms.

EXERCISES IN EXPERIMENTATION: Do these exercises with the forms of any of the scripts you have practiced. It could be square skeletal forms, cursive handwriting forms, or any variation in between. Experiment with a few different scripts.

For these exercises try to write freely and loosely. After each of the exercises look at your work and simply notice any interesting shapes or joins you might have made. We are not judging our work, we are not looking for beautiful forms—we are quietly noticing our marks and movements, perhaps noting an element here, an element there that speaks to us in some way.

You may also try writing to different types of music, noting the rhythms and seeing if they can be incorporated in any way into your work. Remember calligraphy is not only about form. It is also the rhythm, the movements between the strokes and between the letters, even as the hand moves in the air, that give grace to our work.

1. On a blank sheet of paper, using just a simple, pointed, felt-tipped or ball-point pen, write out the *aleph-bet* freely, at a slow to moderate pace.

2. Repeat the exercise now writing it a bit faster. Repeat again, writing even faster.

3. Now go through the *aleph-bet* and write each letter without lifting your pen, though still lifting between letters.

4. Now write out the entire *aleph-bet*, this time joining letters whenever it feels "right" to do so.

5. Now write out the entire *aleph-bet* without lifting the pen at all. Vary the speeds for each of the last two exercises.

6. Repeat the above exercise with your eyes closed. Feel the motions of your arm on the paper and in the air, and try to get feedback for what kinesthetically feels "right". Try to develop a rhythm that flows throughout the *aleph-bet*.

7. Going back to your original *aleph-bet*, exaggerate the curved aspects, making each letter as curved as possible.

8. Now make the letters as angular as possible.

9. Exaggerate the widths for each letter making them very wide

10. Now exaggerate the heights, making your letters very tall.

Exaggerating widths

After completing this set of exercises, go over your work closely and see if anything speaks out to you. Are you curious to take an element that looks interesting and try to develop it further, perhaps making it a feature to apply to an entire *aleph-bet*?

During these exercises you might have noticed how features of modern handwriting occur naturally when trying to make the square letters fast without pen lifts, for example the shape of *shin*.

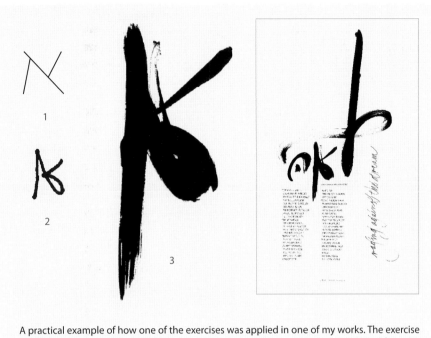

A practical example of how one of the exercises was applied in one of my works. The exercise started with writing a simple skeletal *aleph* (1). Next step is writing the letter without lifting the pen (2). Liking this shape, I returned to it when calligraphing the heading for a poem called Leah. The title was written with a large Sumi brush, which produced a powerful looking *aleph* (3).

Next, try the above exercises again, this time utilizing different writing tools.

Experimenting With Tools

As I have mentioned throughout this book, the look and spirit of our letters is influenced by the tools we use. Here I encourage you to try to write with different tools. One can really write with anything. (One of my favorite writing tools is an emery board.) Have at hand brushes, both flat-edged and round-tipped, popsicle sticks, ruling pens, pastels, crayons. You can even try found objects, such as twigs and branches. With brushes you can vary the pressure, which will strongly affect the thickness and shapes of your strokes.

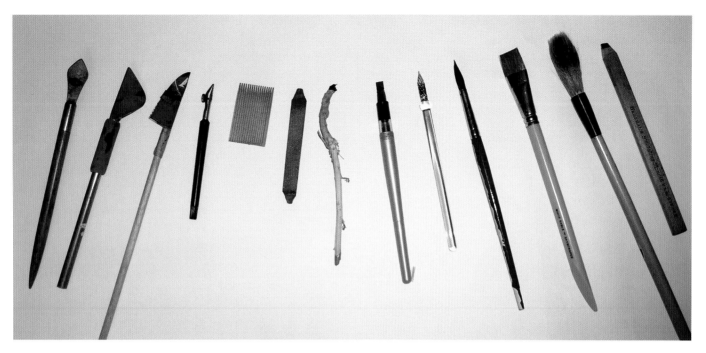

A selection of tools other than the broad-edged metal nib. From left to right: Ruling pen, folded pen, "Coca Cola pen" (home-made from a cut aluminum can attached to a dowel), ruling pen, dental plaque-remover picks, emery board, found twig, Pilot parallel pen (this does have a broad-edged metal nib), glass pen, pointed brush, flat brush, Japanese sumi brush, carpenter's pencil.

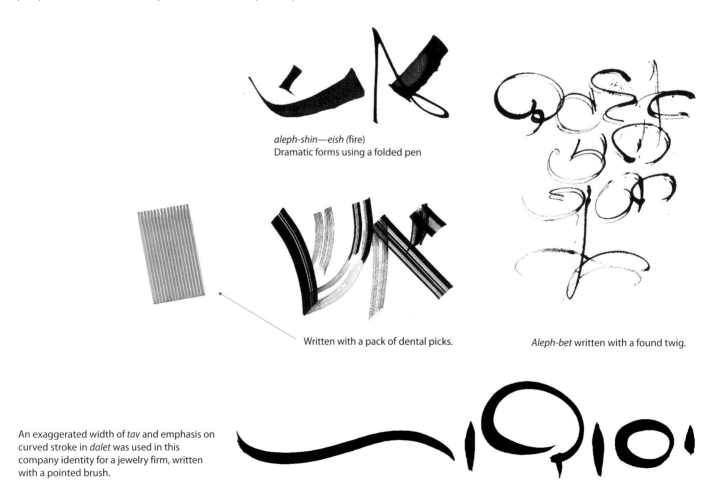

*aleph-shin—eish (*fire)
Dramatic forms using a folded pen

Written with a pack of dental picks.

Aleph-bet written with a found twig.

An exaggerated width of *tav* and emphasis on curved stroke in *dalet* was used in this company identity for a jewelry firm, written with a pointed brush.

Aleph-bet Improvisation Exercise

Now take a large piece of paper, at least 50 x 70 cm. Choose a favorite tool and, drawing inspiration from whatever you gleaned from the previous exercises, design an *aleph-bet* page. No pre-planning. Your aim is to fill at least one dimension of the page (height, width or both, leaving proper margins) with the entire *aleph-bet*. Be sure to write incorporating your entire body, with the motions emanating from a loose shoulder. You are not limited to keeping the sizes of all your letters the same, nor their color. But of course we are still looking for good design, so there must still be a feeling of unity about the piece, even if it is made up of varying elements. Below are some improvisations I have done with different tools.

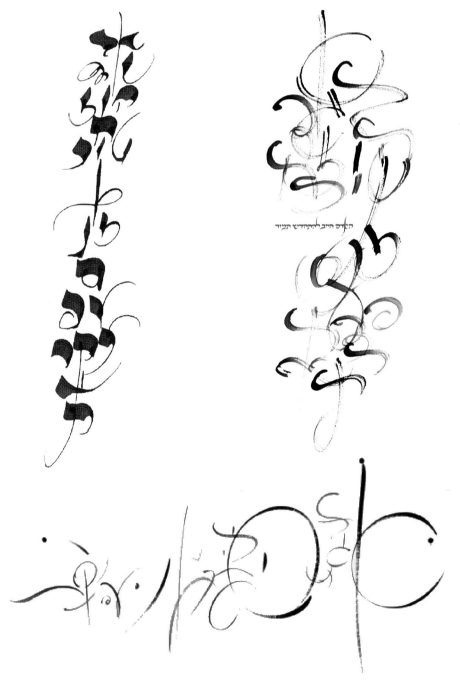

Far left: *Aleph-bet* improvisation, utilizing exaggerated pen manipulation. Written with a 6 mm Parallel pen

◀ *Aleph-bet* improvisation
Written with an emery board and gouache on paper, 1990

Freely written *aleph-bet*, written with a pointed brush

The Story of Shir, or "It's Not About Going Wild for Wild's Sake"

I would like to describe in brief a practical application that came out of "just" playing. In search for more expressive Hebrew letter forms, I was going through some of the exercises mentioned above, just playing, writing with a simple monoline pen. I was not worried about legibility—just seeing what my hand wanted to do. Below are a couple of those "play" trials.

Some of the textures looked promising and so I next tried writing, in an improvisational layout, a couple of verses:

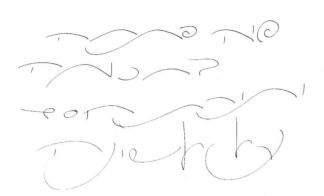

I liked the rhythm and texture of that but realized I was sacrificing legibility. I then tried to "tame" the wildness while still retaining some of the features:

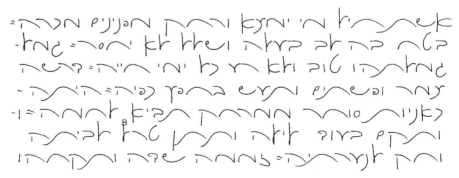

This look was interesting to me but my hand, in a very physical and "kinesthetic" sense, did not enjoy writing those forms with restraint. It was then that I first thought of the idea of developing a digital font instead. On the next page you see the final result, the font Shir.

אֶל הַכֶּפֶר דּוּדִי ךָ בְּכָרֵאי יַ לֵין שָׁאָי :
הִנָּךְ יַפָה רַעְיָתִי הִנָּךְ יַפָה עֵינַיִךְ יוֹנִים :

Once I had the font I wanted to produce something tangible with it. The forms of the font and the way the letters related to each other suggested to me both femininity and playfulness. I thought of *Shir Hashirim*, the Song of Songs, perhaps the only Biblical book where the feminine voice is the dominant one, and where the beloveds always seem to be in playful relationship. And so the *Shir Hashirim* book, set in Shir, was created.

Izzy Pludwinski. *Shir Hashirim*, limited-edition book, with illustrations by Mordechai Beck
Photo courtesy of Yair Medina at Jerusalem Fine Art Prints

I mention this project in order to give a concrete example of how play can lead one onto unplanned journeys. When I began I had no inclination to develop a font and no intention to produce a book. I was "only" playing. But when in a state of play one lets go of expectations and predefined results. The focus is rather on the here-and-now. If you can approach your work with a certain curiosity and openness, you might become aware of unexpected possibilities which in turn can lead you onto new and exciting adventures, calligraphic and otherwise.

NOW WHAT?

"Who is wise? He who learns from everyone." (Ben-Zoma)

I do hope this book has been, and will continue to be, a source of inspiration. But it should not be the only one. For self-study there is a list of recommended books in the appendix. In addition I strongly urge you to take in as much written Hebrew as you can. Seek out museums, libraries, Hebrew magazines. Search online. If in Israel you will have unparalleled exposure to Hebrew lettering of all kinds. Keep your eyes open to the lettering on shop fronts, book covers, advertisements, buildings—you will find a plethora of both traditional and modern Hebrew lettering. View as much as you can and try to learn from everything, the good as well as the bad.

For those relatively new to the field of Hebrew calligraphy who want to further their studies, my best advice is to find a teacher to learn from personally, as the dynamic interaction would be invaluable. This, however, might not be possible for all. Next best would be any exposure to general calligraphy. Subscribe to a letter-arts journal, such as *Letter Arts Review*. Seek out a local calligraphy guild, see what classes or workshops might be available in your area. If there are none, do not despair. Firstly there are calligraphy correspondence courses. Secondly, calligraphy is related to all the visual arts so taking a class in drawing, graphic design, painting, bookbinding—all these will have a positive influence on your calligraphy.

"It is not good for man to be alone"(Genesis 2:18). Fortunately, the calligraphy community is a very supportive group, made up of interesting "characters". There are calligraphy forums on the internet and calligraphy groups on the social networks, whose members are usually more than happy to share tips, images, information and advice. I urge you to join in as every new member who gets involved helps to strengthen the calligraphy community and keep it thriving.

Ultimately though, as mentioned at the very beginning of the book, it will be your own passion and curiosity that will determine how far and in what direction you need to go. Trust that inner voice, for "All things that the (pure) heart speaks are the words of the Divine…" (Rebbe Nachman).

FINAL WORDS

We have come full circle, and it is time to bring this book to a close. I would like to conclude with a *midrash*. It is told that many nations were offered the Torah. The Israelites responded uniquely when they said *na'aseh v'nishma*, "We will do and we will hear". This is usually understood as a declaration of total faith—even before hearing what it says, we will do it. Another interpretation explains it thus: "We will do", and as a result of our doing, "we will learn" (hear). Learning is not to be done in the abstract—it comes about as a result of engagement.

So the time has come to stop talking about calligraphy. Pick up your pens and start the journey. Where it will lead to, no none can tell; but the possibilities are endless.

I leave you with a rephrasing of the words of the wonderful artist and lover of letters, Ben Shahn:

> Calligraph what you feel,
>
> Calligraph what you believe,
>
> Calligraph what you are.

Acknowledgements

I am indebted to so many people who helped me along the way, starting with my first calligraphy teacher, Jay Greenspan. I took his class in the late 70s at the 92nd street Y in New York where I received a solid grounding in the fundamentals of calligraphy, as well as a holistic approach to this art. We started our classes with a breathing meditation. This created a special, almost sacred atmosphere in which to do our lettering. This is something I have tried to recreate in my own work as well as my own teaching classes.

The man who taught me *sofrut* is a master *sofer* and a truly humble man, whose name I shall keep anonymous. When we students first started writing the *STaM* script, it took us a long time to even write a single line—sometimes over 20 minutes. We thought this was normal. One day we arrived early for class and our teacher was writing a *Megillah*. I timed him at somewhere around 2½ minutes. But the fascinating thing was he wasn't writing fast. It was just that there wasn't a single wasted movement. It was an awe-inspiring experience that I can only dream of one day accomplishing.

Two teachers tutored me privately for months in English calligraphy—Alice Koeth and Lili Wronker, asking for no compensation in return. They truly loved their craft and taught me totally *lishma*—for its pure sake. Lili giving me lessons at her home and Alice at the Steuben glass studio at the end of her work day. More than being wonderful (and very patient!) teachers, they taught me much about the art of giving.

Much of the practical information presented here I learnt during my studies at the Roehampton Institute in London. The calligraphy school there was headed by the superb teacher, Ann Camp.

In writing this book I was greatly helped by friends and colleagues who read the book and gave freely of their time and suggestions. To Paul Kay for doing the initial editing of the book, and to Sivan Slapak for the final proofread. To Randy Hasson, who read each chapter as it was being written, and with humor and wisdom gave constructive comments and enthusiastic support. Sharon Binder also read significant amounts of the book and I am grateful for her comments and support. Eliyahu Misgav generously offered of his knowledge and image-base of contemporary Israeli calligraphy, and Batsheva Ida Goldman helped with her extensive knowledge of Judaica and Judaica artists.

To Ruth Lubin, who designed the book and had to put up with my comments and stubbornness. If there is anything lacking in the book design it is due to my irrational obstinacy.

Sharon Lieberman Mintz, Curator of Jewish Art at the Jewish Theological Seminary in New York was instrumental in helping me obtain reproductions of many of the historical manuscripts. The JTS Library generously allowed me use of their manuscripts from their magnificent collection.

Jean-Claude Kuperminc and Avraham Malthete of the Library of the Alliance Israelite Universelle in Paris generously allowed the reproduction of the manuscript presented on page 167.

Yigal Gross, head of the Graphic Design department at Emunah College, allowed me access to the Yerachmiel Shechter calligraphy collection which is stored at the college, and generously gave permission to reproduce the images of Shechter's work and those of his Bezalel students. Every effort was made to identify the creator of each of the works (some almost 90 years old!) but unfortunately some were not signed. Although I tried my best to track down each and every artist, in some cases I did not succeed.

To Itzik Rennert, head of the Department of Visual Communication at Shenkar College for permission granted to use images from student work.

Dr. Edna Engel of the Hebrew Paleography Project at the National Library in Jerusalem generously allowed me access to her research of Ashkenazic scripts and was helpful in answering my many questions.

Misha Beletsky was equally gracious with his time and willingness to help me find the right publisher as well as offering of his expertise in book design, as was friend and colleague Marcia Friedman. My good friends Elisha Mallard and Benjy Caplan gave freely of their time in providing editing advice and technical assistance.

I am grateful to the many artists who were generous in providing their works to help illustrate the book. First to Evelyn Pauker for making available the works of her husband, Fred Pauker. To my colleagues who allowed use of their works to be reproduced for the book: Malla Carl, Lynn Broide, Sharon Binder, Josh Baum, Ruth Lubin, Avraham Borshevsky, David Moss, Archie Granot, Amalya Nini, Joy Rosenblum, Luba Bar-Menachem, Leah Crust, Gina Jonas, and Melissa Dinwiddie. To the artists I collaborated with in producing the two *haggadot*, Yael Hershberg and Avner Moriah. To Zeev Lipmann, who at age 90 granted me an interview in addition to allowing me to include his work. To the artists who, although I did not know them personally, still kindly permitted use of their works: Frank Lalou, Mark Podwall, Matt Berkowitz, Oded Ezer, Adi Stern, Doron Nuni, Yaara Baruch, Hadass Bar Yosef Gath, Michel D'Anostino, Daniel Groover, Nava Shoham, Stephanie Adler, Rachel Deitsch, Ray Michaels, Sivia Katz, Nishima Kaplan, Arnona Rozin, Moshe Chatumi and Stan Brod. To the families of Arye Alweil and Sigmund Forst for permission to reproduce their works. To Ruth Bruckner who, back in 1989, did most of the work producing the skeletal *aleph-bet* chart on page 8. I wish I could have included the works of many other deserving artists but unfortunately, space limitations did not allow it.

Charles Pearce was kind enough to allow me to use his wonderful pen drawings of the Mitchell and Brause nibs, shown on page 24. Yair Medina kindly provided the photograph of the Shir Hashiurim book on p.183. Jonathan Drake kindly granted me permission to reproduce the image shown on page 22.

None of this would be possible without the cooperation of Matthew Miller of Toby Press. I first went to him for advice on whom to seek as a publisher and he answered simply "We'll do it". His willingness to invest in a book on Hebrew calligraphy in these tough times in the publishing world is no small matter and I am grateful for the opportunity he offerred.

Last, but certainly not least, I would like to thank my family: my wife Sheffi, and my two daughters, Tamar and Miri. Firstly for their love and support and secondly for helping with the photography, and in Tamar's case modeling for the photo on p.22.

For Further Reading

HEBREW CALLIGRAPHY

The Book of Hebrew Scripts, Ada Yardeni. Carta, 1991
 An excellent book on the history and paleography of the Hebrew letter.

Specimens of Medieval Hebrew Scripts, Volume 1: Oriental and Yemenite Scripts, Malachi Bet Aryeh, with Edna Angel and Ada Yardeni. The Israel Academy of Sciences and Humanities, 1987

Specimens of Medieval Hebrew Scripts, Volume 2: Sefardic Script, Malachi Bet Aryeh and Edna Angel. The Israel Academy of Sciences and Humanities, 2002

 The above two volumes are invaluable source books, each containing well over a hundred plates of historical manuscripts.

The Hebrew Letter, Ismar David. Aronson, 1990
 Good overview with plates of different styles presented on separate cards.

The Art of Hebrew Lettering, E.F. Toby, 1951
 A selection of different script styles, penned by Ze'ev Lippman

Alphabet, Hebrew, Jacob Maimon, in *Encyclopedia Judaica.* Keter Press, 1972

ENGLISH (LATIN) CALLIGRAPHY

Writing & Illuminating & Lettering, Edward Johnston. Pitman, 1906
 The classic book by the person who revived the art of broad-edged pen lettering in England.

Foundations of Calligraphy, Sheila Waters. John Neal Bookseller, 2006
 An excellent manual presenting instruction and analysis of a wide variety of Latin hands, as well as design for calligraphers.

Pen Lettering, Ann Camp. A&C Black, 1984
 A brief and concise introduction to proper lettering.

Brush Lettering, Marilyn Reaves and Eliza Schulte. Design Books, 1993

The Practical Guide to Lettering and Applied Calligraphy, Rosemay Sassoon, Thames and Hudson, 1985

The Calligrapher's Handbook, edited by Heather Child. A&C Black, 1985
 A selection of articles encompassing the craft of the calligrapher.

The Mystic Art of Written Forms, Friedrich Neugebauer. Neugebauer Press, 1981

The Art and Craft of Hand Lettering, Annie Cicale. Lark Books, 2004
 A good foundation on scripts and design, plus interesting projects to try

CREATIVITY AND RELATED TOPICS

No More Secondhand Art, Peter London, Shambhala, 1989

Drawing on the Right Side of the Brain. Betty Edwards, Tarcher/Penguin, 1979

The Artist's Way. Julia Cameron. Tarcher/Putnam, 1992

Finding the Flow: A Calligraphic Journey, Gina Jonas. Self published, 2006

Love and Joy about Letters, Ben Shahn. Grossman, 1963

The Shape of Content, Ben Shahn. Harvard University Press, 1992

Body Know-How, Jonathan Drake. Thorsons, 1991

Online Calligraphy-Supplies Stores (partial selection)

John Neal Books: www.johnnealbooks.com (Based in the U.S.)

Paper and Ink Arts: www.paperinkarts.com (Based in the U.S.)

Jerry Tresser: www.jtresser.com/goldsize.html (specializing in gilding materials)

Cornelissen and Sons: www.cornelissen.com (Based in the U.K.)

Shepherds Faulkiners: www.falkiners.com (Based in the U.K., specializing in fine papers)

Calligraphity: www.calligraphity.com (Based in the U.K., specializing in calligraphy books)

Scribblers: www.scribblers.co.uk (Based in the U.K.)

Blots Pen & Ink Supplies: www.blotspens.co.uk (Based in the U.K.)

Quietfire Design: www.quietfiredesign.ca (Based in Canada)

Calli Art: www.kalligraphie.com (Based in Switzerland)

Atelier für Kalligrafie www.schriftkunst.de (Based in Germany)

The Great Calligraphy Catalog: www.thegreatcalligraphycatalog.net (Based in France)

Mary Koperdraat Calligraphy: www.kalligrafie.nl (Based in Holland)

Wills Quills: www.willsquills.com.au (Based in Australia)

Index

Sephardic script 5, 45, 46, 49, 55ff
 exemplar 56
 manuscript analysis 162, 164,
 165, 167
STaM script 155
serif
 formation of in Yerushalmi 64-65
 defined 9
 formation of in Pauker script 52
 formation of in Sephardic 45
Shahn, Ben 4, 123, 185
Shechter, Yerahmiel 34, 68, 84
Shenkar College 119
Shir font 135
 development of 182
Shir Hashirim 154, 183
Shoham, Nava 142
shpitz 71, 158
size
 for gilding 132
 in papers 20
sloping head stroke 47
smudge 25, 43
sofer 4, 151, 155ff
 method for justifying text, 108
spacing
 interlinear, 17, 134
 optical, 15
 principles of 15
 to justify text 107ff
 See also Letter spacing *and* Word
 spacing
Speedball nibs *See also* nibs
 A and B series, 98
Square Script 4, 5, 9, 85, 90, 166,
 167, 168, 171, 173
Stern, Adi 90
stretching letters 46, 108–110
subtle curve stroke 164
 in Foundational 48–9, 50
Susya 94
Synagogue mosaic 94

T

Tape *See* nibs
t'fillin 4, 155, 159
Tetragrammaton 63

Toby, L.F. 51
Torah 3, 4, 9, 108, 109, 155, 159,
 172, 185
touch-ups 99
Tresser, Jerry 132, 188
troubleshooting 33

U

u'knina 143, 144, 145, 147

V

Variations
 Foundational Script 45ff
 Ashkenazic Script 77ff
vocalization *See nikkud*
vowels 139, 140

W

word spacing 14, 17, 109, 111,
 112, 150
work surroundings 23
Wolff, Barbara 13, 130
Wrist-twist method (for lefties) 26
Wronker, Lili 129, 175

Y

Yardeni, Ada 13, 160
Yemenite Script 168
Yerushalmi script 63ff

About the Author

Born in Bensonhurst, Brooklyn in 1954, Izzy Pludwinski is a freelance calligrapher and calligraphy teacher. He studied as a Sofer STaM in Jerusalem and took his formal calligraphy training at London's Roehampton Institute.

Izzy has taught Hebrew calligraphy in Jerusalem since 1983 and also set up the Hebrew Calligraphy course at the Spiro Institute in London. In addition he has lectured at the Emunah College Symposium on the Hebrew Letter and has given Hebrew Calligraphy workshops at the Israel Museum. Izzy now teaches via a correspondence course he has established, as well as teaching privately, in addition to keeping up a heavy workload as a freelance calligrapher. His varied commissions have included calligraphy for several special-edition *Haggadot*, work for the President's Office of Israel, lettering for the Yakar Synagogue in Jerusalem and the design and publishing of a fine-art edition of the Song of Songs. He was recently in Wales at the invitation of Donald Jackson to write the Hebrew for the St. John's Bible Project.

Though firmly entrenched in the world of traditional Judaica, Izzy's calligraphic passion lies in finding ever-new expressive forms for the Hebrew *aleph-bet*—a path that has led him to anywhere from font development to Zen-influenced abstract Hebrew calligraphy. He lives in Jerusalem with his wife and two beautiful daughters.